ART FOR A PURPOSE
The Artists' International Association, 1933 — 1953

by Robert Radford

Winchester School of Art Press,
Park Avenue, Winchester, Hampshire

I would like to acknowledge my debt of gratitude to the many people who have enabled this book to come to fruition. In particular I would like to mention Lynda Morris, David Elliott and Brandon Taylor. My most profound thanks are offered to the many past members of the AIA who, over the years, have assisted my research. They have given their time and their resources generously. The quality of their experience, the clarity of their recollections, their wisdom will always be in my mind. I should like to dedicate this book to them, for the value of their example.

Photographic Acknowledgements

F. H. K. Henrion, James Holland, Robert Medley, W. Suschitzky, Kunsthaus Zurich, Marx Memorial Library, Morning Star, Imperial War Museum, Narodnie Galerie Prague, National Union of Mineworkers, National Museum of Labour History, Tate Gallery.

The publishers gratefully acknowledge the financial assistance of the Southern Arts Association.

Front Cover Illustration shows the motif designed by F. H. K. Henrion for the 'For Liberty' exhibition in 1943.

First edition published in the United Kingdom 1987 by:
Winchester School of Art Press,
Park Avenue,
Winchester SO23 8DL
Hampshire

Designed by Rachel Hodge, Hampshire County Council Design Unit
Printed by Lyndhurst Printing Company Ltd
Published by Winchester School of Art Press

British Library Cataloging in Publication Data:

Radford, Robert
Art for a purpose: The Artists' International Association, 1933-1953 — (Winchester studies in art and criticism).
1. Artists' International Association — History
I. Title II. Series
700'.6'01 NXZI.2.A.7.

ISBN 0 9506783 7 6

CONTENTS

INTRODUCTION

The Artists' International Association — abbreviated early on to 'the AIA' — first saw the light of day in the Autumn of 1933 and was to survive as an active body for the next thirty-five years, to be quietly laid to rest in 1971. It was unique in the history of the artistic and cultural life of Britain, in that its primary purpose was to organise visual artists — painters, sculptors and designers — so as to enable them to express their commitment to social responsibility in art and to support radical, political ideas directly in terms of their practice as artists. What is remarkable is not just the AIA's readiness to grasp these two horns of commitment — both to art and to politics — but that this sense of purpose was sustained over a considerable time and that it retained the support of a large and influential section of the profession.

It would be reasonable to expect that the 1930's might have spawned one or two short-lived and loosely organised groups of young artists, who were intent on voicing their political disquiet with the events of their time; and it would be equally reasonable to assume that they might fade from our notice as quickly as any other group belonging to the Bohemian fringes of London's artistic life. But the AIA, although starting on a modest scale, was always well organised, was firmly rooted in practicality, and soon expanded impressively. At the height of its success it could claim over a thousand members, and although this number would have included students and teachers of art, it also

embraced some of the most prominent artists in Britain, drawn from the whole breadth of the professional spectrum, from the Royal Academy to the New English Art Club, from the Circle group to the Euston Road group, from the London Group to the Surrealists. The AIA exhibition of 1937, for example, drew support from such different artists as Vanessa Bell, Jacob Epstein, Barbara Hepworth, Robert Medley, Lazlo Moholy-Nagy, Lucien Pissarro, Dod Proctor and Edward Wadsworth. Indeed at this stage of its progress, it would be more appropriate to look for the absences rather than the inclusions among AIA exhibitors. It need hardly be emphasised that there would have been no other opportunity in London at this time to bring together such a panorama of professional loyalties and stylistic tendencies within a single exhibition.

I stress this impressive range of representation and level of accomplishment not just to show the degree of significance that was achieved by the AIA in its day, but also to highlight the scant attention which the organisation has, until very recently, received. Quite apart from the absence of any substantial study of the AIA itself[1], there has been an almost wilful conspiracy of silence among biographers and historians, who have generally excluded any mention of a connection with the AIA from the career details of their chosen subjects.

Perhaps reasons for this are not hard to find. As art ideology shifted in the late Fifties and the Sixties, a commitment to social responsibility in art became not simply unfashionable but positively embarrassing to many artists wishing to claim a place in the modernist stakes. Others who were now art school Principals, or Heads of Departments, felt it prudent to discount their prior membership of an organisation which hinted at Marxism. Another explanation for the AIA's historical invisibility lies in the absence of any readily identifiable AIA style; for it is well recognised that the pressures of the art market have unduly influenced publication decisions and the art market favours the packaging of art into style categories, but it will be seen how it was unlikely that any unified style should emerge, given the Association's aims and practices.

But the time is now ripe for a closer examination of the work and attitudes of the AIA, for a number of reasons.

It is now accepted that the euphoria and avant-gardist adventure of the sixties, when art was selling well and at times aspired to the condition of fashion, gave way in the next decade to a new seriousness, an outlook which of course contained many directions, foremost among which was a new interest in art's relations with life and politics beyond the hermetic sphere of the art world. The founding

7

of the Artists' Union, the expansion of interest in Community Art, the mounting of two major exhibitions, *Art for Whom* (Serpentine Gallery, London 1978) and *Art for Society* (Whitechapel Art Gallery, 1978), the attention given to the critical writing of Fuller, Cork, Tisdall and others, were all indications of this tendency.

Twentieth century British art has also recently surfaced as a subject deserving serious attention as art history and this is marked by the publication of such recent books as Charles Harrison's *English Art and Modernism, 1900-1939*, Dennis Farr's *English Art 1870-1940*, and Frances Spalding's *British Art since 1900*.

The New Art History has warned that the discipline will fail to be taken seriously as a branch of cultural history, so long as it maintains its customary habit of concentrating on what it regards as the successful art of any period, instead of examining even-handedly the whole range of art production of that period. A study of the AIA provides a useful model for framing just such a value-free cross-section. The usual pattern of this selective approach to the art history of the twentieth century has been to accept without question that the significant story is the 'progress of modern art', disregarding the relatively small proportion of actual art activity which Modernism often represented. This selection is recognisable as the reaction of evangelists, in league to advance certain ideas they hold to be good or even historically necessary. However, we are now more ready to perceive Modernism as no more (and no less) than one of the major dynamic style structures of art history and we no longer stand so much in awe of it. What we can now discern is how much has lain ignored or undervalued as a result of this enthusiasm, for as Simon Wilson has pointed out:[2]

> The history of British art for this period (the 1920's and 1930's) still largely remains to be written. What texts have been written concern the avant-garde and the question of 'realisms' in this epoch has not been explored.

A study of the views expressed and the work exhibited in the ambit of the AIA might help to redress this balance and allow a more discriminating analysis of the forms and meanings of non-modernist modes of working in British art.

There is also the hope that a study of the AIA could make some contribution to the Sociology of Art, in helping to establish the kind of historical data on which a coherent sociological study of the processes of both production and

consumption of art in Britain might someday be based. Such a study would need to ask questions about the social background, the recruitment and training of the artist, how the worldview of the artist is moulded, how economic restraints and different kinds of patronage shape attitudes and career patterns. Equally, attention would have to be given to identifying the various types of art audience, be they part of the greater public, experiencing art corporately through national and local gallery provision, or the individual purchaser of works of art.

The creative work associated with the young poets and writers from Oxford, in the train of Auden, and of the more orthodox Marxists of the next generation, epitomised by Julien Bell and John Cornford at Cambridge, is well known, indeed in danger of becoming clichéd. Bernard Bergonzi has warned of the dangers of misreading and mythologising the period[3], and when a comparison is made between the contributions to practical political activity of the period by the Auden circle, and that of the AIA, it seems all the more of a distortion to have left the artists so completely out of the story, as Stephen Spender readily admits about his fellow writers,[4]

> They were ill-equipped to address a working-class audience and were not serious in their efforts to do so. (If their poetry strikes as being addressed to any one in particular, it is to sixth-formers from their old schools and to one another)

which is corroborated by George Orwell[5]

> By being Marxisised, literature has moved no nearer to the masses.

The AIA had as its nucleus a prominent group of the more politically acute and active members, from which a Central Committee was drawn which was responsible for suggesting and establishing policy and strategy. Then there was a ring of regular contributors to AIA exhibitions, lectures and social events, young artists and designers in their early twenties, and thirties, living in London. Beyond this there extended another band of artists with a more established reputation, who would show their sympathy with the AIA's position by lending work to its exhibitions. There was, in addition, a large section of the membership who wished to show support for the general aims of the body but who had less connection with its day-to-day activities. This would include teachers of art, art students, and also associate members who might have no occupational connection

9

with art or design. We must also include the many members of the AIA's regional groups which developed from the early days and which were fairly autonomous in their operation.

Much of the vitality of the AIA undoubtedly derived from the contribution of those employed primarily in poster and advertising art, whose professional skills were particularly appropriate for the topicality and directness required by political art. These 'commercial' artists often resented the caste system within the art profession which demoted their status in relation to that enjoyed by the 'fine' artist. They considered this all the more unfair since (so they maintained) they were putting into practice the only form of modern art which was appropriate to their times — a genuinely popular and democratic art.

When it was working at its best, the AIA was able to operate with a flexibility and a degree of ideological tolerance which were both in step with the ideals of the Popular Front, and attractive to a broad range of artists. In fact the AIA soon established itself as the natural body through which most forms of political activity by artists should be focused, so that, although this study is draped very much over the structure of the AIA, the range of social and political attitudes it reflects can be taken as representing the artists' occupational group during the period 1933 to 1953 as a whole.

It would be misleading however to give the impression that the single function of the AIA throughout the period from 1933 to 1953 was to enable artists to battle with the intractible difficulties of reconciling their artistic values and loyalties with the ever-pressing political reality of the times. Although propaganda work and exhibitions devoted to particular themes were continuous aspects of its programme, other considerations helped to shape their policy and mark out the AIA as untypical of previous groupings of artists in Britain. For example, one policy thread which ran through its fabric from the earliest days to the later was a concern with the occupational conditions of the working artist and designer. The effects of the Depression on commercial work and traditional patronage, as well as a growing sense of sympathy between the AIA and the working classes, combined to provoke enquiry by some sections of the membership into the feasibility of operating the AIA as a kind of Trade Union for art and design, concerned with establishing minimum rates of pay, standard contracts of employment and the provision of welfare benefits.

The other major and continuously maintained theme of the AIA's work, and one which follows naturally from its speculation on the nature of political art, was a determination to create an interest in art among new audiences —

which were largely identified with the economically and educationally deprived sections of British society. This desire of the AIA to democratise the consumption of art implied a serious consideration of both means and media, and some of the most influential aspects of the Association's work were the tactics it evolved to put into practice such schemes as touring exhibitions to factory canteens or provincial libraries, the production of inexpensive artists' prints and the mural decoration of community buildings. These initiatives were of course entirely consistent with the Association's aim of securing the regular employment and continued prosperity of the profession.

This book will follow these developments chronologically; but progress will be interrupted briefly at Chapter Three, which aims to pull together some of the strands of the art-and-politics debate as it was understood in the 1930's, and the crucial issue of style within that debate. I have selected wherever possible the contemporary statements of artists themselves in addition to those of critics and theorists, since such statements have been shaped by the authentic experience of making art, and the problems of reconciling social and artistic pressures have been pondered with paintbrush or pencil in hand.

Another non-chronological chapter towards the end of the book examines some of the issues confronting those artists who were also members of the Communist Party and who were thereby required to think and act as 'Communist Artists'; since, although their story is largely contained within the account of the AIA in its first decades, there are some significant points of distinction to be made.

The AIA, during these years, was by its nature a dynamic body, its declared philosophy being to 'react to time, place and occasion'[6]; and any static catalogue of its aims and practices would misrepresent its changing significance in the lives of at least a couple of generations of artists and their audiences — those who flourished in Britain between 1933 and 1953.

Notes

1.　A pioneering account does appear, dispersed through a number of sections, in D. D. Egbert, *Social Radicalism and the Arts: Western Europe*, New York, 1970.

see also, T. Rickaby, 'The Artists' International', *Block* No. 1, 1979, pp. 5-14.

and, L. Morris and R. Radford, *The Story of the AIA, 1933-1953*, Oxford, 1983, published on the occasion of the exhibition of the same name mounted by the Oxford Museum of Modern Art.

2.　S. Wilson, in *Les Realismes*, exhibition catalogue, Centre Pompidou, Paris, 1981, p. 276.

3.　B. Bergonzi, *Reading the Thirties*, London, 1978, and 'Myths of the Thirties', *Times Higher Education Supplement*, March 19th, 1982, p. 13.

4.　S. Spender, *The Thirties and After*, London, 1980, p. 23.

5.　G. Orwell, *Inside the Whale*, London, 1940.

6.　Editorial Statement, *AIA Bulletin*, June 1939.

THE ARTISTS' INTERNATIONAL 1933-34

There was surely no precedent in Britain for the formation of a society of artists drawn together to express a common attitude about political and social issues; certainly none of which the founding members of the AIA were aware. The William Morris/Walter Crane tradition of socially responsive art practice had to a large extent expired by the mid-1920's through its association with an earlier generation, and in any case this tradition held out little hope or guidance for the activity of painters because of its emphasis on the applied arts.

The 1920s were not experienced as heroic days for painting and sculpture in Britain; the energies and enthusiasms of the Vorticist generation did not survive the post-war mood of a return to normality and the more adventurous artist had to look to Paris for any direction and sustenance, but even here one was likely to come across only a derivative, fashionable corruption of the previous strengths of avant-garde work. The whole world of ideas presented to the young aspirant in the 1920s smelt fustily of middle age and this mood was to some extent perpetuated into the following decade through the pages of *Studio* magazine, where, for example, a reader, seeking information about current developments in painting, was directed to 'The Modern Movement in Painting' by T. W. Earp 'man of letters', who confines his study largely to the rise of Post-Impressionism and hastily dissociates himself from:

the jig-saw puzzles and illustrations to Euclid,
which should not delude the young artist, for the
period of technical experiment now seems to be at
an end.[1]

 The Artists' International Association was the con-
ception of the new generation coming to the fore in the
thirties; it was started by artists typically in their early and
mid-twenties, recently out of art school, lacking any credit-
able testament of artistic faith to take up from their elders
and who were facing the realities of a career whose glamour
was fast retreating in the wake of economic decline. Excit-
ing and progressive ideas were increasingly sought by this
generation within the general tide of expansion of interest
in Left Wing politics. The Communist Party was gaining
rapidly increasing support,[2] not only from its traditional
roots in the working class, but it was also attracting growing
numbers from amongst the middle classes and particularly
from within University circles. This new-found support
was demonstrated for example in the supply of finance
which helped to set up the presses of the *Daily Worker* in
1930 and the acquisition of Marx House as an education
centre (with the aid of a legacy donated by a supporter) in
1933.[3] The establishment of Communist Party cells at
Oxford and Cambridge Universities has been frequently
commented on, and the views and attitudes of the radical
element of this generation are glimpsed from such inci-
dents as the famous resolution of the Oxford Union that:
'this house would in no circumstance fight for King and
Country,' or, as Anthony Blunt summed it up:

 About every intelligent young man who came up to
 Cambridge joined the Communist Party.[4]

 But it must be emphasised that the inception and
growth of the AIA had little direct connection with this radi-
cal activity at the Universities which remained for the most
part as philistine as ever in their disposition towards the
Fine Arts, and whilst Blunt and A. L. Lloyd entered the AIA
ambit occasionally, in the role of speakers and critics, and
whilst AIA Propaganda material was used at Cambridge,[5]
the inauguration of the body was entirely the product of the
grass roots experience of young artists and designers, gen-
erally working in London. Some conception of this back-
ground can be gained from the following experiences of
some of the early members.
 One of the crucial figures involved in cementing the
general aspirations of these artists into a positively moti-
vated body was Clifford Rowe, by training and intention a

painter but required to earn a precarious living during the 1930s as a designer for the large Trade Exhibitions at Earl's Court and Olympia which so characterise the era. Rowe had been attracted to Communism during the late 1920s and had already worked for the *Daily Worker*, but before committing himself further to the movement, he decided to visit the Workers' State of Russia to make his own assessment of Communism in practice.[6] So in 1931, he set out on what was originally to have been a seven days' tour but which he extended to a period of a year and a half, which was made possible by his employment with an overseas publishing trust as a graphic designer. The picture he gained from this experience about the role of the artist in Soviet society greatly impressed him. He noted that all the major institutions, including the Red Army and the main Trade Unions, were expected to act as patrons of the arts. In connection with a vast exhibition organised by the Red Army in Moscow, for example, Rowe was himself commissioned to contribute to an international section to depict some aspect of the class struggle in England. It was through his involvement in this enterprise that the conception of an Artists' International took shape in his mind, for he was particularly struck by the example of the Chinese and Japanese artists' amicable co-operation in the exhibition at the very time of the Japanese invasion of Manchuria.

Rowe's idea of the power of common links between artists of all nations to override the dangers of narrow, nationalist loyalties and frictions was central to the founding hopes of the AIA. The artist and intellectual saw their duty to be guardians of the heritage of humanistic culture which was apparently being so callously hazarded by the greed and expediency of the capitalist and the politician. At this stage the cause of Peace and Disarmament was firmly forged with the primary hopes for social change amongst Leftist supporters of all kinds. It will be seen that these internationalist philosophies were only to succeed at a relatively modest level in the AIA's actual activities but the larger idea of international co-operation among artists was always central to their beliefs.

Percy Horton was 36 in 1933 when he joined the AIA and his political conviction stemmed from an earlier period of radical dissent. He and his brother Ronald, who joined the AIA at the same time, were proud of their working class background. Their mother had been in service and his father, who had lost his job as a tram driver during the First World War being replaced by female labour at lower rates of pay, had had to survive on infrequent casual labouring during the twenties. On the introduction of conscription in 1916 Percy Horton had registered his conscientious objec-

tion as a socialist, (he was a member of the ILP), to contri-
buting to the war effort and, whilst most conscientious
objectors accepted being drafted to either non-combatant
military service or to alternative civilian work, his objection
was absolute. But his refusal to co-operate with the war
effort was not accepted by the tribunals and so his contin-
ued opposition was regarded as a breach of military dis-
cipline which led to imprisonment in extremely harsh con-
ditions, including three months in solitary confinement.

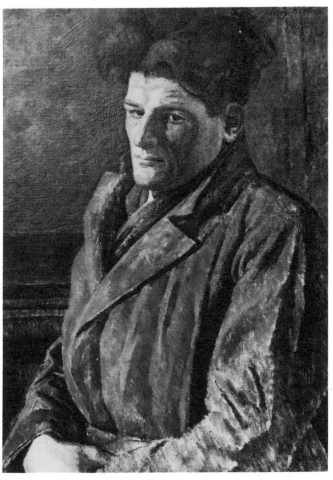

1. Percy Horton, *Portrait of an
unemployed man, c 1936.*

On release at the end of the War he attended the
Central School of Art and Crafts and then in 1922 was
awarded a Royal Exhibition to study at the Royal College
where his fellow students included Moore, Hepworth,
Ravilious and Freedman and where he took up a teaching
post in 1930. He was later also to have a profound influence
as a teacher at the St Pancras Working Men's College and in

17

1949 was appointed Ruskin Master of Drawing at Oxford where his students included John Updike and R. B. Kitaj.

There was then, little danger of Horton sentimentalising working life or of suffering any *naive* enthusiasm for the imagery of radical political action and by the late 1920s he had started on a number of portraits of working people which are affirmations of individual depth of character and personal dignity which avoid on the one hand the archness of the anecdotal 'character study' or, on the other, the symbolic type required by Soviet Socialist Realism. Horton seeks to co-opt in these paintings the traditional power and status of the oil portrait for the interests of the working class. He sustains the portrait formats dual function in representing both an individual personality and, at the same time, the more objective class qualities represented by that individual, giving the pictures titles such as *The Postman,*

Figure 1 *Unemployed Man, Woman Ironing* and *Old Farm Labourer.*

The formative experiences of another founder member, Peggy Angus, are instructive in communicating the appeal to this disenchanted generation of the social organisation of the Soviet Union particularly in respect of its recognition of the contribution of the artist.

Her political awakening came about at school through her friendship with Ramsay MacDonald's daughter during the period of the First World War. Her father was opposed to the friendship, since MacDonald was regarded widely in the country as a traitor due to his efforts to organise international Labour to strike and withdraw its support for the continuance of the war. She reacted by pursuing her own political education and was already well informed about Communism when she took up a scholarship place at the Royal College of Art.

She too took the fact-finding trail to Russia in 1932, the educational experience commencing on board the cruise liner to Leningrad with discussions and talks organised by and for her fellow travellers who reflected varied hues of political commitment and sophistication, from the trade union delegate to the Bloomsbury Communist, indeed to the confirmed Tory. She noted with approval the presence of women sailors amongst the crew.

She had gone out as a delegate for the National Society of Art Masters, and on her return Angus reported her impressions of life in Russia[7] which interestingly reflect the transitional period prior to the more dogmatic imposition of Socialist Realism during the later 1930s. At the Hermitage, she was struck by the concept, communicated by captions to the paintings and the presentation given by the guide, that the art of the past had been the propaganda of the ruling class and this new framework for understand-

ing art was experienced as a great revelation. She was, on the other hand, disappointed at the standards of portraiture for the new regime, with titanic images of the founding fathers of Communism expressed in a style 'reminiscent of the worst kind of Victorian oleograph'. In the new city of Kharkov, Angus came across portraits in a more modern style and, when she asked about this discrepancy, was told by the artists that Socialist Realism was the people's choice but that this was excusable since they had inherited a degenerate tradition and that within five years public interest in contemporary modes would be improved. She came in contact with a young textile designer from America (there were many writers and artists from the USA combining study and work there, often coming from families of former Russian emigrants) who noted the different attitudes to textile design in Russia; instead of her former instruction in taking motifs from nature or traditional ornament, here she was expected to produce designs which might at first look abstract but which on closer examination revealed their association with machine and energy forms. This student was hoping to follow a painting course, and when Angus wondered if this was not considered a rather passé activity now, was told that, on the contrary, at present only public buildings had the benefit of works of art, soon every worker would be wanting an original painting for his or her room.

Angus was informed that all artists were members of the *Painters' Guild* which claimed a reasonable number of works per year in return for a wage and a workplace; and that any extra production could be sold privately. She asked whether the State was dogmatic in the subjects that it wanted depicting and received the reply that painters naturally paint subjects which comment on life around them in a way which avoids any need for outside direction, although it was admitted that following an excess of pictures depicting blast furnaces in the previous year, artists had had to be reminded of alternative subjects which would be equally suitable. Another form of payment to artists came through State competitions for new public works since all entrants were indemnified. This particularly applied to works in connection with architectural schemes and Angus describes Russia (presumably with Kharkov in mind) as an architect's paradise which favoured building 'in the new unadorned style'.

She noted that advertising as it is understood in the West was not to be found, but that instead warning and exhortatory posters and diagrams appeared in many public places such as those demonstrating 'the physiological facts of marriage' at the registry office and factory production

charts in which individual workers were rated on a diagrammatic scale ranging from the tortoise to the aeroplane. The excellence of design and quality of lithographic production of children's books was mentioned. She concludes this miscellany of impressions on an optimistic note; while accepting reservation about the artistic quality of much of what she saw, she pointed out that it was long after the political revolution in France before that country's painting achieved its flowering, and with so much attention given in Russia to the visual education of young people, great things could be expected in a few years' time.

Another British artist who visited and found work in Russia at this time was Pearl Binder who had been similarly motivated to make her own assessment of the achievements of the Socialist Republic at first hand and who was sufficiently impressed by what she saw to return on several occasions. She received the signal honour for a British artist, to be given a one-person show at the Museum of Modern Western Art at Moscow where she showed drawings and prints based on life in London's East End and another series entitled *Backstage* based on the working life of the theatre. One of the attractions that Russia held out for the Western artist and especially for the graphic artist was the sheer amount of work available, for, with a continuous programme of teaching over 100 million the basic skills of reading and writing, the skills of the illustrator were constantly in demand.[8] Visiting artists from Europe and America were therefore generally welcomed provided they were prepared to contribute a spell of work while they were there and during one such visit Pearl Binder was asked to contribute to the prestigious, satirical magazine *Krokodil*. Her lively, linear style adds much to the charm of a number of illustrated books and articles about Russia published in Britain such as Bertha Malnick's *Everyday life in Russia* of 1938.

Prior to her discovery of Russia, Binder had taken what was an unusual step for a young artist in 1929 of going to live in Whitechapel. This was partly because she thought the East End was more appropriate to her own background and income than London's more fashionable or Bohemian haunts, but more importantly because she wanted to learn about the richness of experience and to observe the variety of occupation to be found amongst the working people of this part of the city.

All these impressions of art in the Soviet Union, either directly experienced or encountered indirectly by report were influential in setting the stage for the inauguration of the AIA. While on the return journey back to England, Rowe contacted a friend, Misha Black, a young

man of 23 then struggling to establish a modest claim as a painter. Black called together a group of like-minded friends to discuss how to proceed with their ideas about forming a unified organisation of artists in London. The occasion was given a Bohemian and conspiratorial flourish by its setting in the candle-lit and orange-box furnished interior of Black's room at the Seven Dials.

A further meeting was arranged when Rowe got back, where he persuasively contrasted the positive role which the artist enjoyed in a socialist society to the hardship and dismissal afforded to the artist in the West. Pearl Binder, who had been attending an evening class in lithography run by James Fitton at the Central School, brought along not only her tutor but also several fellow students, including James Boswell,[9] James Holland and Edward Ardizzone.

This class of about a dozen students developed something of the character of a radical discussion group as a bonus to its training in graphic skills and it is apparent that the London County Council was for a time the unwitting sponsor of some of Britain's most mordant political propaganda of the period. Fitton generously maintained that most of the group knew as much about lithography as he did, and made the point that the process by which political consciousness was developed was essentially gradual, not serving the call of any one party, but directed to the general cause of anti-Fascism. The reality of Nazi Germany was soon brought to the group's attention by the admission to the class of two recent immigrants, Hans Feibusch from Germany and Georg Ehrlich from Austria.

This second meeting, held around October 1933, was attended by about twenty people who were by no means all known to each other at this stage. It set about making arrangements in a more organised way and settled, for example, on the name for a new body, 'The Artists' International', which reflected both a respect for the Socialist International and also Rowe's vision of common feeling amongst artists throughout the world. One of the rejected suggestions for a name was 'The International Association of Artists for Revolutionary, Proletarian Art'. They also took the far-sighted step of appointing Misha Black to chair the group, a post he was to occupy with energy and considerable organisational ability for the following eleven years.

There was some diversity of personal motives prompting the first members to come together and varying degrees of political innocence and sophistication were in evidence; each might select a different point of emphasis but the overall unifying principle on which they all agreed

21

was that of opposition to Fascism. Their first published statement in 1934 reveals the direction and tenor of their original preoccupations in the following list of aims:

The International Unity of Artists against Imperialist War on the Soviet Union, Fascism and colonial oppression. It is intended to further these ends by the following practical measures:

1. The uniting of all artists in Britain sympathetic to these aims, into working units, ready to execute posters, illustrations, cartoons, book jackets, banners, tableaux, stage decorations, etc.

2. The spreading of propaganda by means of exhibitions, the Press, lectures and meetings.

3. The maintaining of contact with similar groups already existing in 16 other countries.

The statement then goes on to record the more detailed ways in which these aims had been projected into practice up to that point:

We have instituted fortnightly discussions on Communism and Art from all angles. We are working closely with the Marx Library and the Workers' School. We have taken part in strikes and elections, producing mimeographed newspapers on the spot, backed up by cartoons and posters. This will give us the direct experience we need of contact with the masses.

We have made contact with revolutionary art groups abroad and plan international exhibits.

Among our activities have been posters done for the Marxist Club of London University, preliminary work for an animated film cartoon for the Workers' Film Movement, drawings and illustrations for the first number of 'New Challenge', our new workers' sports paper; a puppet show to be shown in the streets, etc. We are also decorating halls for revolutionary meetings and other activities.[10]

There were 32 members recorded at the time of this report who, in addition to those already mentioned, included John Davison, James Lucas, S. E. Weaver, Bill

Wolfe, Ewan Phillips, A. L. Lloyd, Betty Rea, Peter Peri and Francis Klingender and the number was expanding rapidly. Along with this increase in number, the group was also gaining diversity from its mixture of age, cultural background and philosophy. Percy Horton had suffered imprisonment and social ostracism as an objector to the First World War on grounds of political conscience, Klingender was a German-educated Marxist and sociologist, Peri had experienced at first hand, as both a socialist and a Jew, the horrific reality of Nazi Germany from which he had just taken refuge.

The first major success for the Artists' International in attracting attention from the larger world beyond that of the various pacifist and revolutionary groups to which it offered its propaganda services was to be an exhibition which took place in September and October, 1934 in a former motorcycle showroom in Charlotte Street. This exhibition, mounted under the title *The Social Scene,* and depicting the 'Social Conditions and Struggles of Today', inaugurated a programme of didactic shows, usually described as being 'on a central theme', which was to develop as one of the characteristic means of bringing about the group's aims. Few of the exhibits have survived and we must rely heavily on Press reviews for an account of its content in the absence of any extant catalogue. Further, many of the exhibitors for this first show have since faded from memory and many would be more accurately described as amateur painters. The event was planned as a package of propaganda activity with the paintings and drawings on display supplemented by book stalls and posters; lectures were offered on 'Revolutionary Proletarian Art' and 'Marxist Art History'. It was intended that the show would afterwards travel throughout the U.S.S.R. Visitors were greeted with a manifesto which expressed with rather more earnestness than elegance, their uncompromisingly Marxist stand at this stage:

> We must say plainly that the AI supports the Marxist position that the character of all art is the outcome of the character of the mode of material production of the period. Today, when the Capitalist system and Socialists are fighting for world survival, we feel that the place of the artist is at the side of the working class. In this class struggle we use our abilities as an expression and as a weapon, making our first steps towards a new socialist art.[11]

Douglas Goldring, in his review of the show for *The Studio,* dismissed the general standard of work as 'crude

and bad' but picked out for mention 'an excellent portrait of Lenin' by Norman Walkington. Herbert Read in *The London Mercury* was even more scathing in his criticism of the quality of the work but at the same time declared himself sympathetic to the aims of the organisation and agreed to lecture to the group on abstract art. A by-product of this lecture was the essay Read contributed to the AIA Publication *5 on Revolutionary Art.*

The fullest critique was offered by T. H. Wintringham in the newly founded *Left Review.*[12] He feels the need to make allowance for the relative inexperience of many of the contributors but is more concerned about their ideological naivety than their artistic failures. On the evidence of the work in front of him he detects a greater 'real feeling for the working class political movement than for the working class itself'; and proceeds to apply a Socialist Realist critical analysis to some of the individual works. For example, he pointed out, that in connection with a painting of men working on haystacks, if the farmworkers were not themselves depicted convincingly, it was something of a gesture of defeat, for the painter to include details of their wages in the form of an appended caption. In another instance, A. J. Wray's *The Bees and the Drones* in which the Company Director is showing a visiting party round a factory, the positive features of the workers' skilful and powerful control of machinery had not been depicted, only their exploitative and humiliating conditions of work. But there were many other things which he found successful, such as the satirical drawings of James Boswell and James Holland, the photographs of Edith Tudor-Hart, especially one called *Sedition?* showing a trio of self-parodying detectives taking notes at a public meeting and a wall-sized photo-montage poster produced by the architects' section of the AI, contrasting the achievements of housing policy under Socialism and Capitalism.[13] On the whole, he concluded that the exhibition represented a great and cheering contrast to the work of 'bourgeois cliques and individuals'.

A number of more established artists had also been approached and had agreed to exhibit alongside AI members. These included Robert Medley, Claire Leighton, Paul Nash and Henry Moore, (these last two representing Unit 1) and Eric Gill. This last invitation, as well as representing a feather in the cap of the young organisation, was to have an involved sequel for Gill himself.

Eric Gill survived as the most important exception to the opening comments of this chapter to the effect that the Morris tradition of thought concerning the social purpose and conditions of production of art had been largely forgotten. He took from Morris much of his argument and elo-

quence about the corruption of art wrought by Capitalism and aestheticism, but departed from him in his own belief that Socialism could be best achieved within the framework of a return to faith in God and of the simple relationships of a monastic, guild collectivism. As a Fabian, Gill had taken much from G. K. Chesterton's scheme of 'Distributism'. He was a convert to Roman Catholicism and was constantly in conflict with the orthodox hierarchy of the church regarding his frequently expressed ideas on socialism, on sexuality, and on church architecture and liturgy but had also recently been the subject of an episode much enjoyed by the popular Press — his *Ariel* for the new Broadcasting House had given rise to objections to the prominent private parts of the figure and he was forced to bow to public prudery and doctor the sculpture.

Gill's actual contribution to *The Social Scene* did not express any social comment in its subject but his presence amongst such company provoked a letter to the *Catholic Herald* warning readers of the subversive strategy of Marxism:

> Under a semblance of concern for world peace,
> Marxism attempts to enlist all peace lovers in its
> bogus, anti-war organisations . . . under cover of a
> society calling itself the Artists' International,
> Marxism has recently invaded the domain of art.
> Let there be no mistake about this British section of
> the so-called Artists' International. It is neither
> British nor international nor is it primarily
> concerned with art.

Gill took up this challenge with avidity and after replying to the *Catholic Herald*, republished the correspondence in *Left Review.* It is worth quoting at some length from his reply as it gives another picture of the kind of work exhibited as well as representing the views of that growing section of liberal thought which was not embarrassed by the company of Communists in its desire to express support for the Peace Movement and Anti-Fascism.

> I visited the exhibition, rather expecting to find
> many anti-God paintings, as I had been told I should
> do, but in half an hour's walk round, I could see
> none. All I saw were various works depicting the
> hardship of the proletariat, the brutality of the
> police, the display of armed forces against street
> demonstrators, orators, starving children and slum
> conditions generally. There were also a few works in
> the vein of Van Gogh's 'Yellow Chair', that is to say

25

scenes depicting simple workmen and scenes of working life.

It was not a big exhibition, it was not held in a fashionable quarter. It might be described as a pathetic affair compared with the exhibitions of what your contributor doubtless calls 'Art' in fashionable West End galleries and art dealers' shops.

Suppose it to be true that the Artists' International is primarily concerned to propagate Communism; even so, there was nothing in the terms under which we exhibited, which made it obligatory. And there was nothing to hinder any Catholic artist for showing that he could stand up for social justice as well as any Marxian.[14]

He then goes on to give voice to the theme which will be encountered again in his essay in *5 on Revolutionary Art*, that is, an attack on the emasculation of art which is encouraged by contemporary aesthetic ideas that direct the viewer to appreciate art entirely in terms of formal qualities. Gill expressed his dismay at the notion that we should enjoy the painting of Giotto for its plastic values alone rather than out of a love for St Francis: finally, we are asked to agree that pictures painted under the inspiration of Communism are as much 'Art' as pictures painted under the inspiration of Christianity.

Gill's notion of demonstrating the common ground between his species of Christian Socialism and the ideas of the more orthodox Marxists was put sorely to the test when a more worldly trade unionist asked him, through a letter to *Left Review*, why he did not employ union labour as his assistants. Gill (whose collectivist ambitions are revealed in the AIA's catalogue entries, attributing his work to 'Eric Gill and Companions') replied that, much as he regretted the fact, the kind of work by which present day stonemasons learned their trade, ill-equipped them for the kind and quality of execution he needed for his ecclesiastical sculpture.

The AIA was to maintain a constant and fruitful confraternity with *Left Review* throughout the magazine's brief but influential life span from October 1934 to May 1938. The editors and contributors, notably John Strachey, Ralph Fox and Randall Swingler styled themselves *The Writers' International*[15] and produced a lively monthly review of short stories, poetry, reviews and comment which sought to establish a balanced, workable application of Marxist dialectics to art practice. Much of its attraction to readers

was undoubtedly the responsibility of its illustrators who were all drawn from the ranks of the AIA, and it could be argued that these images preserve for the modern reader the sense of social tension and desperate anger and impatience in the face of interest and hypocrisy rather more convincingly than the prose and poetry of their writer comrades.

James Boswell, a New Zealander by birth, came to London in 1925 to study at the Royal College of Art and during his last year as a student in 1929 was drawn into the circle of left wing writers which included Montagu Slater, Randall Swingler and Edgell Rickword. He joined the Communist Party in 1932 and started out on a successful professional career as an illustrator and art director. He was then a natural choice for the (unpaid) job of art editor for the new magazine where, in company with James Holland and James Fitton, the characteristic style of the review's satirical cartoons and drawings was soon widely recognised and appreciated. There were occasional contributions from other illustrators and cartoonists such as Pearl Binder, Claire Leighton and Pinchos (a Belgian garment worker from the East End) but this trio of 'the three James" produced the bulk of the drawings, tending to take an issue each in turn.

Boswell's recurrent subject, the depiction of the class enemy in all its guises, was firmly established in his contribution to the first issue of *Left Review; You've gotta have blue blood*, for example, itemizes its typical accoutrement. He would be wearing riding breeches which, over the years, have obviously wrought a serious defect to the form of the lower limbs, the narrow, sloping shoulders of the riding jacket suggesting much about capacity for hard work and the exiguous bowler hat implying that there is little of any importance underneath which would need protection. It is implied that if you take away the clothes it is likely that there would be nothing of humanity left at all. The figure's companions reiterate that couturier's creation, mindless and arrogant femininity, with faces the products of the cosmetic trade (which remains unable however to entirely disguise a total distaste for the world around), the padded shoulders, fur collar and high heels indicating a devotion to the life principles of posture and decoration.

In case we are tempted to dismiss too lightly today this attack on the 'upper class twit' it should be recalled that there was, at this time, far more deference amongst the middle classes to the idea of the aristocracy's natural rights to power, and the Institutions and the National Government itself were seen by the Left to be dominated by various versions of this breed. A related but distinct aspect of the class

Figure 2

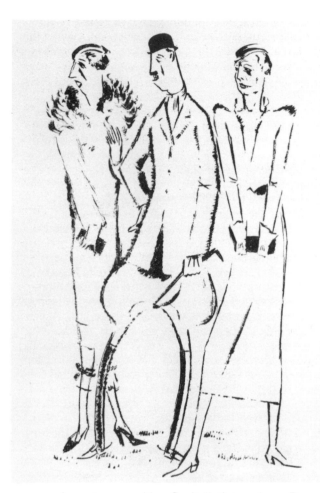

2. James Boswell,
You gotta have blue blood,
illustration for Left Review,
October 1934.

Figure 3

enemy character was 'the Capitalist' to whom Boswell
assigned a different set of scenarios and physical embellish-
ments. In the *Empire Builders,* we are spared details of the
regulation pin-stripe suiting but are offered a Spotter's
Guide to the Capitalistic Physiognomy. Hair is either close
cropped, slicked down or entirely absent, moustaches are
welcomed but again they must be close cropped and not
permitted to extend beyond the nostrils — rather similar to
Hitler's in fact — the nostrils themselves tend to be more
prominent than the eyes which must betray no light of emo-
tion or character, only a steely determination to maximise
profit. The face as a whole shows an unhealthy colouring
and complexion especially in the region of the jowls and
below the eyes. This manner of stippled and scratched
marking is one of the more obvious devices which Boswell

took from the graphic work of George Grosz[16] as well as something of his style of outlining and, of course, Grosz's range of subjects, notably in that unappetising view of the business-man's feeding habits, *Hatton Garden Luncheon.* Boswell was in fact occasionally criticised for delineating types which were more Germanic than British in their features and his work was always open to the orthodox, Socialist Realist charge that it ignored the positive elements of working class life and aspirations; but nevertheless his images were always in wide demand for radical publications.

Under the pseudonym 'Buchan' Boswell contributed drawings and prints to the *Daily Worker* which usually adopted a more realist mode.

James Fitton was born in Oldham and came to London in 1923 where he studied lithography at the Central School of Art and Design with A. S. Hartrick. As already mentioned, Fitton's evening class at the Central in the mid-

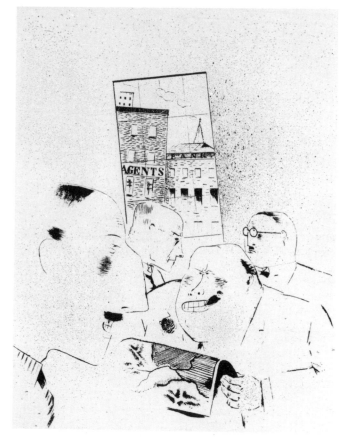

3. James Boswell, *Empire Builders, 1935.*

thirties was fertile in its inspiration of anti-Fascist imagery from a group of young graphic artists who evidently achieved a mastery of technique under his guidance.

Fitton serves as an example of that type of artist who was so frequently encountered in the pre-war period but which conditions do not often encourage today. As a 'commercial artist', he established an enviable reputation in advertising design and book illustration which gave him the financial stability not only to donate time to radical causes through the AIA, but also to develop as a painter. Later on in his career, as his fine art production grew in demand, he was able to place more emphasis on this side of his work, and after election to the Royal Academy in 1954, he served energetically in the running of that body.

Fitton's work for the *Left Review* was more varied in style and subject than that of Boswell. An early example from 1934, *A New Use for Perambulators* reveals his readiness to extend the cartoonist's traditional range of tech-

Figure 4

4. James Fitton, *A new use for perambulators, Left Review*, November 1934.

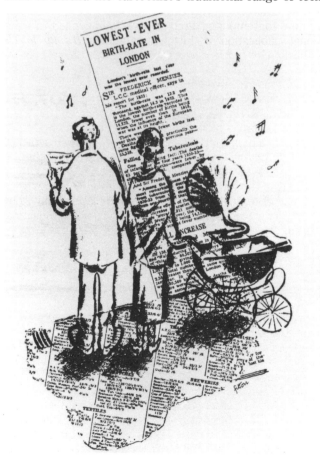

nique, particularly in his use of collaged elements. Against the static facts of a newspaper item on the falling birthrate and stock market quotations, a young couple standing in the gutter busking to the tune of 'Land of Hope and Glory', supply the tragic substance to the human pathos behind the statistics. On other occasions, for example in *Art and Industry, a Self Made Man*, the image engages in an ironic dialogue with numerous slogans culled from manuals on how to succeed in business, arrayed around the central figure. Fitton's skills as a caricaturist are demonstrated in *Sunday Oracle*, depicting Garvin, the editor of *The Observer*, with a greetings card signed 'love Adolph' displayed on his desk.

To Fitton's mind the demands of political art required a crisply contemporary rather than a dourly traditional mode of presentation. He maintained that the most familiar 'popular' art was to be seen in advertising design where the application of Cubist and Constructivist techniques and motives was extensively employed. An impressive example of how contemporary graphic style was applied to agitational publication is Fitton's pamphlet *It's up to Us*, published by *Left Review* in 1936. An array of lively lay-out techniques, collaged caricature drawings and photomontage and creative typesetting give force to the evidence of statistics and news clippings, that War and Fascism can only be resisted by a unified Popular Front.

The third of the James', James Holland, was also later to pursue a highly successful career in advertising design. His *Left Review* work contrasts with that of the others in being much more pictorial in conception and more sympathetic to the tonal qualities of lithography. The imaginative use of textual quotation often adds a pointedly ironic effect, as when the cockney cheeriness of the music hall refrain:

> With a ladder and some glasses
> You could see to Hackney marshes
> If it wasn't for the houses in between

is turned on its head by a depiction of the grim reality of an East End slum scene. Again, the squalid back yard of the slum terrace sets the mood of despair afflicting the unemployed in Holland's *The Sailor's Return* of 1935.

Figure 5

The work of Boswell, Fitton and Holland is mentioned by Edward Wadman in an article *Left Wing Layout* in *Typography*, Summer, 1937, which also examines with approval the progressive design of books published by Victor Gollancz, Lawrence and Wishart and the Left Book Club. Wadman's opening remarks clearly characterise the

5. James Holland, *The Sailor's Return, Left Review, May 1935.*

position of artist/designers such as the 'Three James'':

> Latter-day capitalism has called into being an
> enormous machine of commercial propaganda,
> which is manned very largely by clever young men
> who are socialists. You will find them on
> newspapers, in the cinema, in advertising, in
> broadcasting. They are interesting and dangerous,
> these young creative people of the Left, because
> theirs is not the simple agitation of the have-nots.
> They are highly paid and comparatively free, but
> their daily work gives them exceptional
> opportunities for seeing the wasteful and trivial uses
> to which our economic system puts the vast powers
> of the modern world. When such men turn from
> their bread and butter to the sphere of political
> propaganda the results are decidely significant and
> may one day be decisive.

The signs which might mislead us into assuming a
Communist Party domination of this inaugural period, re-
flect rather the romantic, almost cult attraction that the
Party held for the young intellectual at the time: that ideal-
ism which we meet in Edward Upward's protagonist, Alan
Sebrill in *In the Thirties*, who after a lengthy period of feeling
unable to write, eventually comforts himself with the
thought: 'If he joined the Communist party, he might be
able to write again'. The tones of near religious supplication
is caught as Alan becomes involved in the work of his local
branch:

> However little hope there might be of his eventually
> becoming Wallop's equal (Wallop was a Party
> worker employed as a building labourer), as a
> human being, Alan would no longer need to regard
> his bourgeois origin as putting him in a position of
> social inferiority. Membership of the Party
> transcended class differences between members.

Quite apart from the appeal of the lore and language
of the young Communist, the point has to be stressed that
for most people in the 1930s there were none of the pre-
judicial associations with which the word 'Communist' has
since become enshrouded. The Party was demonstrably
anti-Fascist; it supported the call for world peace, and the
majority of politically sophisticated artists were content to
recognize these aspects and to bear no antagonism towards
Communists. As Quentin Bell recalled in 1958,

The Communist element was very strong and as a left-wing socialist, I considered it very healthy. With the European Nightmare becoming even more horrible, I felt no scruple about working with Communists, or indeed anyone who would oppose Fascism.[17]

It would be historically misleading to attempt to identify individual Party members within the AIA; people joined and left the Party at different times, and given the specific programme of the AIA, Party membership of any one artist simply never arose as an issue. Of the original AI group, probably only Rowe, Boswell and Lucas were members and Rowe estimates that when the AIA membership was at its 700 mark no more than a hundred would be Communists, although a much greater proportion were closely sympathetic. On the other hand, although they were numerically in the minority of the membership, the Communists did tend to be the most active, in organising propaganda events and on committees and it was recognised that much of the overall dynamism of the AIA and many of its specific events were generated by Communist members.

Mention has been made of some of the immediate motivations and attitudes of the founder members but there were other factors latent in their circumstances which must have played their part in making the aims and ideas of the AIA so attractive to an occupational group who had previously showed so little regard for the notion of common interest in political action. In 1931 the general census revealed some 10,000 individuals who styled themselves artists, but of whom only some 700 claimed to be supporting themselves primarily by their artistic work. One implication of this — and it is well substantiated by biographical evidence — is that at the outset of the decade, most artists were depending to a greater or lesser extent on private incomes. It was of course precisely this kind of rentier income which was proving vulnerable as economic depression took on chronic dimensions. It was also bound to affect the levels of surplus income which had facilitated earlier patterns of private patronage, even though the editor of *The Studio* writing in 1934, was clutching at the straw of a new kind of patron, the new middle-class flat dweller who might replace the former, moneyed buyer by making more purchases but at lower prices. But two years later, the President of the Royal Academy, Sir William Llewellyn, soon sank this hope with the gloomy prediction that:

The fate of picture making is sealed, I can see no future . . . people are not picture minded and

houses are smaller and decorative schemes have no place for pictures.

He also went on to complain that the growing practice of free admission to exhibitions was clearly 'drugging the market'. *The Studio* followed these comments with a report on the disheartening employment prospects for students graduating from the Royal College. After a period of training of between five and seven years, even if any employment was secured at all, the remuneration and working conditions were often scarcely tolerable. One recent ex-student was reported working from 9.15 am to 6.30 pm, making drawings of jewellery for 30/- (£1.50) per week. Six ex-students were employed by a zoological society to copy specimens at 6d (2.5p) per plate, each plate taking about half an hour to produce; others painted lampshades in a factory or coloured cartoon films for 25/- (£1.25) per week.

A statement by James Holland confirms this widespread sense of discontent and the political interpretation which many young artists applied to it.

> Economic crisis killed the active but undiscriminating patronage that the younger English artists had enjoyed since the war. About eight years ago these artists were faced with the choice of a cut-throat competition for what crumbs of patronage remained, continuing to paint until overtaken by starvation, giving up art, or using their abilities to discredit a system that makes art and culture dependent on the caprices of the money markets. The last has always seemed to me the only realistic course.[18]

William Townsend's journals provide a valuable record of the experiences and interpretations of a typical representative of the generation of artists as they encounter the political pressures of the decade and engage in the task of reconciling these pressures with the choices of art practice before them.

He was soon reporting the dismal round of galleries and art editors in the vain hope of securing a commission for a book jacket or illustrations and concluding:

> One finds oneself only too easily in the ranks of the unemployed in this field.[19]

Townsend's friend and contemporary William Coldstream's evidence graphically attests to the mood of

desperation amongst young artists and the nature of their political reaction:

> The 1930 slump affected us all very considerably. Through making money much harder to come by, it caused an immense change in our general outlook. One painter I knew lost all his money and had to become a traveller in vacuum cleaners. Everyone began to be interested in economics and then in politics. Two very talented painters who had been at the Slade with me, gave up painting altogether, one to work for the ILP, the other for the Communist Party. It was no longer the thing to be an artist delighting in isolation.[20]

It is significant that so much of the vitality of the Artists' International sprang from members who were primarily employed as advertising and poster artists. One of the undercurrents of their discontent flowed from the snobbery which was sensed to exist within the profession and which reduced the status of the commercial designers in relation to those who practised exclusively the 'fine art' of painting. This distinction was felt to be particularly unjustifiable at a time when the practice of commercial art played a much more usual part in the young artist's occupational experience than it does today. Furthermore, there was a genuine feeling among the more progressive designers that, in contrast to the over-worked, post-impressionist or frankly academic vocabulary of the painting styles that the thirties had inherited, or to the escapism of Abstraction and Surrealism, they were the practitioners of the only forward looking art modes which were appropriate to the times. Along with this essentially Bauhaus derived attitude (Moholy-Nagy's arrival in London in 1935 provided a vital focus for this spirit) there also ran the idea that theirs was a genuinely popular and decocratic art form which could enrich the visual experience of everyone, almost subliminally, without requiring the viewer to conform to earlier precepts for appreciating art. There is some kinship of idealism here with the initiatives of the DIA which led to the commissioning of painters to produce posters for the publicity campaigns of Shell, the British Transport Commission and Imperial Airways, under schemes of art patronage by industry, directed by J. L. Beddington and Frank Pick. The idea that advertising represented in practice the most insidious form of Capitalist exploitation and hence was unworthy of the collusion of socially progressive artists and designers does not seem to have surfaced very vociferously in the thirties.

Although the first year of the AI must have been very demanding on the enthusiasm of its members, working with several radical and Peace groups, making banners and posters and leaflets in support of various demonstrations, organising lectures and discussions and setting up their first exhibition, they were far from ready to sit back on their achievements seeing expansion as a major priority. They wanted to extend their membership beyond the existing small band of politically conscious artists in order to engage the majority of their profession who had not yet taken the step of commitment. As Betty Rea recalled,

> We seem to have been all the time struggling with the apathy of the profession until the Soho Square exhibition in 1935.[21]

Already in 1934 a letter was sent out to twenty artists who were selected on the basis of their representation of particular sections of the art world. The letter stated the concern of The Artists' International about the current threats to cultural progress at home and abroad and invited their response. The replies were encouraging, Dame Laura Knight assured her support of their aims, Duncan Grant stated his willingness to be openly associated and the landscape painter Ethelbert White joined up and 'a curator of a famous museum expressed his support'.[22]

One particular spur to awareness of such threats near to home came with the 1934 Sedition Bill which threatened to restrict many of the traditionally respected rights of public expression. The National Council for Civil Liberties (NCCL) was founded to oppose this Bill. Augustus John was one of the instigators of the NCCL to which the AI became affiliated, and he was to be an occasional supporter of AI activities over the next few years, though his essentially anarchist philosophy presumably restrained him from too close an association.

Having sensed the tide of goodwill within the whole scope of the profession indicated by the response to these letters but at the same time aware that much of this potential was still held back by the narrowly Marxist tenor of their 1935 manifesto, it was decided that a more liberal approach would be productive.

Notes

1. T. W. Earp *The Modern Movement in Painting*, London, 1935.

2. James Klugman in Clark, Heinemann, Margolies & Snee *Crisis and Culture in Britain in the 30s*, 1979, gives the following figures for membership of the Communist Party of Great Britain: *1930* (2,500); *1936* (11,500); *1939* (17,500); *1942* (56,000).

3. Marx House was established in 1933, combining the functions of library of Marxist and labour movement literature and a Workers' School under the principalship of Robin Page Arnot. Crumbling but historic premises were found at Clerkenwell Green in a building which had been used by the radical clubs from as far back as the turn of the eighteenth century and more recently by the radical Twentieth Century Press. Clive Branson (an AIA member, later killed in the war) was able to donate the required purchase money as the result of a fortuitous legacy and Marx House became a centre of considerable activity with its numerous meetings, discussion groups and educational work. The Library seems to have benefitted from well-heeled support on a later occasion, when in 1940 there was an exhibition of paintings by Steer, Sickert, Roualt, Braque and Picasso, many of which were for sale in aid of Marx House.

4. Anthony Blunt, 'From Bloomsbury to Marxism', *Studio International*, Nov 1973.

5. A photograph of posters for an anti-War exhibit at Cambridge University, described as by the Artists' International 'Revolutionary group of England' appears in *International Literature*, 1 (7), 1934, p. 152.

6. Information derived from interviews given to Lynda Morris and Robert Radford, 1979.

7. Peggy Angus, unpublished lecture notes for report to The National Society of Art Masters, 1932.

8. An extensive article 'The Graphic Arts of Soviet Russia', Dr S. Osiakovski, *Studio*, March 1935, in relation to an exhibition at the Bloomsbury Gallery, is usefully illustrated.

9. James Boswell's recollections of the inception of the Artists' International are recorded in Bellamy & Saville, (eds.) *The Dictionary of Labour Biography*, 1972-82, and reproduced in L. Morris and R. Radford *The Story of the AIA*, Oxford, 1983, p. 9.

10. From the first AI Bulletin, as quoted in 'Revolutionary
 Artists Organise', anon, *International Literature* 1934 1 (7)
 p. 151. 'New Challenge' was in fact published as
 'Challenge'.

11. As quoted in Douglas Goldring's review of 'The Social
 Scene', *The Studio* December 1934, p. 307.

12. T. H. Wintringham, 'Artists International', *Left Review*,
 November 1934 pp. 2-4.

13. The work of Lubetkin, Adler and Gaster and the montages
 produced by Misha Black. A number of architects such as
 J. M. Richards and F. Skinner were associated with the AI
 but soon this Architects' Section expanded into a
 'specialist body', the Architects' and Technicians'
 Organisation (ATO) following an inaugural meeting at the
 Conway Hall in February 1935. It continued for the next
 five years as a focus for the political conscience of the
 profession and for a precise critique of its social
 responsibility see P. Coe and M. Reading, *Lubetkin and
 Tecton, Architecture and Social Commitment*, London 1981.

14. 'Eric Gill on Art and Propaganda', *Left Review*, June 1935
 pp. 341-2. For fuller text see Eric Gill *Collected Letters*
 London 1960.

15. Formed in February 1934, the 'British Section of the
 Writers' International's first publication in April was
 Viewpoint — a revolutionary review of the arts, it stood for
 'militant communism and for individualism and
 metaphysics in the Arts', see S. Hynes, *The Auden
 Generation* 1976. The Left Review and the AIA held joint
 meetings and lectures at 26 Frith Street under the name of
 'The Soho Discussion Circle' in 1935 and 1936; see
 Andrew Croft, 'Alick West of Marx House', *Quarterly
 Bulletin of the Marx Memorial Library*, April 1982 p. 7.

16. An exhibition of Grosz's work, 'Social Satires' was held at
 the Mayor Gallery in 1934.

17. Quentin Bell, 'On the Side of Humanity', article in the
 Daily Worker, April 2nd, 1958, on the occasion of the 25th
 anniversary of the AIA for which an exhibition 'AIA 25' had
 been brought together at the RBA Galleries. The Daily
 Worker article also contains remarks by Misha Black,
 Betty Rea, Peter Peri, James Boswell and Diana Uhlman.

 A lecture given at Oxford by Bell on 'Art and Politics' was
 reported (with some reservations) in the *AIA News-Sheet*,
 no 4, April 1937.

18. As quoted in Alfred Durus 'English Revolutionary Graphic
 Art', *International Literature*, 1936.

19. *Townsend Journals* (Unpublished ms University College, London) entry for March 12th, 1933.

20. William Coldstream in 'The Artist Speaks', Lambert, R. S. (ed), *Art in England*, 1938.

21. Betty Rea, contributing to 'On the Side of Humanity', *Daily Worker* April 2nd, 1958.

22. Betty Rea, 'Revolt Among the Artists', *International Literature* (5), 1935.

FROM SOHO SQUARE TO GROSVENOR SQUARE 1935-37

A new policy was adopted by the Artists' International in 1935, aimed at attracting the wider reaches of the profession who might have been deterred by its previous stance which clearly implied a specific commitment to a socialist political programme from its members. In the words of the AIA pamphlet from 1938, *The First Five Years*:

> It (the Artists' International) had not thought of artists qua artists — but only in connection with the needs of the working classes.

The most obvious symbol of this shift of attitude was the adoption of the new name, *The Artists' International Association* and a new rallying call:

> The AIA stands for Unity of artists against Fascism and War and the Suppression of Culture.

This approach had the desired effect in helping to remove qualms about too restrictive Marxist associations for a much larger section of artists of older generations and more established reputations who could happily lend their names to the support of all three of these aims, and a period of rapid expansion soon followed.

It was recognised in 1935 that there was a large and growing tide of anti-Fascist sympathy particularly following Italy's campaign in Abyssinia. Typical of this more liberal

persuasion newly co-opted by the AIA are the views expressed by David Low:

> I am an average man who has no decided objection to a dictated morning, if I could be guaranteed a perfectly free afternoon, would have to insist on an economic rather than a political solution, of a kind that aims at a redistribution of economic power not a redistribution of hokum. Whether Lenin was right or wrong, it is a point in his favour that he did not find it necessary to put on uniform and be a hero.[1]

Low, through his creation of Colonel Blimp maintained a satirical attack on Fascism in Europe and its Conservative sympathisers at home in his highly popular cartoon features for *The Daily Express*, even when these frequently countermanded the editorial directions asserted by Beaverbrook elsewhere in the paper. Low was happy to be associated with the AIA and served for a while on its advisory council.

This new policy should not be read as just a local solution to the AIA's pattern of development but as a part of the general movement of international proportions towards Popular Front sentiment and organisation. Already in 1934 the Independent Labour Party and the Communist Party had set up a joint committee, The Socialist League, for anti-Fascist action and such was the mood of ideological generosity on the Left at this time that approaches were made by the Communists to affiliate with the Labour Party with the aim of forming a United Front. Stafford Cripps from within the Labour Party was particularly committed to this idea and founded *Tribune* in 1937 to promote a Popular Front programme for the co-ordination of the policies of the Left. The Communist Party continued to press for the success of the campaign although their appeal was marred for some by the reports of unacceptable behaviour by Communist organisers in the Spanish War. Nevertheless, as Orwell observed:

> In England the Popular Front is only an idea but it has already produced the nauseous spectacle of bishops, Communists, cocoa magnates, publishers, duchesses and Labour MPs marching arm in arm to the tune of Rule Britannia.[2]

The Popular Front idea was central to the philosophy of such groups as the Left Book Club, which through local groups involved a generation of typically young, middle-class people in a programme of shared activities —

43

rambles, discussions, dances, agitational theatre, and so on.

In Britain the main impulse of Popular Front sentiment seemed more directed to demonstrating opposition to Fascism and the Right-Wing policies of the National Government than towards a genuine dialogue to advance the cause of Socialism and a pattern of suspicion and friction was to characterise the official relations between the Communist Party and the Labour Party for the duration of the decade.

Encouragement was given to the promoters of the movement by the establishment of the Front Populaire government in France in May 1936, although, following a period of strikes, devaluation and the incapacity to break the non-intervention agreement in the Spanish War, it gave way to the centrist Daladier government in April 1938. But this general mood of rapprochement and optimism had implications for cultural organisations too. The Association des Ecrivains et des Artistes Révolutionnaires (AEAR) and the Union des Peintres et des Sculpteurs combined their activities under the auspices of the Maison de la Culture, with the philosophy of directing the energies of all cultural workers, including architects and film makers. They published a periodical, *Commune*.[3]

The newly-strengthened AIA, whilst confessing the errors of its youth in its lack of attention to the artistic and technical quality of its production, by no means slackened its involvement with and comment on current political issues both at home and on the international front. It was an election year and the National Government's campaign promoted the policy of re-armament despite widespread opposition to such policies in the country. Pacifist ideals were especially upheld by the artist members of the AIA and its response was channelled in two directions, in supporting meetings and demonstrations both through the attendance of its members and by the production of posters, placards and banners as well as cartoons for various magazines of the Left.

One of the frequently repeated claims of the AIA was that official propaganda — even in wartime when its general purposes were supported — was hopelessly inadequate and badly judged, and that they could do a much better job of it with the aid of their members who were experienced, commercial publicity designers and, at the same time, were politically informed and engaged. This claim made its first appearance in a criticism of the Labour Party's election posters which, while purporting to warn electors of the dangers of a rearmament policy by means of a photograph of a child in a gas mask, resulted, it was felt, in

the contrary effect of frightening them into supporting the
National Government's policy. The AIA therefore pro-
ceeded to bring out its own posters stressing the more posi-
tive ideals of the anti-War policy.

The Italian invasion of Abyssinia provided a crude
demonstration of Fascist imperialism and its arrogant dis-
regard for the ideals of the League of Nationa convinced
many waverers of the true nature of the threat and the need
to organise against it. William Townsend registers this
sense of concern felt by many of that background and
generation which typified AIA members. We find him
attending meetings, reading pamphlets and newspaper
reports, even writing to *The Times* and making lengthy
analyses of the situation. It must be admitted that this level
of involvement and earnest enquiry was perhaps unusual,
but it does indicate the force of public feeling which led the
AIA and associated bodies like the NCCL to call a meeting at
Conway Hall in October on the Abyssinian question.

This accumulation of anti-Fascist sentiment estab-
lished the atmosphere in which the AIA mounted the exhi-
bition called *Artists Against Fascism and War* in November,
1935, which was its first show to make a significant
impression. It was housed in an old Georgian house in Soho
Square which was due for demolition, but after a thorough
redecoration it provided a spacious and inviting display
space in the heart of the Bohemian territory of Fitzrovia.
The exhibition was opened by Aldous Huxley, who in his
foreword to the catalogue proposed the case for the artist
'as a special case of the good citizen . . . while painting, he is
controlled, scrupulous, conscientious' in contrast to the
type of the dictator who had no use for such qualities.
Lectures on 'Marxism and Aesthetics' and 'The Crisis in
Culture' were held at the exhibition by Alick West and John
Strachey. Over 6,000 visitors paid threepence each to see a
show which combined a range of work of great diversity
which it is difficult to imagine being brought together under
any other circumstances for, as Montagu Slater put it in his
coverage of the show for *Left Review*:

> Those whom art politics have put asunder, an
> exhibition against War and Fascism has joined
> together.[4]

This mood of widespread consensus is revealed by
the collaboration with the AIA's enterprise of such promi-
nent and diverse figures as Eric Gill, Augustus John, Laura
Knight, Henry Moore and Paul Nash, who helped with the
selection of work as well as contributing items of their own.
The 72 year old Lucien Pissarro not only agreed to exhibit

45

but also to join the AIA, which made a link with an earlier association between an artists' group and a definite political viewpoint, that of the Neo-Impressionists and Anarchism.

Abstract painting and sculpture was shown by Moore, Hepworth, Nicholson, Piper, Tunnard and Moholy-Nagy, while naturalist modes were represented by many artists, notably Ethelbert White, James Bateman, Ethel Walker, Harold Knight and Charles Cundall (who chose to depict the Durham Miners' Gala for the occasion). One section was devoted to photographs of working class life including the work of Edith Tudor-Hart and other members of the Workers' Film and Photo League.[5] The internationalist claims of the organisers were well substantiated by the presence of work sent from France, Holland, Poland and Russia and included some distinguished names, Gromaire, Léger, Lhôte, Masereel and Zadkine.

The majority of these, newly invited artists from the established exhibiting societies showed the kind of work with which they were normally associated — a portrait of King Feisal from Augustus John or a healthy, young female representing 'Dawn' from Laura Knight — rather than taking on a subject specifically related to the didactic theme of the exhibition. However, more directly applicable subjects were offered by many of the original AIA members such as Cliff Rowe's *Canvassing the Daily Worker* or Peri's sculpture, unambiguously titled *Against War and Fascism*. This socially engaged subject matter was more prevalent in the prints and drawings section from which ring out titles like *Prostitution, South Wales Tubercular Miner* and *Poison Gas*. This latter, the work of Peggy Angus, is in fact a satirical print attacking the Jubilee celebrations; the 'poison gas' seeping from the newspapers, and the banner bearing the loyal slogan 'Long live the King' placed cannily above an 'Underground' sign.

Townsend visited the show and, whether or not he was smarting at the rejection of his own entries, he did not find it a very happy experience.

> Perhaps it was chiefly names they wanted and if that was so, I cannot blame their choice, for that would at least serve their end of making an impressive demonstration of solidarity.

He offers a forthright reaction to some graphic work from Poland:

> which were the most painful and horrible things I have ever looked at, almost too horrible to look at indeed, corruption displayed and commented on

with cold ferocity and meticulous exactness.[7]

Montagu Slater's review for *Left Review*[8] is somewhat
rambling and discursive but his general tone seems to be
some regret that the new directions, the new synthesis
which Klingender for one had hoped for and in support of
which Bukharin is cited on this occasion, have not yet
revealed themselves. He found that only in the Abstract
room did the exhibition seem to gain 'tendency and direc-
tion' and the Socialist Realism of Rowe and Peri is criticised
on the basis of the questionable analogy that, just as one
cannot make a poem about a poem, neither can one hope to
make a painting out of a demonstration which is an art form
in itself.

By May 1935 the Artists' International had secured
premises at Parton Street, in a little radical pocket of
London with Lawrence and Wishart and the Conway Hall as
near neighbours. These premises enabled them to offer the
facilities of a club with a sandwich bar, library, chess and
darts. A regular series of lectures and discussion classes
was held as well as life drawing sessions and a sketch club
for mutual criticism. The intellectual style that was
favoured, that of the rigorous, logical, Marxist analysis can
be glimpsed from this extract from a resumé of a discussion
led by Alick West about this time at Marx House:[9]

In a class which aimed at clarifying the role of the
intellectual today, the question was asked, what was
the reason for the present appeal of primitive art,
especially the carvings by African Negroes. Various
answers were given: (1) that it was a mannerism
and a matter of pure whim that the artists' fancy
happened to be taken by African carvings; (2) that
these carvings were phallic symbols and with the
weakening of the bourgeois morality the sexual
inhibitions were weakened; (3) that there are two
sorts of awareness of life — intellectual and
emotional; the latter of these having been atrophied
by capitalism and being very strong in primitive art,
such art appeals to us, since it gives us what we
lack; (4) that the interest in primitive art is a flight
into a more primitive way of thinking, is despair at
the intellectual contradictions in a time of economic
crisis which capitalism is unable to solve.

The question then arose: which of these views was
compatible with the Marxist stand-point which the
whole of the class professed?

The first answer was rejected as being an equivalent to a refusal to think the question out at all and consequently an abandonment of the Marxist demand for the utmost intellectual effort on every question that comes up. The second was rejected as not explaining why the interest in African carvings was greater than the interest in phallic symbols drawn on the walls of a urinal.

The third answer, with its opposition of intellectual and emotional awareness, necessitated fuller discussion, . . .

Artist members who were unemployed were asked to join in propaganda production sessions, painting banners and posters for which a small fee would be payable since a nominal charge was made to the organisations which used their services; but it was emphasised that these payments would have to be very small since they were working for working class organisations. Particular preparations were made for the May Day demonstrations which were used to focus members' anti-Fascist discontent and also to protest against the Monarch's Silver Jubilee celebrations, for it was thought that the previous 25 years which had witnessed the killing and mutilation of millions in the First World War and the unemployment of over two million workers hardly merited such hearty enthusiasm. One of the great coups for the anti-Jubilee campaign was arranged by some Communist party members who strung a banner across the processional route, which was unrolled at the last minute to reveal the legend '25 years of Hunger and War'.

Open Fascist meetings and street parades were a provocative aspect of this period and AIA members were energetic in their opposition. Reg Turner remembers some of these confrontations.[10]

There was the direct confrontation at Olympia, the first huge, Fascist demonstration that Mosley organised. . . . I got several cracked ribs there. I remember Jim Lucas and I with banners trying to get into the hall and all the barricades and police outside; it really was street warfare.

The commitment to oppose re-armament and militarism led to the creation of a special function of the AIA in 1936, the 'Peace Publicity Bureau' through which artists, lay-out men and copywriters were invited to pool their talents to counter the Government's growing armament campaign. An example of work done under these auspices

is the broadsheet with cartoons by Edward Bawden, which contrast a parade of decorative guardsmen with a tragi-comic scene of strolling citizens trying to carry on their normal activities with their heads encased in gas-masks.[11]

Strength of support for the Peace movement was very widespread in the country and was far from being simply the preserve of the artist and intellectual. Its most vociferous organ was the Peace Pledge Union which was conducted by Canon Dick Sheppard, who with the aid of slogans like 'War will cease when men refuse to fight', rallied nearly 150,000 pledges from people who undertook never to become involved in another war.

But the fragility of any such pledges when tested against the continually advancing threat of Fascism in Europe was already becoming clear with the outbreak of Franco's military rebellion in Spain in the summer of 1936.

The agony of the conflict in Spain was urgently brought home to the circle associated with the AIA by the death of one of its members, Felicia Browne, who was killed in action while attempting to aid a wounded colleague one night in August 1936.[12] A commemorative booklet of her drawings was published by Lawrence and Wishart to raise funds for Spanish medical aid. These drawings, extracted from the sketchbook she had with her in Spain, are mostly of the peasants and soldiers, with whom she was living. They show a fine sense of characterisation and an imposing quality of design and stature. She had not yet acquired any wide reputation but the anonymous foreword appreciation suggests an impressive and admirable personality.

Figure 6

A student at the Slade from 1924-6, Browne had then travelled to Berlin where she became apprenticed to the craft of stone masonry: she returned to study metal work and made several trips abroad 'to see art and to express the real and rooted life of workers and peasants'.[13] In 1933 she joined the Communist Party, and to raise money worked as a kitchen maid in a hotel, 'where she gave the girls hope and spirit and encouraged them to join a trade union'.

On a drawing excursion in Spain she was overtaken by the events of the rebellion and she immediately joined the Republican militia. She was the first British citizen to be killed in the conflict. Her position represented the acid test confronting the politically engaged artist, the choice between defending the principles of communism and democracy by relying on one's special contribution as an artist, or by committing oneself to direct action; the booklet foreword quotes from one of her letters to a friend:

You say I am escaping or evading things by not

6. Felicia Browne, *Drawing from a Spanish sketchbook, 1936.*

painting or making sculpture. If there is no painting or sculpture to be made, I cannot make it. I can only *make* out of what is valid and urgent to me. If painting or sculpture were more urgent or valid to me than the earthquake which is happening in the revolution, or if these two were reconciled, so that the demands of the one didn't conflict (in time even or concentration) with the demands of the other, I should paint or make sculpture.

The AIA was to be occupied with the war in Spain from this point until the eventual recognition of Franco's victory, organising public meetings and fund-raising schemes and helping to look after refugees. A few of the many banners and posters that were produced in connection with Spain survive in the care of the International Brigade Association. James Lucas designed the banner with which the British section of the International Brigade entered Spain. It was embroidered by Phyllis Ladyman and the finial of the pole was carved in the shape of a clenched fist by Betty Rea.

The concern of many artists in Britain about the rebellion and civil war in Spain sprung from their affection for a country which had been a popular place for long, summer painting and sketching holidays. David Bomberg, for example, had been forced to make a hasty departure from Spain and, although he had not emerged before as a politically active member of the AIA, we find him in February 1937 stirring things up at the London Group by submitting a resolution that they affiliate with the AIA (there were in fact many joint members of both bodies); and moreover that,

> The London Group members . . . be prohibited from exhibiting with reactionary groups; that the London Group consolidate with the AIA and Surrealist Groups in their support of anti-Fascism in politics and art; that funds be granted for Spanish Medical Aid; and that honorary membership of the London Group be extended to certain left-wing poets and writers.[14]

Bomberg's concern to take a stand against Fascism must also have been spurred by Mosleyite attacks on the work of Jewish artists in Britain. In October 1936 two public sculptures by Epstein were daubed with anti-Semetic slogans.

The London Group which was largely regarded by the Left as the epitome of faded, Bloomsbury aestheticism at

the time, did not accept Bomberg's resolution though they did refuse to send work to the controversial official exhibition of British Art in Berlin. The German Government was intent on holding an exhibition of British Art in Berlin and despite the incontestable information coming from Germany about state interference in cultural activity and the application of policies of racist and political discrimination against artists, several of the British artists invited were prepared to accept: Sir John Lavery, for example, was able to affirm:

> If I thought for one moment that any political significance attached itself to the exhibition, I would not give it my support.[15]

This blinkered refusal to acknowledge reality was even in evidence in the London Group's ultimate decision against acceptance, when the Chairperson was at pains to point out that this decision had been reached solely on the grounds that the German organisers required the right to reject any of the works submitted by the Group, so 'it will be seen that the refusal to participate in the Exhibition has no political significance whatsoever'.[16] Perhaps the tone of the typical London Group member is caught in the forlorn advice of the editor of *The Artist* that artists should keep out of politics and:

> If the younger members of any society try to introduce politics — Kick 'em out.[17]

In December 1936 an exhibition 'Artists Help Spain' was assembled at short notice yet works were readily donated by John, Epstein, Paul Nash, Lucien Pissarro, Gill, Grant, Vanessa Bell, Nicholson, Moholy-Nagy, Ravilious and Bawden, amongst others to raise funds for a field kitchen for the International Column.

Fund-raising ventures continued throughout the period of the Spanish war and took many forms; in March 1938, for example, the AIA arranged a cabaret performance with songs by Auden and music by Britten, sung by Hedli Anderson. These were probably the cabaret songs, including *O tell me the truth about love*, which have been described as being in the manner of Cole Porter.[18] Margot Fonteyn and Robert Helpman danced, and the evening also included a male strip-tease performance.

Ewan Phillips, for the AIA, organised another fund-raising scheme in aid of Spain. Under the *Portraits for Spain* scheme, the public were invited to commission a portrait from one of the artists who had agreed to take part in the

scheme and who included Epstein, Gertler, Gill and John.
The artists then contributed all or part of the fee to Spanish
Relief funds for food or medical supplies. Drawings cost
between one and fifty guineas and oils from five to five hun-
dred guineas. At least one donation of £500 was received
this way from Augustus John and the scheme was able to
send out a fully equipped field ambulance to Spain. On
another occasion a rug was made up by a group of miners'
wives to a design by John Piper, and auctioned to raise funds
for Spanish Relief.

The continuous involvement of the AIA in the situa-
tion in Spain was firmly demonstrated by its joint sponsor-
ship, with other Spanish campaign organisations, of a
major meeting in June 1937 at the Albert Hall. Many artists
had come along to this meeting in the hope of seeing and
listening to Picasso who was one of the invited speakers.
He was in the event unable to attend, offering the explana-
tion that he was pressingly occupied with a mural for the
Paris exhibition dedicated to the victims of Guernica. He
had, however, drawn a design for the programme and
donated an original drawing for auction. The drawing was
described as 'A recondite little piece of metaphysical
abstraction' by Townsend,[19] who records the events of the
meeting movingly — but the work was withdrawn when the
bidding stalled at £80.

W. G. Constable, the first director of the Courtauld
Institute, spoke at the Albert Hall meeting on the theme of
the Spanish contribution to culture. J. B. S. Haldane, the
biologist and popular writer on scientific matters and Isobel
Brown, whose success as a fund raiser for Spain was often
remarked on, were among the other contributors to this
four hour rally. But for many it was the presence of Paul
Robeson which specially dominated the evening; he was
originally expected to be heard by radio transmission from
Moscow, but at the last moment flew in to London to appear
in person. As William Townsend recalled:

> It was a brave and truly noble speech; the battle-
> front is everywhere, he said, and every artist must
> take his stand on one side or the other and I have
> taken my stand, I stand unalterably in support of the
> Spanish Government. That a negro artist could say
> that at an international gathering and that those
> words should evoke rapturous applause which went
> on and on is of impressive significance . . . and then
> he sang and so easily filled the air, it seemed
> everything at that moment that he was singing not
> only for two oppressed peoples but for oppressed
> peoples everywhere.[20]

In the first part of 1937, the AIA was concentrating on two major projects, a further, large-scale exhibition and an Artists' Conference to be held at the same time. The decision to set up the First British Artists' Congress records the ambitious and comprehensive aims which the organisation now saw itself as able to take on and it was presumably modelled to some extent on the inaugural meeting which had led to the establishment of the American Artists' Congress.[21] The general tendency of the subjects for discussion was to do with occupational questions which foreshadowed the quasi-Trade Union or Professional lobbying roles that the AIA were to increasingly develop.

Separate panels were assembled to concentrate on 1) painting, sculpture and engraving, 2) teaching, 3) industrial and commercial art, and 4) students. The three day conference opened on April 23rd, 1937, with a public meeting at Conway Hall to discuss 'The Relation of Art to the State and Public' and further sessions were held at the exhibition premises, 41 Grosvenor Square, at which the reports and recommendations of the specialist panels were discussed. On the Sunday, following a Congress Dance, a session on 'Peace, Democracy and the Artist' was held.

A great deal of work was put in by these panels made up of AIA members with appropriate specialist interests, who met in the weeks before the Congress to draw up recommendations and resolutions. Some picture of the issues which concerned artists, designers, art teachers and students in 1937 can be gained from the following examples:

> That teachers of art in elementary schools should be specialists, in the sense that they should have an understanding of child psychology and possess qualifications resulting from adequate instruction in art.

> That wood and metal work should constitute a lesson in design. An end should be put to the present divorce between the teaching of wood and metal work and the remaining subjects in the art curriculum.

> That the employment of practising artists as part-time or full-time teachers in the art schools be increased. Such teachers to be allowed to continue practising and not required to take a course in pedagogy.

Art History, as taught in this country, is in general

unscientific and haphazard and very inadequate.
Special provision must be made in all schools of
university standing including the RCA to train in this
subject.

That an artists' co-operative or centre comprising
an exhibition building and art centre for
contemporary work only should be provided in
London. . . . Generally speaking, the aim of the
centre would be to create a system of national and
international co-ordination and development of
exhibition, sales, publishing, social and educational
facilities. It is felt that such a centre would greatly
increase understanding between the public and the
artist. In order to meet the expenses of the centre,
this commission urges the government, the LCC
and the local and provincial authorities to subscribe
to a permanent grant.

That a certificate of merit for good design be issued
by the Council for Art and Industry for merchandise
meeting with its approval.

That in order to raise the standard of design for
industry in this country the status of the designers
in industry should be improved, by providing better
means of promotion at adequate rates of
remuneration.

Congress wishes to express its disgust at the
continued ruin of the natural qualities of the
countryside by vulgar erections and signs . . .
Congress suggests that all government bodies seek
the assistance of artists and architects in decisions
regarding such material.

The recommendations of the panel looking at social
and political relations concluded with the following points:

That only under a democratic Government can
economic conditions and freedom of work for artists
be protected and advanced. We shall therefore
oppose all attempts to destroy our present
democratic rights and to assist in the extension of
such rights, both here and abroad.

Congress deplores the suppression of freedom of
expression in Fascist countries such as Germany
and Italy, as shown in the notorious public burning

55

of famous works of literature, the banning of progressive art from exhibition, the expulsion, exile and imprisonment of famous artists and other cultural workers on grounds of racial discrimination and reactionary opinion. It opposes the general anti-cultural attitude implied in the attempts to enforce 'nationalist culture' and expresses its solidarity with all who have suffered from this attitude, and resolves to oppose all attempts to limit the freedom of expression from whatever source they may arise.

That as working artists we will not undertake the design or execution of any propagandist material that directly or by implication aims to create support for a war of aggression, or any action in support of such a war.

That we as skilled professional workers regard the present tendency to concentrate the resources of the nation on preparations for war, at the expense of the well-being and education of the people, and the recent attempts to shackle the rightful liberties of the peoples by Acts of Parliament, designed to prevent just opposition, as inimical to the freedom of expression necessary to the progress of culture and civilisation. We protest therefore against this tendency and demand that the first essentials of national security and health, i.e. employment, education, and civil liberty for all, be given immediate priority over all considerations of national defence or offence.

That artists may greatly assist the National Peace Movements of this country by joining their local Peace bodies with a view to assisting them with advice and help with their propaganda. In order that such activities may be properly co-ordinated and directed on a national scale Congress urges copywriters, advertising experts and artists also to join and support the Peace Publicity Bureau with a view to developing this organisation so that it can meet the many and varied propaganda needs of the National Peace Movement.

The Congress agreed to set up a permanent commission to look into the possibility of forming some kind of trade union for artists. This 'permanent commission' does not seem to have proceeded very far but the published resolutions of the Congress bring together many reasoned

and well-informed criticisms. Recommendations for the reform of art education, both in schools and art colleges, were put forward, and an appeal was made for the establishment of government-backed bodies very much like what the Arts Council and the Council of Industrial Design were to become. This pressure to look for a way of shaping the occupation of the artist into an activity which could be governed by trade union conditions was probably largely supported by Communist members who saw it as a way of insuring a closer solidarity with the Labour movement, but many members were sceptical about how the heterogeneous body of people who they knew as artists could ever be fitted into standardised categories of recruitment, qualification and description of work which the prospect of unionisation suggested.

The intention of the 1937 exhibition held at 41 Grosvenor Square, April 16th — May 5th, was again to draw representation from the whole range of current styles and from members of all the major exhibiting societies; from all who wished to show support for the principles of 'Peace, Democracy and Cultural Development'. To overcome any complaints of bias to any one school on the part of the selectors, three separate juries were empanelled, one for Surrealist work, one for Abstract work and one for everything else.

When the exhibition was arranged, the abstract room was taken up largely by members of the *Circle* group though Kandinsky and Léger were also included. An installation view of their section is illustrated in the *Circle* book published in 1937. The Surrealist room contained an impressive representation of the leading figures of the movement, including Ernst, Tanguy, Miró, Klee, Picasso, Man Ray, Dali, Delvaux and Giacometti; it would appear to have been work which had been retained from the Surrealist Exhibition of the previous year.

A further section was given to Working Mens' Groups, prominent among which were the Ashington Group from Northumberland[22] and Percy Horton's students from the Working Men's College at St Pancras. Most reviewers were happier to express support for the intention and objects of the show than for the work itself. The main criticism was the sheer weight of numbers — over 1,000 works — and the overcrowding and visual incoherence which resulted.

Townsend did have some work accepted on this occasion but his journal entry is scathing:

> The Grosvenor Square show is monstrous, every
> painter is there but the effect is depressing beyond

words — there are many too many pictures in an effort to include a great number of artists rather than to maintain a very high standard, not only too many pictures so that all drown together, but much too great a proportion of trash, Geoff [Tibble] and I even ran through some of the rooms.[23]

Indeed, the *Left Review* critic, whilst he was far more sympathetic to the show, confessed himself at a loss in front of such comprehensiveness to select any helpful criterion for assessment.

The Surrealists, despite their effort to prove their mettle as a serious, politically conscious body, only attracted the customary *Left Review* dismissal of their exhortations as having 'the vagueness and chaos of anarchism' and their attitudes showing a confusion of 'Society with the chatter pages of *Vogue*'.[24]

Little comfort could be extracted from the show for those with aspirations for the emergence of a new popular visual language; the traditional work still revealed:

the invisible barrier . . . separating the work from living experience. So young yet already the hand of the museum is upon them.[25]

The section devoted to 'worker-artists' was equally discouraging to the *Left Review* critic for although the content showed a more natural contact with social experience, it was felt that the manners and subjects of the professional artist had cloyed their potential to make an original contribution to proletarian culture.

The Surrealists published a broadsheet, bearing a design by Henry Moore, which was distributed to accompany the Congress and Exhibition. It reminded visitors of the specific political issue of the day which was causing so much concern to both the liberal and the left conscience — the policy of non-intervention of the British government in Spain.

The prolongation of the Spanish war and the involvement of British volunteers had brought the two formative principles on which the AIA was built — opposition to War and to Fascism — into tension. For some time, the Communist party had been playing down its previous association with the peace movement and from now on the unconditional pacifists were to become an increasingly isolated minority within the echelons of the Left as the doom of ultimate military confrontation with Fascism became all the more apparent.

The Surrealists' broadsheet marks the point where

this change of attitude was becoming more apparent; it
points out the far from neutral effects of the policy of non-
intervention by the Government and its move to make re-
cruitment of volunteers illegal:

> One thing is clear. With all respect for the motives of
> pacifism, for the sincerity and courage of pacifists,
> this form of non-intervention is completely
> discredited in practice by the Spanish experiment.

Yet, despite this shift of direction, the peace move-
ment was for a time still strongly supported within the AIA
and in the summer of 1937, we find a number of its mem-
bers, including Misha Black, Betty Rea and James Holland
in Paris, preparing two rooms, the League of Nations
Room and the International Peace Campaign Room, for the
Peace Pavilion of the International Exhibition. In the highly
charged political atmosphere of this event, with the pavil-
ions of the USSR and Germany glowering opposite each
other and the Nazi flags mysteriously hauled down every
night, the French Popular Front Peace organisations had
financed the erection of an unofficial Peace Pavilion situated
just outside the Trocadero entrance to the main site.
Holland designed what he describes as 'a diagrammatic
mural — almost a flow chart' showing all the groups work-
ing together for peace.

The British designers recall with mixed astonishment
and amusement the experience of working with the French
building workers caught up in Popular Front enthusiasm.
Quite apart from their make-shift technical methods —
ladders, made on the spot out of scrap timber and 6″ nails,
etc — there were frequent interruptions and days off for
sundry anti-Fascist activities. The Peace Pavilion was
damaged by fire on one occasion and after suspicion of
arson fell on the right-wing Cagoulards, a regular sentry of
workers was posted, armed with nailed clubs.[26] Holland
gives some sketches of the event, in the heroic manner, in
Left Review for August, 1937.

The AIA sought to remind the public of the continuing
resistance to the Japanese in China by an exhibition in
November 1937 of Chinese drawings and woodcuts. The
idea of showing examples of the cultural production of a
country involved in war and political crisis must have been
effective in conveying the very humanity and subtlety of a
people who might otherwise be reduced to the mere
cyphers and statistics of the news report. This exhibition,
called '5,000 Years Young' was also suggestive to artists
here, for whether one was attracted by the traditional ink
drawings or the more Western influenced woodcuts, here

was an example of an aesthetically admirable art form which was at the same time popular in terms of cost of production and subject matter.

Notes

1. David Low, introduction to *Political Parade*, London 1936, an anthology of cartoons.

2. George Orwell, in *New England Review*, October 17th, 1938, quoted in Pimlott, B. *Labour and the Left in the 1930s*.

3. Sarah Wilson, 'La Beauté Révolutionnaire, Réalisme Socialiste and French Painting 1935-1954.' *The Oxford Art Journal* October 1980, pp. 61-69.

4. Montagu Slater, 'The Artists' International exhibition 1935', *Left Review* January 1936 pp. 161-6.

5. Robert Radford, 'Edith Tudor Hart — photographs from the Thirties', *Camerawork* July 19th, 1980, pp. 1-4.

6. Terry Dennett, 'England. The (Workers') Film and Photo League' in *Politics/Photography 1*, pp. 100-117, London, 1979.

7. Townsend Journals, November 1935 (unpublished). The Polish exhibitors were given as Tadeusz Cieslewski, jnr, Bronislav Linke, Tadeusz Kulisiewicz and Witold Miller.

8. Montagu Slater, 1936, op. cit.

9. A. Croft, 'Alick West of Marx House, 1935-7' *Quarterly Bulletin of the Marx Memorial Library*, April 1982, pp. 3-8.

10. Lynda Morris and Robert Radford, *The Story of the AIA 1935-53*, Oxford Museum of Modern Art, 1983, p. 34.

11. Illustrated in *Left Review*, May 1937.

12. Nan Youngman, who had been a fellow student at the Slade recalls this incident as a turning point in her own convictions:

 I was sitting on a beach in Cornwall reading a newspaper when I saw the announcement of her death. I did not want to believe it, I was horrified and from that moment I began to be aware of living in history, aware of what was

happening in a way I had never done before . . . The first
thing I did was to join the AIA which seemed to me the
most tremendous political action . . .

Lynda Morris and Robert Radford, 1983, op cit p. 31.

13. This and following quotations are from the foreword to
Drawings by Felicia Browne, 1936 published by Lawrence
and Wishart. There was also an exhibition catalogue with
a foreward by Duncan Grant.

14. W. Lipke, *David Bomberg: A Critical Study of his Life and
Work*, London, 1967, p. 81. In some lecture notes headed
'On Art and Revolution', undated but from the mid-
thirties, Bomberg reveals a Marxist, informed analysis of
the problems of artistic style and didactic purpose. Lipke,
op. cit., p. 121.

15. Notes and News, *Artists' News-sheet*, January 1937.

16. Letter from R. P. Bedford, *Artists' News-sheet*, April 1937.

17. *The Artist*, March 1937. This could hardly have been a
direct reference to Bomberg though since he was a
founder rather than a 'younger' member of the London
Group.

18. C. Osborne, *Auden, Life of a Poet*, London, 1980, p. 148.

19. *Townsend Journals*, entry for June 24th, 1937.

20. *Townsend Journals*, entry for June 24th, 1937.

21. The American Artists' Congress had been substantially
reported in the AIA Bulletin, April 1936. Many further
striking parallels can be drawn between the work of the
AIA and the contemporary organisations of politically
committed artists in the USA. The first John Reed Club
exhibition in New York in 1932 was called '*The Social
Viewpoint in Art*'. In 1936 the American Artists' Congress
against War and Fascism was set up with objectives
closely comparable to the AIA, including the search for
means of popular presentation of art. Within a year it had
attracted 600 members with Max Weber, Stuart Davis and
George Biddle prominent as organisers and was engaged
in a programme of exhibitions, lectures and
demonstrations. It took part in events in support of the
loyalist cause in Spain and arranged for the showing of
'Guernica' in New York, as well as actively campaigning
for the rights of artists under the WPA, FAP scheme. A
later slogan employed in common with the AIA was
'Artists for Peace, for Democracy and Cultural Progress'.
English cartoons were occasionally published in the
American magazines, *New Masses* and *Art Front* and a

61

number of personal friendships united the movement, notably that between Philip Evergood and Richard Carline.

These parallels reflect at one level the widespread appeal of Popular Front sentiments, and at another, the organising skills and influence of the Communist Party internationally.

See G. M. Monroe, 'The 30s: Art, Ideology and the WPA', *Art in America*, November/December 1975, pp. 64-7, and G. M. Monroe, 'The American Artists' Congress and the Invasion of Finland' *Archives of American Art Journal* Vol 15, No 1, 1975, pp. 14-20.

22. The Ashington Group was the most successful survivor of a number of Workers' art groups established in the Thirties. It grew from a WEA class in art appreciation set up in 1934 at the request of miners from Ashington Colliery who were subsequently encouraged to depict their own working lives. See Robert Lyon 'An experiment in art appreciation', *The Listener*, May 29th, 1935, reprinted in Lambert, 1938, op. cit.

23. *Townsend Journals* (unpublished entry for April 23rd, 1937), U.C.L. ms.

24. Review by J. S. H., *Left Review*, May 1937.

25. J. S. H., op. cit.

26. James Holland's recollections in 'The Thirties', *The Designer*, November 1979, p. 4.

From Soho Square to
Grosvenor Square
1935-37

WHAT DOES SOCIALIST ART LOOK LIKE?

When we look now at the broad range of work accepted for the major exhibitions of 1935, 1937 and 1939, we assume that the contrasts of style and attitude that this mixture presented must have provoked lively debate about the questions of style; of essentially what socialist or what revolutionary art should actually look like. But there never was an AIA style and it was contrary to the aims of the group to seek for one. The Association aimed to enrol the efforts and talents of the whole profession in defence of the cultural values on which their place in society depended, values which were being so alarmingly and progressively threatened by Fascism and militarism throughout Europe. As the AIA expanded after 1935 to attract a large number of artists and designers with little political awareness and conviction beyond this major issue of opposition to Fascism at home and abroad, it was unreal to assume that the broad majority of membership was committed either to working for the achievement of socialism or the discovery of the formula of socialist art. Furthermore, these enquiries were also delayed through pressure of business. The AI was set up initially as a propaganda agency for the production of banners and posters for sundry Left-wing organisations against tight deadlines and tighter budgets, so to some extent issues of pictorial style were relegated to the status of 'academic' interest only.

But by 1936 such questions were emerging, and although the policy of the AIA was to stand on principle

away from making definite stylistic choices, the debate did grow and continue throughout the years up until the War. This was due no doubt partly to the effect of the all-embracing exhibitions, partly to the AIA's programme of lectures and study groups, but perhaps mostly due to the genuine doubts and crises of conscience experienced by individual artists trying to reconcile their own conditioning and practice as artists with their maturing political consciousness. One aspect of this conditioning was the question of how to react to the various options suggested by the Modern Movement. It must be remembered that AIA members would have experienced an art training, with all its associated values, which was academic in the traditional sense — drawing from the cast, etc — and the alternative excitement of Constructivist or Surrealist approaches would have been, for many, very alluring.

There can be no doubt that there was in the beginning much more enthusiasm than knowledge, much more good-will than certainty, amongst the Artists' International's membership about the complex nature of the relationship between art and politics and its strategic implications. Not only did they lack an obvious visual tradition from which to advance, but there was at first very little by way of an authoritative and accessible theoretical guide to assist them in their wish to achieve a Socialist art practice. To help rectify this problem lectures and debates were arranged, led by such speakers as Moholy-Nagy, F. D. Klingender and Herbert Read and a collection of essays *5 on Revolutionary Art*, published in 1935, reflects the subject matter of this area of discussion. Its cover, in the style of 'The New Typography', was the work of E. McKnight Kauffer.

As Betty Rea makes clear in her foreword, the range of views offered in these essays is wide and not entirely free from contradiction, but certainly they clarify for us today some of the more frequently maintained positions of the mid-1930s on issues of art and politics and show as well something of the difficulties that any unified approach would have to accommodate. But if the overall answers were inconclusive, we cannot doubt that the papers lived up to their intention of provoking discussion and indeed self-questioning among artists, for, as the Editor Betty Rea concludes in her introduction:

It is time the artists began to think what kind of future they want and what they can do to get it.

Herbert Read, in the opening essay *What is Revolutionary Art?* manages to suppress the impatience with Marxist doctrine which would be proper to his own anar-

65

chist viewpoint, throughout this cogently argued apologia for the election of certain artistically revolutionary styles as appropriate vehicles for revolutionary social action.

He points out that many of the difficulties with the present, orthodox Marxist understanding of art and its revolutionary purpose stem from Marx's failure to develop further and to a more sophisticated exposition, his recognition that there was an unequal relationship between the development of material and artistic production. It is regrettable, Read claims, that later Marxists have not shown something of Marx's own respect for the complexity of the problem before delivering themselves of banal and superficial statements. He argues that this superficiality only served to deter the establishment of a 'Vital Artists' International' because such conclusions were generally unconvincing to most artists. He steps aside from the example of Soviet Art with the plea that he has not been to Russia to see for himself and finds reports from those who have, to be contradictory. So despite his concluding slogan to the effect that 'REVOLUTIONARY ART IS INTERNATIONAL', he proposes to concentrate on the case of Britain alone.

The main thrust of these superficial arguments that he dismisses as 'cant', (although maintained by 'otherwise' impeccable communists'), is that Revolutionary art consists only in the due depiction of red flags, machinery and factories. This error is manifest in the failure of the first exhibition of the Artist International and in the weakness of the work of the essentially 'second rate', Rivera.

Read then directs us to the example of architecture, though here he is aware of the growing reaction to Constructivist styles taking place at that time in Russia. Surely, he concludes, no one here would suggest that a new Socialist architecture should be cloaked in a Georgian or neo-classical garb but that it would follow the lines of development shown by Gropius and Le Corbusier, i.e. an abstract, objective approach to architectural design. The progressive Communist must therefore be equally unwilling to accept the simple-minded, anecdotal styles of painting; and just as he recognises the intellectual strength of Gropius' architecture, he must also learn to respect abstract painting and sculpture. Read forestalls the dismissal of this view by Communist artists from Germany who could claim they had put this approach to the test and found it insupportable because it lacked any appeal for the proletariat (he must be referring to the views of the recent arrival Laszlo Peri in particular here) by suggesting that their failure was in quality or perhaps persistence rather than kind.

Read maintains that the abstract movement contains,

'all the artists of any intellectual force' and cannot be dismissed as formalist or decorative, moreover most of them are to some extent sympathetic to the Communist cause. He anchors his case for abstract art to that most resilient of aesthetic theories — one to which Gropius and Le Corbusier would happily assent — the platonic concept of ideal forms and harmonic relations which underlie the accidents of surface appearances. Certainly Read is opposed to the pursuit of 'pure form' and utter detachment, but he doubts if this is ever achieved anyway because, no matter however unaware of the fact he may be, the artist is inevitably drawn along by the currents of history.

Read finds himself in some difficulty in defending the objective school he is advocating — and he cites Mondrian, Helion, Nicholson, Moholy-Nagy, Brancusi, Gabo and Hepworth — which he sometimes calls formalist and at other times denies the term's applicability. His defence of their apparent retreat to the ivory tower is that they are, purely as a transitional measure, keeping 'inviolate until such time as Society will once more be ready to make use of them, the universal qualities of art'. Indeed, in the case of architecture and certain aspects of industrial design, an application of these qualities can already be effective in literally building the new society.

He contrasts this positively, revolutionary claim of the work of artists who are typically non-political in their public voices with the position of the Surrealists who avow themselves to be Communists. The role of the Surrealists (or Superrealists as he is already renaming them) is relevant for the time being in subverting the structure of bourgeois consciousness but, Read argues, this role is essentially negative and short lived. The ringing slogans of his conclusion recall the battles of the Constructivists and the Leninists of ten years before in Moscow and clearly show his colours flying with the former battalion:

> Communism is realist, scientific and essentially
> classical. But let us realise that we have
> romanticists in our midst — tender minded idealists
> who would like to blur the precise outlines of our
> vision with democratic ideals of egalitarianism,
> Tolstoyan simplicity and naivety, community singing
> and boy-scouting.

Perhaps the clearest exponent of just this egalitarian romanticism must surely be Eric Gill with whom Read became acquainted at about this time. Whilst Gill acknowledged Read's wide knowledge and agreeable nature he diverged violently from what he saw as Read's promotion of

67

the cause of 'pure form' as the dominant direction for Modern art to take. He disputes Read's notion of Genius and asserts that it is not a normal activity for people to think in plastic terms and tells him, 'your idea of the artist as abnormal man is what revolts me'.[1]

As international tension increases during the 1930s decade, Gill's correspondence reveals an increasing radicalism; he willingly describes himself as a Communist and is prepared to accuse the Catholic church of collusion with Capitalism through its investment activities. He is though in no sense a Party man and remains a pacifist throughout the decade, even at the outbreak of the war.

His own essay in *5 on Revolutionary Art* is rather slight and appears to have been written originally for a Catholic readership. His principal purpose, however, as in his *Catholic Herald* correspondence, is to point out that, in its effects, all art is irretrievably propaganda for one viewpoint or another:

> The paintings, sculptures and architectural designs exhibited at the Royal Academy every year express the 'values' of the dominant class. Therefore they are propaganda for the successful bourgeois.

Gill argues that the invention of studio jargon about 'tone values', 'formal relations' etc. serves to divert the painter from the embarrassing admission that this art is, in effect, propaganda for the idle rich. He wants to establish recognition of the fact that any art once made public must reinforce the values of that public to which the work appeals, rather than argue that painters should 'only paint pictures of starved, Welsh miners'. As a Christian, he regrets the confusion of a world without faith or one confused by contradictory faiths, and points out that it is only under such conditions that the modern view of art, deprived of meaning, could survive. He wishes to absolve the idea of propaganda in art from being considered inherently bad, for what Gill deplores is the conspiracy between the contemporary art critic and the 'complacent bourgeois' to deprive art of its former power for meaning beyond the confines of the studio.

Francis Klingender, born in Germany in 1907, but of British-born parents, received his schooling and undergraduate training in his native country but came to England in 1925 when he read Economics at the London School of Economics. In 1934, he gained a doctorate and was engaged during the decade on various official social and economic surveys.[2] He was closely attached to the AIA, where his clarity of mind and breadth of learning were valu-

ably employed in the discussion groups and lectures that pioneered Marxist approaches to Art History in Britain. Klingender's special interest in the sociology and social history of art bore fruit in his publication during the time of his association with the AIA of *Marxism and Modern Art* in 1943 and *Art and the Industrial Revolution* in 1948.

In his *5 on Revolutionary Art* essay, *Content and form in Art*, he introduces what to most of his readers must have been the unfamiliar concept of a Marxist analysis of Art History. His obviously close acquaintance with the writing of Marx and Engels in its original form was to provide a standard of method and thoroughness of argument which was rarely matched by any English-trained scholars in the field at this time.

Klingender points out the need to establish clearly the proper relationship between form and content in art, especially in the paradoxical light of the current situation in which the pursuit of abstract art seemed to be advancing at precisely that time of political and economic crisis which rendered the social isolation of the artist all the more absurd.

He then drafts out the ground rules for his inquiry into the history of 19th and 20th century developments which form the background to the current position. He has to point out that the 'aesthetic' methods of most previous art history are inapplicable and, further, that any method which confines itself to cataloguing changes in form or iconography is equally invalid for arriving at the real significance of artistic change. The preferred method, then, must be firmly rooted in an appreciation of the nature of the social group from which the work of art under examination is generated and furthermore, for the greater part of modern history, this will mean an examination of the class structure of the given social group. So long as a class-structured society continues, Klingender maintains, it is impossible to apply the aesthetic criteria of only one section of that society, at one point in time, as equally binding on all sections.

Content then will have to be studied not as an independent entity but as extending naturally from the social reality of that social group. The particular intellectual and emotional dimensions of that social reality will determine the typical form by means of which that content is communicated, but, he insists, 'Form without content, form torn from its vital source of social existence must necessarily be sterile'.

With this general approach established, Klingender goes on to sketch out its application to modern art history with particular attention to revolutionary and post-

revolutionary France. Because of the unusually lucid pattern of development of the stages of Capitalism in France he considers that this period can provide 'a standard scale' against which to measure the social significance of art in much more complex situations such as that of contemporary Britain.

Because of the complexity of the task of applying this interpretation to the period from David to Gauguin in three or four pages, the details of Klingender's argument are highly compressed (the essay was based on a series of twelve lectures) but they do add up to a coherent illustration of his theme. As the twentieth century is approached, attention is given to developments in Germany and Central Europe (of which the average AIA reader was likely to have only a rather shady knowledge). Some idea of the pace and direction of Klingender's argument can be gathered from the following extract:

> The subjective naturalism of the Impressionists was now discarded in favour of an absolute subjectivism that was no longer concerned with 'external' reality in any shape or form, but either claimed to interpret the 'inner meaning' as it appeared to the sovereign ego of the artist (the bourgeois intellectual, crushed between the forces of collective classes, strove desperately to find a compensation in art for his own impotence), or else delved into the primitive impulse world of the mysterious realm of the subconscious.

He does not fight shy of analysing the contemporary position in England and makes an interesting comparison between the 'progressive' English artists, including film makers and theatrical producers, with their early post-war German counterparts such as Grosz and Piscator.

Presumably, in an effort to take into account the resistance in Britain to the current style of Socialist Realism associated with Russia, he makes a point of warning us against a too hasty condemnation of this 'temporary prevalence of academic form' which he attributes to the peculiar problems involved in raising the artistic consciousness amongst large masses of people who are only just for the first time encountering the benefits of art.

To Klingender, the prospects are bright, as he foresees a new style developing in the hands of progressive British artists which will exert an appeal to the workers:

> Transfused with the vital energy of the new social content, the technical achievements of modern art

will at last lead to an undreamed of enrichment of human experience.

Somewhat similar intentions lay behind the contribution from A. L. Lloyd who was later to achieve prominence not as a draftsman but as a collector and historian of folk music. His essay *Modern Art and Modern Society* again aims at clarifying the phenomenon of contemporary art by reference to its inheritance of successive changes in the relationship between the artist and society over a lengthy historical period.

His opening remarks, after paying tribute to the development of Marxist theory of the social and economic bases of art by Plekhanov[3], warn of the temptation such a theory might present to the deduction of an over facile explanation of these relationships. He deplores the willingness of certain Marxists, 'who imagine they need only be Marxists to criticise any damn thing', to engage in such discussion without feeling that they should have any specialised knowledge of art and its history. Lloyd maintains that their over-simplified attempt to give a direct economic explanation to the ideological developments of any period has sometimes led to the downright misrepresentation of history where the facts have not proved to be accommodating.

What he loses to Klingender in terms of clarity of method and succinctness of expression, he makes up in the liveliness of his language and the irony of his tone. Lloyd characterises something of the current brand of distaste for the aesthete amongst politically, radical artists and commentators of the time:

> this atmosphere . . . which has been responsible for turning modern art into the channels it has since pursued, into these strange and rarified grottoes, where exquisite little mollusc artists can shrink and expand in privacy (or relative privacy, they love you to watch them, but through a glass).

As to advising the artist on a strategy for effective, revolutionary practice, Lloyd is not very specific. Certainly a new social order is rising and a proletarian consciousness which is evolving will require new forms of artistic expression. Whatever the eventual nature of these new forms, the new artist must be ready to take over:

> all that is valid for him and his class from the powerful, sensitive and excellent production of the great modern artists such as Gris, Picasso, Helion

and Henry Moore.

Lloyd was ambivalent about Picasso's work though and saw its quick succession of style and abundance of themes as representing 'the symbol of the dominant class', reacting to the epoch of violent social contrasts and friction.

The variable and often ambiguous attitude of Left critics and artists to Picasso during the thirties recurs again in their responses to *Guernica*.

The fifth essay, Alick West's *On Abstract Criticism*, is concerned to establish the currency of this term which he feels should be recognised as representing the main tendency of orthodox criticism, even though its abstractness is not admitted, nor so immediately obvious as in the case of abstract art.

Although something of the force of West's arguments has been reduced by the fact that he confines his examples to the criticism of literature, it is clear that the principles of his analysis hold good, without significant adjustment in the field of the visual arts.

In fact he examines at some length the case of Coleridge, looking first at Coleridge's own conception of the place of the individual in society and then at how Coleridge is presented to us by the influential scholar I. A. Richards. According to West, Richards states his intention of examining all that is 'relevant' in Coleridge's thought and West points out that this undefined criterion of relevancy has the effect of cutting out all aspects of Coleridge's extensively voiced concept of social reality as conditioned by political and economic circumstances. West cites this as an example of the standard procedure of abstract criticism — to separate certain aspects of an artist's or writer's expression from its underlying social origins and to gravely falsify it thereby. Further, according to West, this idealist, critical position is not neutral or innocent of political effect, but gives support to the desire to stay aloof, to seek a non-existent No-Man's Land between Fascism and Socialism. West points out the different meanings attributed by the bourgeoisie and the working class intellectual to the word 'abstract'; what the former takes as attenuated praise, to the latter means 'perfectly useless, obstructionist and disguisedly hostile'.

The main influences that were at work, then, in securing for AIA artists a coherent framework for an art of social responsibility were predominantly Marxist, as the general pattern of ideas offered in *5 on Revolutionary Art* confirms. This Marxist approach was directed both through the more academic channels of scholarly lecturing

and criticism by Klingender and Blunt[4] (both were indebted to the teaching of Frederick Antal, exiled to Britain from 1933)[5] and the more agitational articles from the Moscow based, *International Literature* dedicated to establishing the practice of Socialist Realism.

Given that Socialist Realism is not, as it is regularly caricatured, a simple, mono-directional approach with a given formula for any medium, but rather the total embodiment of Soviet aesthetics[6] it is not surprising to find that there was still a great deal of manoeuvring of position and debate even when the general principles were agreed. At least five distinct strands of practice can be discerned which were pursued by socially committed artists in Britain, most of whom were connected with the AIA, which fall within the territory of Socialist Realism: a) Soviet style, Revolutionary Romanticism, b) Public Mural Art, c) Satirical commentary, d) Workers' Art (Proletkult) and e) Documentary Recording.

The sculptor, Laszlo (later Peter) Peri[7] provides a valuable example of the first of these strands of Socialist Realism and how it was possible to achieve a valid personal direction within it, both in terms of his production and his political commitment. Peri was born in Budapest in 1899, became involved with the Constructivism of Moholy-Nagy and Bortnyk of the 'MA' group and travelled and worked in Paris and Berlin, taking in the Dusseldorf Constructivist Art Congress in 1921 before he settled in Berlin. In 1925 he merits a place in Lissitzky and Arp's *Isms of Art* as an 'abstractionist' and he pursued the social logic of Constructivism by working on architectural sculpture for the Berlin Architects' department, but by 1928 Peri had come to the conclusion that abstract forms could not satisfy the artistic needs of the common people and diverted his plastic knowledge to develop a style of realist sculpture to be used in association with architecture. His Communist activity intensified at a time when it was becoming progressively more risky and he became involved in producing satirical drawings for the Communist press. After the Reichstag fire in 1933, imprisonment and physical attacks on communists became frequent and Peri with his British-born wife, were amongst the first refugees from Nazism to come to Britain.

He was an early member of the AIA and a frequent exhibitor. His chosen material was cement and concrete, whose main advantage of cheapness indicates not only the poverty of his domestic and working conditions but also discharged his working materials of an aura of inherent value which might confuse an appreciation of the image or object produced. He developed his own mixes and techniques of

73

cement handling which allowed a flexible use of colour in what were perhaps his most interesting pieces in the mid-30s, the reliefs such as *May Day in Hyde Park* of 1936.

The weight of Peri's biographical credentials and his proximity to the real teeth of Nazism obviously impressed many British artists and critics as much as did his pictorial and modelling qualities. Klingender, in reviewing an exhibition of Peri's work at Foyle's gallery in 1936, stressed the importance of Peri's formative discipline in abstract art as a basis for his present work:

> He has succeeded in applying his powerful weapon of a new technique to its proper and fruitful task of expressing the vital experiences of ordinary men and women.[8]

7. Peter (Laszlo) Peri,
Aid Spain, Coloured Concrete,
1937.

Anthony Blunt too was an early and constant supporter of his work; in his essay *Art under Socialism and Capitalism*[9] Peri is picked out as one of the few signs of hope for the emergence of a proletarian art and Blunt locates him in the straight line from Daumier to Dalou. He produced at least two monumental, polychrome heads of Stalin and his free-standing work is well represented by the figure of a woman, looking upward in apprehension as she holds a child to her skirts, entitled *Aid Spain*.

Figure 7

Peri's personal qualities impressed many who knew him, especially the absolute integrity and determination with which he clung to his ideals even in the face of constant poverty and sparse recognition. Although often restricted by necessity to the production of small scale figures and reliefs, his main ambitions lay in working on a public scale in association with architects and these opportunities only started to open up for him in the 1950s and 1960s when he received a number of commissions for housing schemes and schools. Much of his character is apparently preserved for us in the creation of James Lavin, the hero of John Berger's novel, *A Painter of our Time*.

Peri's concern to employ the materials of his day and to exploit the formal developments of abstract art can be compared with the approach of another monumental sculptor dedicated to Left causes, Lawrence Bradshaw. Bradshaw retained the use of traditional materials and an academic realism in his commemorative sculpture, most notably, in his bust of Karl Marx in Highgate Cemetery.

The number of paintings of stature and conviction which were produced in Britain in the authentic modes of Soviet-style Romantic realism in terms of form and content are very few indeed; one might cite Carpenter's *The Death of Gabriel Peri* discussed later in connection with the *For Liberty* exhibition or Derek Chittock's *The Arrest of the Dockers*. Both of these pictures were owned by the *Daily Worker* (now the *Morning Star*). But these were not products of the thirties, indeed *The Arrest of the Dockers* dates from c1952 and was inspired by the example of the French Socialist Realist, Gérard Singer.[10]

Cliff Rowe certainly produced works of this type but none have survived from the 1930s and Rowe's accounts of his tortuous examination of conscience in confrontation with the Communist Party's approved style of realism is given in chapter 7. The most substantial example of Rowe's work which has survived is in the second category of Public Mural Art, the mural scheme on the History of Trade Unions for the Electrical Trades Union (now EEPTU) for their training school of Esher.[11] But yet again this was a scheme of the 1950s not the 1930s and its style reflects

more the wishes of the client than those of the artist at this stage.

A mural scheme which does fit into the Socialist Realist category and which is of the earlier period is Jack Hastings'[12] mural, measuring 10' × 20', for the library of Marx House. This mural, which is by all accounts still in good condition but has been regrettably hidden behind bookshelves for a number of years, was the first significant example in Britain of the didactic mural for a long time, and caused considerable interest.

The *Daily Mirror*, for example, covered the event with a photograph of Hastings at work and an interview with the artist from which we can deduce something of the iconographical scheme. Hastings explained that;

> The large, central figure, for which a Welsh miner was the model, symbolises the worker of the future upsetting the economic chaos of the present. On the left, I have tried to portray the origins of the Labour Movement, the Chartist movement; on the other side, I show the present day Labour Movement. Among the figures are portraits of Robert Owen, William Morris and Marx. The paint itself is pure, earth colour ground in water and is certainly not in any pastel shades.[13]

The mural was painted by traditional fresco methods, directly on to the wet plaster, and Hastings was working at the rate of ³/₄ of a square yard per day with a plasterer arriving early every day to prepare the next section. Hastings had been a History student at Oxford and had then gone on to the Slade. Whilst on a painting excursion to the South

Figure 8

8. Jack Hastings, *Mural for Marx Memorial Library, 1935.*

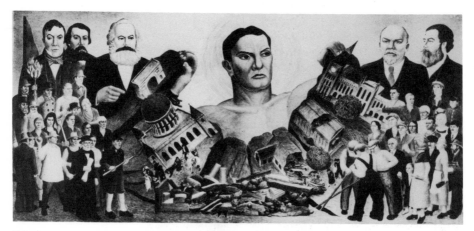

Seas he had encountered an exhibition by Diego Rivera in San Francisco which greatly impressed him and he was taken on as assistant to Rivera for a number of mural projects in San Francisco and Detroit. So well did Hastings learn from Rivera, that he was himself commissioned to produce a mural for the Chicago World's Fair. After this, he visited Mexico before returning to London with the hope of arranging an exhibition of Mexican Muralists at the Tate; but this did not in the event materialise.

As to the third category, the revolutionary function of satire is very evident, working as it does to achieve a number of different aims; to offend and undermine the confidence of class enemies, to deflate their importance in the eyes of waverers who might otherwise be impressed and, as a means of expression, to identify targets and direct the viewer's scorn and ridicule. The work of the *Left Review* cartoonists is a prime example here.

The aspiration of the three James' was to revive the strength of the English tradition of the political cartoon with the feeling moreover that this was a mode of expression which accorded well with the aims of Socialist Realism. According to James Holland:

> With the cartoons that have appeared in *Left Review*, we feel that we have broken away from the middle class and infantile code of good taste which has reduced English cartooning to emasculated illustration and religious hysteria.

> With my own work, I want to show something of the real life of this country which goes on in city suburbs, industrial towns, factories, shipyards, coalfields, shops and offices. This unfashionable material has only been used when falsified by a spurious romanticism. The English tradition of realism has been lost for more than a century. I want to show the chaotic life under an inadequate and decaying social structure.[14]

The three James' and 'Gabriel' of the *Daily Worker* were exhibiting at the Museum of Modern Art in Moscow at the time of this statement in 1936 and whilst the show was well appreciated for the most part by the reviewer for *International Literature*, Alfred Durus (Kenemey), he found it necessary to warn that the exhibitors 'had not entirely freed themselves from all traces of formalism'.

Let us move on to the fourth category of Socialist Realist production, that of Workers' art. Centres such as Morley College, The Working Men's College and the

Toynbee Centre have been long established offspring of the Ruskin/Morris socialist tradition in England of giving opportunities for members of the working class to continue their education. On to this tradition, was grafted the Soviet concept of Proletkult, based on the argument that an authentic Socialist art could only emerge from the traditions and experiences of the proletariat itself, rejecting the degenerate forms of bourgeois art. In the 1930s there arose in Britain a new recognition of and respect for the art of the worker. To an extent this new appreciation was stimulated by two elements within the ideology of Modernism as well; the recognition and subsequent partial incorporation of the 'naive' artist and the sentiment within Surrealism that academic training was a hindrance to expression.

But with a few notable exceptions such as the Ashington Group and Percy Horton's Working Men's College students, the move to encourage workers' art does not seem to have had the same success as the Worker Writers Movement, for in the event the persona of the 'classless Bohemian' often proved more attractive to those with a working-class background who moreover desperately sought to acquire professional levels of technique and recognition. The case of George Downs, one of the few genuine, working-class artists to emerge within AIA circles, provides an example of the unwillingness of many in the same position to be typecast, and is discussed later. Horton himself was sharply aware of the dangers of a situation in which workers' art could be diverted into the category 'naive art' by the dominant cultural ideology and then be instantly gelded of its political force as authentic proletarian expression. He encouraged his St Pancras students to achieve high standards of accomplishment in drawing and painting so that they could make an effective injection of new content into the mainstreams of art which were so infected with bourgeois values. Writing as 'Toros' in *Left Review*, April 1938, he warns:

> The upholders of the present social system have not been slow to recognise the value of encouraging workers to occupy their leisure in such an innocuous activity as painting. Facilities for workers to draw and paint at evening 'Institutes' and the arrangement by big industrial concerns of exhibitions and competitions for art produced by their employees — these are examples of the sort of encouragement which has been given. If the type of art produced is such as to make no demands on the intelligence, so much the better. The Sunday painter is encouraged to be

a harmless little man absorbed in what Cézanne once called 'sa petite sensation' and oblivious to the social questions agitating his fellow men.

But for many socially conscious artists in the late thirties the essential directness of expression and authenticity of context associated with workers' art had a compelling attraction. So, for example, towards the end of 1938, the group of pit-men painters from Ashington in Northumberland received visits from various members of the Mass Observation circle and an exhibition called *Unprofessional Painting* featuring the work of this group together with various other 'unprofessional' painters — George Downs, Bus-driver Stockley, Alfred Wallis, Vivin, Bauchant — was brought together to tour a number of centres.

Julian Trevelyan recalls the disturbing impression such artists made against the background of so much drifting faith in the established conventions of painting:

> These and other Sunday painters that I have met filled me with doubt about the value of professionalism in painting; they expressed themselves with so much more 'sayfulness' (a favourite word of Tom Harrisson's) than most of the exhibitors at the London group or the Royal Academy: they had had to forge for themselves their own language and the need to do so must have been very strong in the first place.[15]

Trevelyan's paintings from around 1938-40 reveal his attempts to embody something of this directness and immediacy, in their rejection of professional conventions of drawing and composition. He was not alone in this; Clive Branson, trained as a contemporary and friend of Coldstream in all the proprieties of Slade drawing, co-opted something of the rawness and explicitness of the untutored vision in the style with which he depicted street life in Battersea in 1939, and the terror of the first bombing raids of the Blitz.

This brings us on to the Documentary movement which is recognised as a widespread characteristic force within the culture of the thirties, making an impression notably in film but also in literature and the theatre. Its essential qualities of 'scientific' objectivity and the need to place the subject matter in the foreground to minimise the effects of the medium of expression, make documentary recording a very problematic mode for painting and sculpture but a very appropriate one for photography.

Edith Tudor Hart brought to British photography something of that sense of radical engagement with the medium, using it as a means of bringing about social change in a manner which was current in the Soviet Union and Germany in the late twenties, (she had learnt her photography at the Bauhaus in 1931). According to Tudor Hart:

> The USSR showed the way in both film and still photography by developing a camera technique expressive of the new life of its people, showing the world the powerful expressive possibilities of the camera which had sprung from the new spirit of an awakening nation. It ceased to be an instrument for recording events and became a means for influencing and stimulating events. It became a living art, embracing the people. . . . In the hands of the person who uses it with feeling and imagination, the camera becomes . . . a vital factor in recording and influencing the life of the people and prompting human understanding nationally and internationally.[16]

Her photographs, typically of the living conditions of women and children in London's areas of poverty and delapidation, were extensively employed as propaganda for causes concerned with poverty, poor health and bad housing. She made photo-montage posters for the ATO (Architects' and Technicians' Organisation) and for the Communist Party in the 1935 election campaigns, produced Figure 9 photo-reports of the conditions of unemployment in South Wales pit villages, and the photographic evidence for such socially conscious books as Margery Spring-Rice's *Working Class Wives*, in 1939; in sum she pioneered the use of photography as agitational evidence in Britain.

Humphrey Spender, in distinction from his work as 'Lensman' for the *Daily Mirror*, undertook two documentary programmes for socially and politically committed causes. In 1934 he was asked by a campaigning probation officer to take photographs showing the appalling conditions of domestic life in Stepney, and for *Left Review* he recorded the progress of the Jarrow Hunger Marchers in 1936. He was later the official photographer for Mass Observation's *Worktown* project but here the intention was to produce imagery in the manner of the anthropologist's recording of scientific data, rather than for the agitational purposes of socialist documentary working.[17] It is significant that Mass Observation indicated the 'objective' approach of their investigators by describing them as 'the

cameras with which we are all trying to photograph contemporary life'.[18]

9. Edith Tudor Hart, *Photograph taken in the East End c 1932*. It was used for the National Unemployed Workers' Movement pamphlet with the caption: '*On her way to collect garbage after the market has closed.*'

Although only a relatively narrow strand of the Documentary movement of the thirties was committedly socialist or revolutionary in intention, the general effect of most documentary working was inevitably to make social comment and to demonstrate areas of social concern. It was pursued largely under the Fabian idea that those in power can be better persuaded of the need for social reform by the accumulation of facts rather than rhetoric. If the movement was opened by the publication of J. B. Priestley's *English Journey* in 1933 and continued with H. V. Morton's *Our Fellow Men* in 1936 — 'I have gone round the streets with an insurance agent and I have visited the back yards with a dustman' — or with AIA member, Pearl Binder's drawings and accounts of theatrical work in *Backstage*, it saw its most significant achievements in films like Cavalcanti's *Coal Face*, of 1936, Elton and Anstey's *Housing problems*, of 1935 or Anstey's *Enough to Eat*, 1936. Townsend in his journal note for November 26th, 1937, reflects this belief in the value of the objective document:

> I thought of a series of drawings, as objective as possible, simple so that everyone could see what they were about, in pure line; interiors, exteriors, people working and playing, and the ideas would come from them just as they do when you walk through the streets from poor to rich quarters and in and out of shops and houses.

This device of confrontational contrast as a means of rousing awareness and indignation, in connection with social inequity, was a frequently employed means of pictorial rhetoric, particularly in the photo-journalism of magazines such as *Picture Post* and *Lilliput*. April 1939's issue of *Lilliput*, for example, included a two-page item from Tudor Hart, one page showing a beauty parlour for dogs, above the caption, 'Should we have this?', and the other page showing a London slum scene, with the caption, 'Must we have this?'.

A curious hybrid of the documentary movement was the Mass Observation project itself.[19] This enterprise was founded in 1937 by the anthropologist Tom Harrisson and the poet and journalist, Charles Madge; its first intentions were to scientifically observe and record the behaviour and opinions of the (working class) majority of people which, it was thought, were often at variance with the dominant views of the press and radio. The first operations of Mass Observation focused on the Abdication controversy and on the Coronation of George VI and reports were published of both these studies. The research programme used two

methods of investigation: firstly by recruiting a team of voluntary observers to do the watching and eavesdropping and secondly by inviting representatives from the people under observation to document the everyday incidents of their lives by keeping a detailed diary. The main area for collecting this data was Bolton, to which Harrisson sought to give an 'everyman' gloss by christening it 'Worktown'. As it stands, this scheme can be seen as complying with the same objective, documentary interests which were reflected in the writing and film making of its time, but another element was interwoven within this scheme of sociological investigation which accounts for much of its quirkiness and for the brief flirtation with it by a number of poets and artists, including Graham Bell and William Coldstream.

This added element came from the involvement of members of the Surrealist group, in particular Humphrey Jennings and Julian Trevelyan, who had independently developed a fascination with popular superstitions and phobias, such as investigating how people had reacted to the apocalyptic image of the burning of the Crystal Palace and, seeing the confluence of their aims, they joined forces with Mass Observation. As well as becoming involved in the Bolton project, they set up another investigation programme in the slightly less culturally startling location of Blackheath. It was shortly after the Surrealist Debate in March 1938, in which Trevelyan and Jennings had taken part, that Bell and Coldstream spent three weeks painting in Bolton. The impulse for the idea followed from Harrisson's observations of how Bolton citizens used their local Art Gallery which directly led him to think about the problem of popular art from the other side of the coin — from the point of view of consumption.

Harrisson set up a project to determine whether 'Worktown' residents, untutored in and unexposed to contemporary painting, would react intelligently when confronted with examples of such work. Accordingly he invited Trevelyan, Coldstream and Bell and Michael Wickham to come up to Bolton and paint scenes of the town and photographs of the resulting pictures were shown to people in the street and their opinions and responses recorded. Harrisson's own rather dubious sensitivity to the niceties of art style — or perhaps it is just the result of his populist style of expression — can be gauged from his descriptions of their work:

> Two of these painters were of the school of realism often called Social Realist. The third was an Impressionist, vivid vigorous, Gauguin sort of stuff. The fourth was a leading exponent of the

83

Surrealist school, no attempt at realism but psychological complication.[20]

Figure 10

Coldstream's painting *Bolton* was painted from the roof of the City Art Gallery and Bell's *Thomasson Park* from the same vantage point. Bell also produced a sketchbook of ideas for a programmatic visual survey of the city's social life, with such scenes as middle-class houses, interior of a cotton mill, a wedding, a funeral and a Saturday night dance.[21]

Whether, on the evidence of the responses from those interviewed, Harrisson was justified in feeling he had demonstrated that 'ordinary folk are ready to be interested in even the most abstruse painting' is a matter of debate. Certainly Coldstream's painting was the least criticised but the lack of people in the streets of his picture, *Bolton*, was often objected to, especially since it did not match up with the evidence of the smoking chimneys. One respondent concluded that the scene must represent the two minute silence on Armistice Day. Incidentally, all the respondents thought the visiting southerners were obsessed with chimneys in their depictions.

10. Graham Bell,
Thomasson Park, Bolton,
1938.

Harrisson's conclusions took the form of an exhortation to painters to 'do something about painting stuff of public interest and get their paintings shown outside the West End'. But his interest was by the end of 1938 turning away from the hope of producing popular painting from professional painters and was turning far more to the promise of worker artists such as the members of the Ashington Group.

These five main strands of Socialist art practice were not the only contenders for the allegiance of young artists who wished to reflect the social realities of their time. What was almost universally accepted by the younger generation was the need to escape from the fustiness of Bloomsbury aestheticism. Many were attracted by both the work and the ideas associated with the Constructivist and the Surrealist movements. These movements were first coherently presented to a British public by *Unit 1*, with Constructivism and Surrealism presented together under the hopeful banner of 'the contemporary spirit'.[22]

The origins of Constructivism were closely integrated with the concept of social revolution from its early Soviet wing, and, through the neo-plasticism of Mondrian and the Elementarism of Van Doesberg and Moholy-Nagy, its vital dependance on internationalism was widely interpreted as corresponding to aspirations for the spread of International Socialism. Yet this tradition was rather muted in the programmes of *Unit 1* and the later *Circle* group, influenced as the English artists were by the relatively apolitical *Abstraction/Creation* circle. However, a kind of social responsiveness can be inferred from *Unit 1's* inclusion of architecture in its programme and the association of Paul Nash and Herbert Read with the promotion of modern design and the relationship between art and industrial production.[23]

Although *Unit 1* artists responded to the approach from the newly formed AI for its first and definitely propagandistic exhibition, *The Social Scene*, in 1934, it would be unwise to draw from this any evidence of political commitment on the part of the group as such, since the individual world view of members as varied as Henry Moore, Edward Burra and Tristram Hillier would be unlikely to cohere within a unified political position at this stage. It can be noted though that all the members of *Unit 1* at one time or another contributed to AIA shows. But the critical response to *Unit 1* indicates something of the ideological ambiguity in which 'the contemporary spirit' was received. Many reviewers saw in their work a disturbing symbol of 'un-British' robotic totalitarianism:

> . . . a Soviet-like flavour, savouring of mass production, the collective man and the like[24]

85

and another reviewer regretted:

this passion for commufascist nomenclature[25].

Unit 1's fragile alliance of interests did not survive more than a couple of years under the pressure of the diverging directions of its individual members; and the Surrealist tendency in British art was to organise itself as a vocal and active body, ready to argue for its own distinctive claims as the essential art of the day. But the Constructivists, whose authority was greatly enhanced by the presence in England of such figures of international standing as Mendelsohn, Gropius, Moholy-Nagy and Breuer as exiles from Nazism, regrouped to make a considerable impression with the exhibition *Constructive Art* at the London Gallery and an accompanying book *Circle*, edited by the architect, Leslie Martin in 1937.

The main ideological drift of the several contributors to the book was to integrate abstract and Constructivist art and International Modern architecture and design with the world view of contemporary science and technology, but again it was curiously silent about its directions in the social and political spheres, despite the inclusion of a section on 'art and life'. The nearest approach we have comes from the crystallographer J. D. Bernal:

> The artist no more than the scientist can occupy himself in permanent satisfaction with the contemplative and analytic sides of his work. Socially art is not complete unless it passes from the solution of problems to something of more immediate social utility.

Moholy-Nagy, who had formerly been convinced of the straightforward relationship between International Modernism and the interests of the proletariat[26] was by now advancing a more contorted argument:

> I am convinced that the sub-conscious can . . . absorb the revolutionary social ideas by means of congenial conceptions expressed in a specific medium. The non-political approach to art is thus transformed, by means of the subconscious into a weapon of an active attitude to reality, pressing for the solution of the urgent social and economic problems of today.[27]

But again reviewers resented what they read as totalitarian and anti-humanist characteristics of the *Circle*

group's work and Blunt, despite the support given to the movement by his fellow Marxist Bernal, could not approve it:

> but at the moment, it is not new aesthetic blood that is wanted, but a revitalisation of art by contact with life.[28]

Certainly it must be noted that despite this apolitical, or at least undisclosed political, position of the Constructivists, they were prepared to exhibit with the AIA under the banner of 'Artists against Fascism and War' in 1935 and, on a fuller scale, with a section to themselves, in 1937.

However, the most visible ideological conflicts within the AIA concerned the position of the Surrealists who established an English section in 1936. For as Percy Horton said:

> It was a damned cheek of André Breton and Co. to pose as Marxists[29].

There was to develop in Britain after 1936, something of a replay of the lengthy dispute that had earlier taken place in Paris when the Surrealists' claims to be dedicated to social revolution were regarded by the Communist Party either as dangerous Trotskyite revisionism or simply as having no credibility and being frankly embarrassing in political terms.

There was, amongst the artists themselves, probably far less divergence in respect of their political positions, indeed their mutual co-operation in AIA activities endorses this. But a number of critics and commentators was drawn to compare the claims to political effectiveness of the respective art styles of the Realists and the Surrealists. This polarisation of view was formalised into organised debate on at least a couple of occasions, in June 1936 at the Conway Hall on the occasion of the Surrealist Exhibition at the New Burlington Galleries and again in March 1938 at the Group Theatre rooms.

Despite Read's claim that Surrealism had within it the potential to stimulate revolutionary action, there was little stress on this aspect in the way that the movement was revealed to London's gallery-going public and the first, widely publicised presentation of the work of the movement in England in June 1936 attracted short shrift from the AIA. James Boswell published in July's *Left Review* an effective lampoon, collaging a quotation from the ubiquitous Herbert Read, in juxtaposition to a herd of corpulent, befurred representatives of the respectable bourgeoisie

Figure 11

87

who did not seem the least put out by the Surrealist exhibits. The quotation read:

> Do not judge this movement kindly. It is not just another amusing stunt. It is defiant, the desperate act of men too profoundly convinced of the rottenness of our civilisation to want to save a shred of its respectability.

11. James Boswell, *Surrealist Exhibition, London, 1936, Left Review, 1936.*

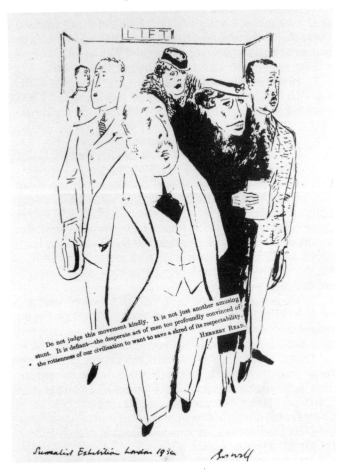

Read's answer to the apparent complaisance of this public would be that most people:

> went there to sneer, to snigger and to giggle and to indulge generally in those grimaces by which people betray the shallowness of their minds and the poverty of their spirit. If the success of this

exhibition is significant, it is merely significant of the decadence of our culture.[30]

This was his claim in his speech at the 1936 AIA debate on the occasion of the Surrealist Exhibition, and he goes on to defend the Marxist orthodoxy of the Surrealist movement:

I imagine that most of you who have come here tonight if not avowed Socialists or Communists, have at any rate revolutionary sympathies. It seems paradoxical therefore that I should be expected to speak in defence of revolutionary art . . . I speak for an art that is uncompromisingly aggressive. It is for others to explain why in this one domain of thought and feeling, we who are revolutionaries should respect the established order of things. . . . The culture of the whole capitalist epoch is poisoned with its own particular virus and no part of that culture is so rotten and ridiculous as that latter day convention of Realism . . . You do not reject the philosophy of Marx because it is impossible for every workman to understand the logical method of dialectical materialism. Why then should you reject a revolutionary art because, for the moment, it is difficult to understand?

But A. L. Lloyd spoke for the AIA members closer to the Communist Party when he rejected the political claims of Surrealism:

If Surrealism were revolutionary, it could be of use. But Surrealism is not revolutionary, because its lyricism is socially irresponsible. Surrealism is a particularly subtle form of fake revolution.[31]

On the occasion of the 1938 debate, the Surrealists' case was proposed by Roland Penrose, Julian Trevelyan and Humphrey Jennings and further force was given to their words by the unspeaking presence of paintings by Miro and Picasso — which Townsend felt was a little unfair.[32] The substance of their argument is not recorded, but only the manner of their presentation; the always fair-minded Townsend concedes the greater fluency and debating skills of the Surrealists at the expense of his Realist friends, and Read, reporting the event in the *London Bulletin*, allows

himself a little mischievous scorn for the Realists:

> We have tried to remember anything contributed
> to the debate by Graham Bell and William
> Coldstream . . . but there is only the stammer and
> the sweat . . . [the realists] are reduced to talking
> about the camera and Courbet. Actually our
> English Realists are not the tough guys they ought
> to be but the effete and bastard offspring of the
> Bloomsbury school of needlework.[33]

Randall Swingler for *Left Review*[34] was better able to
remember what the Realists said but he was by no means
uncritical in his partial support for them. It should be
noticed that it was Realism that was being defended rather
than the particular programme of the Euston Road group,
and Bell and Coldstream shared the table with Peter Peri
who, quite apart from the disadvantage of his halting
English, argued a case for Socialist Realism which the other
two would have been unable to accept without qualification.
Although Swingler contrasted their 'humility and honesty'
to the 'very vociferation, the pretentious flourish' of the
Surrealists, he was disheartened by what he felt to be their
overall lack of faith in the nature and value of the practice of
art, and in the kind of typical subject chosen by the Real-
ists, restricted as it was to representations of their own
friends and homes rather than looking outside their own
comfortable world.

These issues were brought to a head again with the
showing of *Guernica* in London in October, 1938, which
provoked a deal of discussion but little consensus. The
orthodox Socialist Realists were inevitably opposed to such
a violent departure from naturalism and although the value
of Picasso's Communist sympathies was to be officially
recognised by the party for a period after the war, at this
stage he had made no public statement of commitment to
the movement and the fashionable success of his work
could only have been viewed with suspicion by the Left.
Anthony Blunt wrote, in *The Spectator*, August 1937:

> The gesture is fine even useful in that it shows the
> adherence of a distinguished Spanish intellectual to
> the cause of his government. But the painting is
> disillusioning . . . it is not an act of public
> mourning but the expression of a private
> brainstorm which gives no evidence that Picasso
> has realised the political significance of Guernica.

The most common reaction even amongst pro-

fessional critics was confused; few could deny that they were in the presence of powerful and disturbing imagery but the levels of distortion and disruption of pictorial convention that Picasso was wielding often presented an impenetrable barrier to those who were little accustomed to developments of post-Cubist visual language.

Even for those who were more ready and willing to overcome the challenge of readability there remained the prolific problems of *Guernica's* symbolism; whether some kind of literal allegory should be looked for — if the bull is the Fascist then who is the Republican etc. — or whether it should be seen as a more general affirmation of horror in the line of Goya's 'Disasters of the War'.

Stephen Spender, writing in the *New Statesman and Nation*[35] is energetic in his riposte to André Gide's charge that *Guernica* failed because of its eccentricity. He has some interesting comment on the effects of the news media on the public awareness of the actual air raid, stating that the newspaper and newsreel reports were more terrifying than any individual's direct experience because now the totality of the offence could be comprehended, as viewed by 'the wide, cold reporting eye of the camera'. Spender suggests that the flatness and the flickering black, white and grey tonality of Picasso's painting recalls the imagery of the news photograph and the news-reel film.

He refers to one of the specific symbolic elements of the composition with an interpretation which reveals the growing acceptance of the doomed cause of the Republicans as well as indicating the romantic glow which typically coloured the perspective of British supporters of their cause.

> There is grandeur in the severed arm of the hero —
> clutching a noble broken sword with which he has
> tried to ward off the horrors of mechanical
> destruction.

The equivocal support of even the more aesthetically adventurous sections of Left opinion is indicated by the conclusion to a review in *Student Forum* by '3 Chelsea Art Students'[36] which expressed their desire to co-opt the inventiveness of Picasso's forms for closer service to the aims of social responsibility:

> But how long can the artist remain absorbed in his
> own special problems? — Picasso has been too long
> absorbed to emerge completely. His 'Guernica' is
> the last and greatest work of the bohemians. The
> great art of the future — the not too distant future

— will be the work of men who have learnt much of their craft from Picasso and his companions, but who will find a new inspiration and subject matter by living in close contact with the society to which they belong.

Despite Read's demand that the revolutionary intentions of the British Surrealists should be taken seriously there is not much evidence for this in terms of the work they produced except, to a degree in the work of Norman Dawson, *British Diplomacy,* of 1938, or Julian Trevelyan, whose collage, *Rubbish May Be Shot Here,* 1937, included fragmented photographs of the Royal Family, and Sam Haile who showed paintings at the AIA with titles like *Hitler must be overcome, Colonial Administrators* and *Mandated Territories,* though it must be said that the imagery is much less explicit than the titles.

But the view that predominated amongst the politically conscious intellectuals was that literature and the visual arts should shed all traces of élitism, which was held to be synonymous with aestheticism; that subject matter should be significant and should contribute to social awareness and ultimately to the advance of socialism; and that its form should be, appropriate to the subject, of minimal intrusiveness and complexity, and of maximum accessibility. This sounded like Realism, but it became clear even for artists within the Communist party, that Soviet-style Socialist Realism presented huge difficulties. Take Cliff Rowe's position, for example, in an interview with the author in 1979:

> I did not have a great sympathy for naturalistic art.
> The official line is that all art is propaganda. This is
> a simplification that can be valuable, but
> propaganda is not the function of painting, I could
> not take Russian painting.

It is of the nature of young artists to reject the manners and styles of their preceding generations; this has nothing to do with Modernism particularly, it has probably applied throughout the history of Western art. The call went out then, in the late 1930s, for a 'New Realism'. AIA members learned about the launch of this new term as used by Aragon and Léger[37] who also dismissed 'the old-fashioned vulgar naturalism of the nineteenth century'. They learned that Aragon had enthused over the documentary photograph and that Léger had pointed out the impudence of painters manufacturing a popular style of inferior quality when workers chose to decorate their dance

halls with the sculptural forms of aircraft propellers. But in Britain there was no-one of the stature of Léger who was able to reconcile the ideologies of modernism and social realism with such ease and authority; the main hope resided with the Euston Road school. They were of the right generation, had been through a period of experimental abstraction and were, to various degrees, politically engaged.

In 1934 a group of Slade students, substantially those who were later to be associated with the Euston Road School and including Victor Pasmore, Rodrigo Moynihan, Geoffrey Tibble, Tommy Carr and William Coldstream, were practising a style of free-form astract painting generally limited to monochromatic colour but exploiting impasto painterliness, for which they adopted the name 'Objective Abstraction'. 'Objective' apparently refers to the objective necessities of the painting as distinct from forms derived from subjective expression. Despite or perhaps because of the total originality of the resulting work, it failed to take off to the same extent as did the abstract work connected with *Unit 1*. Quite apart from the relative merits of the work, their inability to find a champion of the ilk of Herbert Read, or to relate to a prestigious continental avant-garde movement must have contributed somewhat to this failure to gain public recognition.

Graham Bell emerges by 1938 as the most politically engaged artist of the group, though his steps are often complex and equivocal. He is at one point engaging in Machiavellian plots to take over the AIA in the interests of the Euston Road group, calculating that the abstract and Surrealist schools will be finished within a year but conceding that the 'Doctrinaire (as they think) Marxists who wish the AIA to be merely a political force' might be a little harder to manipulate.[38] Next he is encountered in Townsend's company, taking part in a poster parade urging a boycott on Japanese goods, organised by the Arts Peace campaign along Oxford Street and Bond Street.[39] In January 1938 Bell writes an article for *Left Review* entitled, 'Escape from Escapism', in defence of the current work of the London Group. The escapism to which he refers includes, in fact, the previous Objective Abstraction of his Euston Road colleagues and of such artists as Ivon Hitchens, John Piper and Jessica Dismorr. Interestingly Bell makes the socio-stylistic link between the 'abstract' and 'escapist' work of around 1934 and 1935, and despair engendered by the economic slump. This mood is contrasted with the 'prosperity' and political consciousness of the period after 1936 which engendered a new confidence begetting 'an objective attitude' and a consequently greater interest in 'the things

Figure 12

depicted than in the manner of depiction'.

The article is illustrated with a picture by Robert Medley[40] called *Poor Family*. Certainly there is pathos in Medley's scenes of working class life and Bell ascribes a moral function to them:

> They might inspire a well meaning rentier to reach for his cheque book, or an undergraduate to take up social service

but he regrets the narrowness of contemporary Realist painting in Britain, the lack of the positive and complex features of humanity which he finds ideally presented by Courbet.

12. Robert Medley, *Poor Family, or, The Butcher's Shop, c 1937.*

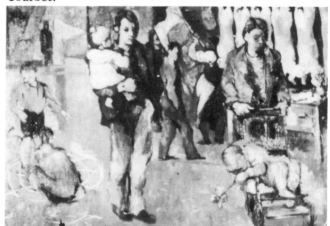

It is also to Bell that we must look for perhaps the only directly political picture to come from the Euston Road group and indeed one which caused his fellow exhibitors at the Storran Gallery in October 1938 considerable unease. Entitled *Red, White and Blue*, it was based on a press photograph of a demonstration in Whitehall in which a mounted policeman threatens to strike a woman protester with his raised arm. One of the policeman has distinctly taken on the facial features of Hitler — this among a show of otherwise placid London townscapes. The Daily Mirror tried, without success, to claim a copyright fee following the exhibition of the picture. Unfortunately, the painting was destroyed during the blitz. It was during this Storran Gallery Exhibition, that Bell, intent on popularising attendance, opened the gallery for a special Saturday afternoon showing for the benefit of all the Jones' in the London telephone directory, to whom he had sent a post card invitation. It is believed that no more than about half a dozen took up the invitation.

Bell's most considered ideas about the social position of the artist are to be found in his essay *The Artist and his*

Public, published by the Hogarth Press in 1939.

The experience of his Mass Observation visit to Bolton clearly still looms large over his impressions:

> Anyone who has travelled in working-class England, knows the horrible, deathly sensation of towns, caught between snobbism and starvation.

Indeed the general tone of his thesis is depressing; the blame for the decadence of contemporary art is attributed to the stupid and conceited middle-class patron; Bell sees it as simply another aspect of the general decadence of Capitalist Society and the degenerating effect it has wrought on institutions like the Church and the public schools, which had once had a proper and dignified role but which were now ruined by deceit and dishonesty. He claims that few artists had managed to resist this decline, though, in their different ways, Picasso, Rivera and Coldstream are the most significant figures for the future because of their attitudes to society, but reservations have to be made, even here. Picasso is held back by 'aesthetic hangers-on' and is deflected from finding a proper direction for his talents; Rivera affects a false naivety out of service to a didactic prejudice. Bell endorses, in a somewhat Ruskinian vein, the moral precept of art, and by implication, of realist art in particular. He connected artistic integrity with a defence of the ideals of 'freedom of choice' and 'social honesty', and contrasted it to immoral escapism through fast cars, hobbies and false freedoms which expose the true nature of Capitalism.

Thus under the menacing shadow of Munich, Bell, who had always up until now been eager to distinguish himself from what he saw as a restrictive Marxist political position, is ready nevertheless to attack Capitalist society for its universally degenerating effects and comes to the conclusion from his examination of the current relations between the artist and his public that:

> The rich hate art because it reminds them of their guilt.

Pointing to the effects of the 'doctored press' and 'narcotic cinema', he claims to show how the artist is obstructed from achieving popular patronage. He concludes that the remedy for this ever-widening distance from the public lies not with any educational initiative but 'by a basic remedy for society as a whole'.

Bell's friend and fellow Euston Road School colleague, William Coldstream, reacts directly to the chang-

95

ing, political stresses of the period and his reactions illuminate the shifting percention of which options were open to the socially conscious artist. He rejects the claims of Socialist Realism as too facile and for a time denies any future for painting as a popular medium; Townsend records:

> He now seems quite settled in the belief that popular artistic needs will be more and more satisfied by the Cinema and that an art of popular appeal, a didactic or elevating influence, calling of course on representation for its appeal, will be in sincerity impossible — the communist ideal of a mass appeal art of high quality arising from industrial and economic progress and enthusiasm being beside the point and naive, . . . The realist must see that painting has no new popular future before it of the old kind and now that film is established.[41]

Coldstream's faith in the benefits of film as a popular art form was based not on the commercial productions of Hollywood and Elstree, but on the work of the Documentary Film movement, which in the hands of film-makers like Grierson and Rotha (a fellow student of Coldstream at the Slade), was attracting a growing recognition. There was a strong sense of idealism and social purpose energising the movement which was entirely consistent with the general tendencies in painting and photography at this period but in contrast to these, film benefited from all the hopes and possibilities of a contemporary and technologically advancing medium which had an established apparatus through which the mass audience could be reached. Films like *Drifters* or *Industrial Britain* and *Coal Face*, were to fulfil much of the requirements of the socialist realist critic, in their celebration of the strengths and skills of the worker. Although the level of social comment in films of this type was necessarily curtailed by reliance on commercial or official finance, the social conscience of the film maker was generally indelibly apparent.

On occasions, it was also possible to bypass this restricting commercial patronage and with the help of voluntary skills and labour, more directly political films could be produced as in the case of *The Peace Film*.[42] In 1936 with the National Government still increasing its arms spending and with the commercial newsreels playing propaganda in support of the Government, a group of Documentary film makers conceived the idea of producing a short film reminding the audience of the potential horror of any future war and directly asking them to approach their MPs to put

more effort into making the 'collective security' principles of the League of Nations work as the sane alternative to rearmament. The film received a wide circulation, aided considerably by Press publicity following the apparent attempt by the Film censors to withhold a certificate for it.

Coldstream went to work as a film-cutter with Grierson and Cavalcanti for the GPO Film Unit where he was involved in such celebrated productions as *Night Mail* for which Auden and Britten were specially commissioned. In 1936 he was a member of Associated Realist Film Producers, an independent body of directors willing to be engaged on documentary and publicity film production. He does not seem to have been engaged in any directing of any significance on his own behalf, and within a year or two his interest in painting was reviving, though he was not unaware of the conflicts this involved:

> The slump had made me aware of social problems and I became convinced that art ought to be directed towards a wider public. Whereas all ideas which I had learned to be artistically revolutionary run in the opposite direction. Public art must mean Realism.[43]

But Coldstream's own practice did not in fact chime in with this principle. Even in 1938, when this statement was made, he was not painting in any way that could be called public and he seems to have settled down with a sense of resignation, to that approach which has proved to be his continued preoccupation since, of tackling with infinite care and concentration the essential problems of painting as representation. His typical subjects at this time were townscapes or landscapes in which detail (and that includes any people inhabiting these scenes) is subsumed by the greater interests of tonal harmony and compositional design, suspended in a tense balance with the demands of a representational honesty. There was a sense of the need to make a humble 'return to nature' in reaction to some of the excesses of the modern movement. This has proved a compellingly persuasive idea throughout the fifty years of English painting that have followed but its puritan resistance to romanticism, either lyric or heroic, its objective distance, and its avoidance, except for the stock conventions of the nude or the portrait, of the human presence could give little comfort to those who hoped for a more socially progressive form of realism stemming from this source.

We are sharply reminded of this inherent failure of Euston Road Realism as political art, by Orwell's observation of 1937 in *The Road to Wigan Pier*:

A belching chimney or a stinking slum is repulsive chiefly because it implies warped lives and ailing children. Look at it from a purely aesthetic standpoint and it may have a certain macabre appeal.

Notes

1. Eric Gill, *Collected Letters*, London, 1960, letters to Herbert Read, August 1934.

2. This research was published in 1935 as *The Conditions of Clerical Labour in Britain since 1918*, in which he discussed the ambiguities of the class identity of this group. He foresees the inevitable alliance of 'the advanced section of the middle strata' with the working class, in bringing about social revolution. He would have readily identified AIA members as belonging to that advanced section. This point is further developed in L. Morris and R. Radford, op. cit., p. 24-5.

3. G. V. Plekhanov, 1856 — 1918, published *Art and Social Life* in 1912.

4. L. Morris, *Realism: The Thirties Argument*, Art Monthly 35, 36, 1980, for a survey of Blunt's art reviews for *The Spectator* during 1936-8.

5. L. Morris and R. Radford, op. cit., pp. 23, 24.

6. C. Vaughan James, *Soviet Socialist Realism: Origins and Theory*, London 1974, passim.

7. Recent exhibition catalogues: *Peri's People*, Minories, Colchester 1970, introduction by Anthony Blunt; *Laszlo Peri Werke 1920 — 1924*, Kölnischer Kunstverein, 1973; *Laszlo Peri 1899 — 1967*, Neue Gesellshaft für Bildende Kunst, Berlin 1982.

8. F. D. Klingender, 'Abstraction and Realism', *Left Review*, June 1936.

9. Collected in *The Mind in Chains*, C. Day Lewis (Ed) 1937.

10. The picture records the arrest of the dockers' leaders, Dickens and Timothy, by officers of the Special Branch, under war-time emergency regulations known as 'section 18b' to restrain potentially subversive activities and normally only applied to Fascist sympathisers. The

picture was bought by the London District of the Communist Party and was to be hung at the Royal Academy Summer Show, but was subsequently removed because of its political explicitness. See Chap. 7.

11. But since resited at the Museum of Labour History, Limehouse Town Hall, London. It represents scenes of the Tolpuddle Martyrs, the General Strike and Electricians at work.

12. Jack Hastings (the 15th Earl of Huntingdon) 1901 —, taught at Camberwell and Central Schools of Art, and was a member of the Art Workers' Guild and the AIA.

13. *Daily Mirror*, October 10th, 1935; photograph and report under the headline 'Earl's Heir paints mural for Workers' College'.

14. As quoted in 'English Revolutionary Graphic Art', Alfred Durus, *International Literature*, 1936, pp. 109, 110.

15. J. Trevelyan, *Indigo Days*, 1957.

16. E. Tudor Hart, notes for an article on 'Photography as a Profession', quoted at further length in R. Radford, 'Edith Tudor Hart, photographs from the 30s', *Camerawork*, July 1980, pp. 1-4. See also E. Tudor Hart, 'More Freedom for the Photo-Reporters', *Photography*, February 1934.

17. Spender's photographs appear under the headline 'The Men Baldwin would not see' in *Left Review*, December, 1936. A selection of his Mass Observation photographs appears in *Worktown*, Brighton, 1977 and *Worktown People*, Bristol 1982.

18. Spender in *The Thirties and After: documentary photographs by Humphrey Spender*, exhibition catalogue, Arnolfini, Bristol, 1981.

19. See *Mass Observation: The First Year's Work*, eds Madge and Harrisson, 1938. A journal *Us* was also published for distribution to project workers. The Mass Observation Archive is presently maintained by Sussex University.

20. Tom Harrisson, 'What They Think in Worktown', *The Listener*, 25 August 1938.

21. See *Camerawork* no 11, September 1978, for sundry articles about Mass Observation and particularly the photography of Humphrey Spender. A photograph by Spender is reproduced showing Bell and the photographer on the art gallery roof. The catalogue for

Worktown, Gardner Centre, Sussex University, 1977, contains a useful descriptive chronology of the involvement of artists and photographers in the Mass Observation schemes.

22. Unit 1 was founded in 1933 and had a major exhibition at the Mayor Gallery which subsequently toured a number of provincial galleries. A *Unit 1* book was produced with an introduction by Herbert Read. Its exhibiting members were John Armstrong, John Bigge, Edward Burra, Wells Coates, Barbara Hepworth, Tristram Hillier, Colin Lucas, Ben Nicholson, Paul Nash and Edward Wadsworth.

23. See for example, H. Read, *Art and Industry,* London, 1934; P. Nash, 'Modern English Furnishing', *Architectural Review,* January, 1930; P. Nash, 'Surrealism in Interior Decoration', *Decoration,* January, 1936.

24. Revi ew of Unit 1, *The Scotsman* October 28th, 1933, quoted by C. Harrison in *Unit 1* exhibition catalogue, Portsmouth, 1978.

25. Review *New Statesman,* November 4th, 1933, p. 551, quoted by D. Mellor in F. Gloversmith (Ed) *Class, Culture and Social Change,* Sussex, 1980.

26. L. Moholy-Nagy, 'Constructivism and the Proletariat', *MA*, May 1922, anthologised in T. Benton, C. Benton and D. Sharp, *Form and Function,* London, 1975.

27. L. Moholy-Nagy, 'Subject Without Art', *The Studio,* 1936; quoted by J. Gage, in *Circle* exhibition catalogue, Cambridge, 1982.

28. A. Blunt, 'Specialists', *The Spectator,* October 22nd, 1937, quoted in *Circle* exhibition catalogue, Cambridge, 1982.

29. As recorded in M. Binyon, *Eric Ravilious, Memoir of an Artist,* London, 1983.

30. H. Read, Account of the Conway Hall debate, *International Surrealist Bulletin,* no 4, 1936.

31. A. L. Lloyd, *Left Review,* July, 1936.

32. *Townsend Journals* (published), entry for March 16th, 1938.

33. H. Read, *The London Bulletin,* April 1938.

34. R. Swingler, 'What is the Artist's Job?', *Left Review,* April 1938.

35. S. Spender, *New Statesman and Nation*, October 16th, 1938.

36. *Student Forum*, November 9th, 1938. The three students are identified as Haslam, Reiss and (Pat) Carpenter.

37. Report by A. L. Lloyd, 'People's Front Heralds New Realism', *Artists' News-sheet*, November, 1936.

38. *Townsend Journals*, (unpublished) entry for January 13th, 1938.

39. *Townsend Journals*, (unpublished) entry for February 2nd, 1939. There is a photograph showing Stephen Spender on the same occasion reproduced in J. Symons' *The Thirties, A Dream Revolved*, London, 1956.

40. Medley was closely associated with Auden, Isherwood and Rupert Doone in the productions of the Group Theatre as costume, lighting and stage designer. In 1936, 'the artist spent some time in Wales staying with miners and discussing Marx', according to the biographical note by John Berger to the catalogue for the Medley retrospective exhibition at the Whitechapel Gallery, 1963. See also R. Medley, *Drawn from Life*, 1983.

41. *Townsend Journals*, (published) entry for August, 1934.

42. P. Rotha, *Documentary Diary*, 1973, pp. 164-170.

43. W. Coldstream, in *Art in England*, R. S. Lambert, (Ed), London, 1938.

THE TIGHTENING SCREW 1938-39

In the later part of the 1930s, the membership of the AIA expanded and its character changed, from serving a small group of like-minded young artists and designers, generally acquainted through common links of generation and art-school loyalty and living within easy reach of central London, to representing the interests of a much more geographically, occupationally and socially diversified body of people including art teachers, students and non-professional supporters. The importance of regular and organised communication became clearer to keep pace with this expansion.

The original Artists International published a regular *Bulletin* from its inception (but extant copies of these issues are rare). This continued as the *Artists' International Association Bulletin* which changed its name and format to an *Artists' News-Sheet* in November 1936 but its publication was sporadic for the next few months although frequent space was allotted in *Left Review* to give notice of events, in compensation for this. Now restyled the *AIA Bulletin*, it appears more regularly during 1939, supplemented by special emergency issues as the declaration of war is approached. Publication continued through the war at intervals of about every six weeks; from 1947 right up to 1964, it appears under the title of *AIA Newsletter*. There were, throughout the span of these periodicals, many changes in format, tone and amount of content, depending on paper supply, cost of print, change of policy and change

of editorial and design personnel, for in a body containing a high proportion of graphic designers, it was a specific policy to circulate design responsibility among its members.

But in addition to keeping members informed on the day to day matters of committee discussion, dates of political meetings and demonstrations, social functions and exhibition details, the opportunity to introduce new ideas and to canvass members' opinion and encourage discussion and local action was always taken up.

For example, in the *Artists' News-Sheet* for September 1938, Richard Carline reports back from his visit to America where he had been making contact with the AIA's sister organisations. Predictably, the example of the WPA schemes of government finance for public art projects, the work of the Artists' Congress and the Artists' Union, as well as the widespread evolvement of a style of Social Realist mural art would all be of great interest to AIA members. Carline, who had been responsible for a number of previous contacts with anti-Fascist artists groups in Holland and France, was to prove one of the AIA's ablest and most energetic executives for the next few years, always on the central committee and putting in a great amount of effort on schemes such as co-ordinating regional groups and organising a public murals conference despite the constraints of war-time communication. He was on the point of arranging an exhibition for the Tate Gallery of work resulting from the WPA schemes but this was frustrated by the outbreak of war with the risks involved in shipping the work. A usefully illustrated article for *The Studio* is the only tangible residue of this proposal.

Carline was inspired from the start of his long association with the AIA by the idea of the world-wide flourishing of the arts. He had written *The Arts of West Africa* in 1934 and was ultimately to pursue these inclinations in his later career. In 1945 he was asked to join Stephen Spender and Julian Huxley with the preparatory commission for UNESCO. He wanted to organise a full scale international exhibition of what artists had been doing during the war to overcome their isolation from each other during that period and to encourage a real exchange of understanding about art — an international brotherhood of artists. He claims these ideas were quashed because the influence of the British contingent was gradually squeezed out by the American personnel who suspected the British of being too Left Wing.[1] However he was to serve for a number of years as chairman of the Painting Committee of the International Association of Art, the co-ordinating council for international artistic co-operation within UNESCO.

Perhaps the principal aspect of international co-

operation in which the AIA became involved was the reception of, and assistance given to, artist refugees from Fascism in Spain, Czechoslovakia and Germany. The first exiles had arrived from Germany as early as 1933 and continued to arrive through the following years, but the Munich crisis, which led to a great build up of this flow of refugees, constituted another barb to the political conscience of artists in Britain and the dissatisfaction they felt with the home government's policy towards Germany.

A sense of identity with the artist in Germany was fostered by the exhibition of *German Twentieth Century Art* held at the New Burlington Gallery in July, 1938. It came about as a response to the Munich exhibition of *Degenerate Art* of the previous year and the London show apparently caused Hitler great offence; he let it be known that if any 'modern' artists had not yet left Germany, they should do so now.[2] The show was largely arranged by the Swiss Irmgard Burchard with the help and support of a number of AIA members. A handbill announcing the exhibition links the issue of cultural suppression in Germany with the Loyalists' resistance in Spain:

> Why does Hitler expel artists?
> Because Fascism is afraid of those who think, of those who see the truth, of those who speak the truth
> Why does the Spanish Government attract Spain's greatest artists to the cause of the people?
> Because Democracy is not afraid of truth.
> Uphold the Right to say the truth.

A Penguin book *Modern German Art* by P. Thoene (pseudonym for Otto Bihatji-Marin) was published to accompany the show. An impressive compendium of work of the modern movement in Germany was brought together covering the Impressionist and Realist schools as well as Expressionism — Corinth, Kirchner, Modersohn-Becker, Beckmann, Kandinsky, Ernst — and much more besides. Kokoschka sent a self-portrait, entitled *Portrait of a 'degenerate artist'* and also another work, which he claimed had been slashed into four sections by Austrian customs officials, and which was accordingly exhibited in that condition. The artists were not directly approached themselves, for to do so would have provoked official reprisal, but the exhibits were culled from private collections, quite a lot coming from Paris. It must be emphasised that much of what was shown here of German Expressionism was completely unknown in Britain, where taste was so dominated by Paris, and this applies with equal force to artists and

public alike, so, whilst the more discriminating and adventurous visitors were alive to the quality of the work, there were also many dissenting voices, who even went so far as to say that maybe Hitler was not amiss in his condemnation.[3]

Profits from the exhibition were to go to refugee relief, and mention was made in the campaign literature of a number of artists who had already taken refuge in London from the Nazis, which included Erna Auerbach, Martin Bloch, Georg Ehrlich, Hans Feibusch, Tisa Hess, Fritz Kraemer and Fred Uhlman. Soon these numbers were going to include artists who today attract an international recognition like Heartfield, Schwitters, Meidner and Kokoschka but who received no official recognition or encouragement in Britain. Indeed, following the intensification of war-time security measures these artists often had to suffer the indignity and hardship of internment camps in such places as the Isle of Man or as far away as Canada.

The artists were quick off the ground in reacting to the need to give assistance to threatened artists in Germany, Austria and then Czechoslovakia, and their example created the precedent for a comparable programme by writers and musicians.

The particular spur to setting up an Artists Refugee Committee to co-ordinate relief efforts was an appeal for help from the brother of Karel Capek, sent to Margaret Gardiner, calling attention to a group of German artists calling themselves the Kokoschkabund who had escaped to Czechoslovakia only to find themselves once more in imminent danger of the concentration camp. Roland Penrose contacted a number of influential British artists and representatives of the major art societies to alert them to the plight of the refugees. Soon a committee was formed which was largely made up of AIA members, and Sir Muirhead and Stephen Bone, Betty Rae, Diana Uhlman, Paul Drury and Richard Carline were all prominent in its operations. A lot of work was involved, for not only did the cause have to be promoted to raise funds in the first place, but host families and jobs had to be provided before an entry visa was issued and in practice this often meant that the refugee artist had to be financially maintained by their hosts for the next five years and so by the beginning of 1939 many homes of artists and their friends in Hampstead (where most of the Committee members lived) would have had 'their refugee'.[4]

A further sub-committee was formed to give assistance to Spanish Refugee artists. A few of these, such as the writer and the teacher of Miro, Francisco Gali, came to London, but most only got as far as camps in Southern

France where conditions were inhospitable, so appeals were made for funds to send a number of them to Mexico but in the meantime artists were asked to send on materials to the refugees in the camps.

Although the British art world was on the whole generous in its welcome for these refugee artists, there were exceptions to this and anxieties were expressed in *The Artist*, about the danger that immigrant artists might somehow spoil the English trade by 'dumping' works of art.[5] *The Artist* was a journal which often exhaled rather blimpish opinions on art and politics which matched its conservatism in matters of painting style.

The newcomers however were typically intelligent and enterprising people and often made great efforts to contribute their diverse talents to their host society, and it is undeniable that they did much to enrich London's artistic life wherever they had access to it, although there was much cause of frustration in that refugees who were doctors, lawyers, academics and artists were rarely given permission to pursue their professions and in practice were confined to only lowly paid menial work. Meidner, for example, was employed as night watchman at a cemetery. Many of them got together to form the Free German League of Culture, the *Kulturbund* in the autumn of 1938, to mount exhibitions and to act in other ways as a focus for mutual support and identity. A house was made available to them in Hampstead by Dr Bell, the Bishop of Chichester, which was converted into the 'Bund's' clubhouse, with a library, a cellar bar and even a small theatre. There were sections for musicians, writers, social workers, scientists, actors and groups for the immigrants' children. It provided not just a social centre but a focus for political discussion. An anti-Nazi monthly journal *Freie Deutsche Kultur* was published.[6]

There was much concern expressed in the first year of the war at the conditions of these artists and intellectuals who, being classified as enemy aliens, had been sent off to internment camps; there was indeed an expression of indignation that these, demonstrably anti-Fascist refugees should ever have been detained there in the first place. The AIA was applying as much pressure as it could through the Central Institute for Art and Design (CIAD) and other government agencies to review the internment regulations as a matter of urgency, as well as appealing for artists' materials and letters to be sent from members. Negotiations with the American Artists' Congress resulted in promises of help and work enabling thirty internee artists to be released and dispatched to the United States.

The AIA's next major exhibition was held from

February to March 1939, at the Whitechapel Gallery, as a demonstration of Unity of artists for Peace, Democracy and Cultural Development, attracting some 40,000 visitors and showing some 300 works. The coverage of style and subject was as catholic as ever, and the more established exhibitors included Duncan Grant, Ben Nicholson, Vanessa Bell, John Nash, William Coldstream, Julian Trevelyan, Frank Dobson and Henry Moore. All were showing work in their characteristic manner with the interesting exception of the Euston Road Group or more specifically Bell, Moynihan, Gowing and Pasmore in company with Carel Weight and probably Duncan Grant, who each took the motif of one of Goya's *Disaster of the War* etchings and transcribed them into oil paintings.

The emphasis of the show, reinforced from the start in its choice of location in London's East End, was the need to recoup a popular audience for the artist for, to quote from the catalogue introduction:

> In the last fifty years, artists, particularly those who paint pictures or do sculpture, have, through no fault of their own, become isolated from the greater part of society which supports them. Only a small proportion of the public can afford the price of admission to the Academy and other big shows. But what is still worse from the artists' point of view is that the man in the street seems to have lost the curiosity which might once have made him want to go in. . . . Artists believe they could still be useful. They are trying to find out how.

This wish to dissociate art shows from the social mystique which was inevitably attached to the exhibitions of the established art societies and the West End dealers was demonstrated by such measures as the random selection of a passer-by to open the show instead of the customary prestige figure, and by holding a popularity poll of works exhibited. This poll was in fact topped by Coldstream's portrait of Inez Spender followed by landscapes from John Nash and Stephen Bone and a portrait by Augustus John.

It was also well realised within the AIA that opportunities to see contemporary art, either 'modern masters' or current British art, were very limited for all those living outside London, for even the large provincial galleries rarely showed modern work. To try to remedy this obvious lack, the AIA set about organising travelling exhibitions. In this intance they were following a lead established by the

Art for the People scheme of the Institute of Adult Education, which since 1935 had been organising touring shows visiting both rural and urban communities which often had no public art collection of any kind. The quality of these *Art for the People* tours sounds enticingly high, with Turners, Constables, Impressionist and Post-Impressionist works loaned from private collections such as that of Kenneth Clark. The shows would be hung in libraries and village halls and serviced by WEA lectures.

The complexion of the AIA tours, whilst sharing the same general intention, was somewhat different. The AIA disliked the philanthropic tenor of the *Art for the People* scheme as well as its avoidance of current work and so, with work largely selected from the Whitechapel exhibition, the AIA embarked on a tour of places like Southport, York, Bradford, Hanley, Kidderminster and Carlisle with a show that included abstract and surrealist work. This proved to be very popular, with over 32,000 visitors coming to the Bradford venue alone and the tour continued until Autumn 1940 before it was terminated by war time travel restrictions.

A further touring show, concentrating on graphic art, called *Britain Today* was also launched by the AIA in 1939. This type of work was chosen, partly for its travelling convenience, but more importantly because, being the chosen medium of many artists who wanted to depict scenes of contemporary life and social comment, graphic work was considered to command a more popular appeal than the medium of painting. So, in addition to the familiar satirical work of Boswell and Holland we find Pearl Binder's depictions of miners, and Hubert Cook's scenes of the Swindon railway works, where he worked, included in a collection which toured sites such as the Toynbee Hall which were likely to attract a working-class audience.

In the two years leading up to the declaration of war, the sense of living on the edge of the volcano was ever more impending, and artists together with their fellow cultural workers, writers, musicians and actors, were increasingly impelled to express their outrage at the Government's apparent failure either to improve social conditions at home or to attempt any other strategy than appeasement in answer to the threat of Fascism. Political demonstrations increased in urgency and level of popular support during the summer of 1938 and the following year and artists, who would only a year before have felt shy of stepping in with a column of marchers, were now not only doing this, but were lending their hands and imaginations to items of 'agit-prop' which accompanied the demonstrations.

The adoption of a written constitution for the first

time in October 1938 formally defined the terms under which the AIA should involve itself in political action. Clause (F) of their objectives reads:

> To take part in political activity, to organise or collaborate in any meeting or demonstration in sympathy with the aims of the association where action seems desirable or justifiable.

In March 1938 artists are present at a march to the Spanish embassy organised by the combined youth wings of the Labour, Liberal and Communist parties, calling for arms to be sent to Spain and the abandonment of the notorious non-intervention policy. This was to be a pre-run for the first of two especially colourful May Day rallies in which the AIA took part. Townsend was there on May Day 1938

13. AIA Contingent, *May Day Parade, London, 1938.*

and has left us a vivid impression not only of the particular excitement of the day and the impressive effect of its massed banners but of the more general enthusiasm for this tangible evidence of Popular Front unity. This show of popular solidarity, no matter how illusory it might have turned out to be, would have been all the more stimulating against the predominant pall of pessimism and frustration which overcast a Britain seeing itself on the inevitable slide into war.

Figure 13

109

Soon after I got there the contingent from the East End began to march in with a great showing of red flags and Communist Party banners . . . all the opposition parties were marching together, Trade Unions, Labour and Communist parties, a crowd of Christian Socialists with portraits of F. D. Maurice and others above them, Co-op guilds — in fact the whole united front with many memorial banners to comrades lost in Spain. Gradually the other groups collected round their banners on the embankment; groups of teachers, of scientists, Left Book Club members, Chinamen and Indians, in fact every possible section of the Left movement in every possible dissection and association was there.[7]

The artists made up a group of about two hundred marchers and prominent amongst them was a band of 'Neville Chamberlains', equipped with top hats, walking canes and face masks (modelled by F. E. McWilliam), who from time to time bestowed on the watching crowd a Nazi salute. These figures were paraded by Roland Penrose, Julian Trevelyan, James Cant and F. E. McWilliam and the Surrealists augmented their effects even further with a giant gilt bird cage, inhabited by a whitened skeleton and mounted on a loud speaker van blazing out the 'Internationale' and Spanish republican songs. This was followed up by another contribution by the Surrealists, though perhaps rather less coherent in its political symbolism — a large, white horse's head stuffed with coloured balloons surmounted on an ice-cream tricycle.[8] Townsend leaves us a visual record of the occasion as well in his wood engraving, *London Marchers* reproduced in the *Journals*.

The Surrealists had shown a modest appearance already at the May Day demonstrations for 1937 under a banner which succeeded in raising the general level of literary reference with its inscribed quotation from Blake, 'a warlike state cannot create'. While making preparations for a Spanish aid meeting in Trafalgar Square it was discovered that the Office of Works did not allow the exhibition of art works in the street and even at demonstrations it would only permit banners; so AIA members negotiated this difficulty by taking along some blank banners, and while the meeting was in progress, they applied sketches of the event directly to the banners, and this collective impression was then exhibited behind the speakers and a collection taken.

In September 1938, in the wake of Chamberlain's Munich agreement, Picasso's *Guernica* was brought over by Roland Penrose and exhibited, together with some forty

preparatory sketches and allied works at the New
Burlington Galleries as part of the campaign of fund raising
and political pressure in support of Republican Spain.[9] As it
happened, the adjoining salon of the same Gallery had been
hired by Francoite interests to display an academic render-
ing of *The Defence of the Alcazar Toledo* by the painter
Zuloaga, which move was of course totally trumped by
Guernica. The mural was subsequently transferred to the
more politically radical ambiance of the Whitechapel Art
Gallery where the exhibition was opened by Clement Atlee,
the Labour Party leader. It was given two further showings
in Leeds and Liverpool before shipment to New York.

It gave the chance to many Londoners who had not
seen this vast, $11' \times 26'$, mural in situ in Paris the year
before, to draw some conclusions about the applicability of
advanced painting style to propagandist art.

The question of support for Republican Spain
remained a priority and in February 1939 a group of ninety
or so AIA members were to be seen painting directly on to
advertising hoardings, giant illustrated slogans calling for
support for the campaign to send food to Spain. This device
provoked a good deal of attention in the Press, notably the
Picture Post and so redoubled the effectiveness of the publi-
city. In the same month, at an 'Arms for Spain' demonstra-
tion in Trafalgar Square, the speeches from Haldane and
Tom Mann were set against a backdrop of banners on which
motifs from Goya's *Disasters of the War* were displayed. The
banners had been made up by Graham Bell, Moynihan,
Gowing, Pasmore and others of their circle and were
obviously connected with the more finished paintings from
the same source which were on show at the same time at
the AIA's Whitechapel exhibition. The use of this imagery
— a graphic condemnation of the universal evils of warfare
— in the context of an 'Arms for Spain' campaign, appears
on the face of things somewhat perverse, and according to
Pasmore[10] it was the intention of the painters that the ban-
ners were to be used for anti-war propaganda and not for an
occasion of this sort. These banners had an interesting
sequel when, in the early months of the War, a Local
Defence Volunteer Brigade, under the leadership of a
retired colonel, broke into Moynihan's home in the depths
of rural Essex and carried off the banners determining them
to be subversive and ample proof of espionage activity; they
have never reappeared since.[11]

A training course in the practice of propaganda design
was started up by the AIA in preparation for the 1939 May
Day Rally, and attracted the following of a number of trade
union and Labour Party groups.

This increasing involvement of the Association in

direct political demonstration was aided by the now more regular issues of the *News-Sheet* and this, the published voice of the AIA, charts something of the twists and turns of policy that Left opinion had to adopt as the eruption of a full-scale war appeared daily more inevitable. In April's issue, members were exhorted to make the forthcoming May Day events as memorable as the preceding occasions, and were spurred on to action with such reminders as, 'The advance guard of Fascism is Chamberlainism' and that 'It is the task of every member to do everything possible to assist the development of an alternative government.'

In May 1939, scepticism was voiced in the editorial comment on the question of conscription; it was suggested that the very need for conscription indicated a lack of enthusiasm and support for the War generally in the country, and also that the Government had signally failed to clarify what we would really be fighting for. On the other hand, the view was also put forward that, given the 'anti-democratic' tendencies within the services, there was perhaps more sense in members working to correct this from within rather than from outside the forces. Following the actual declaration of war, the AIA brought out three successive emergency bulletins to advise members on how they were affected during the first, confusing weeks under the new conditions. In the first bulletin dated September 9th, it is recorded with some satisfaction that following a week of hostilities, there was little 'jingoism, false heroics or bravado' at large, and members were recalled to the fact that the fight was against Fascism as such and not against the 'misinformed, duped German people'. It was acknowledged that the majority of the membership would be prepared to enter such a war against Fascism but conscientious objectors were at the same time assured of the understanding and respect for their views from the AIA. The qualification in this statement, which warned of the misrepresentation incurred by identifying all Germans as Fascists, reflects the view, frequently expressed on the Left at the start of hostilities, that the War was simply being waged to serve the interests of Capitalism and Imperialism, and that the Popular Front should devise a plan which offered Federal Union and Peace to the people of Germany who could then be persuaded to reject the belligerent policies of their Nazi governors.

Meanwhile, Britain's Communists together with those broader bands of the Left who would not have been too put out to have been called 'fellow-travellers' were to undergo a series of severe tests to the fibre of their faith in the correctness of Russia's policy towards Europe. Following the necessity of coming to terms with the Russo-German non-aggression pact, they now had to come to an

understanding of the situation in Poland, when Soviet forces either 'invaded the country' or 'crossed the Danzig corridor to protect Leningrad', depending on their reading of the events. The British Communist Party policy by October, 1939 was one of non co-operation with the war effort, on the basis of the argument that since Britain had refused to assist Russia in the defence of Poland it had demonstrated that it was not in reality engaged in a war against Fascism.

An even more grinding crisis of conscience was enforced on many when in February 1940, Soviet troops moved into Finland, without benefit of referendum, to protect that country's sovereignty. Philip Toynbee voiced the disconsolation of many Communist sympathisers in his consequent explanation to the *New Statesman and Nation* readers as to 'Why I left the Communist Party'. The AIA central committee was unable to express a definite opinion with regard to this issue explaining that they had received sixteen letters from members deploring Russia's action and fifteen letters seeking to justify it.[12]

The apparently equivocal attitude revealed in the emergency bulletins did not pass without protest from a number of members:

> When is the Central Committee going to be honest and admit that its support for Stalin and the present Communist Party was a mistake and a very tiring one for some of its members.[13]

The editor replied to this correspondent and defended the Central Committee's support for the foreign policy of the Soviet Union on the grounds that it gave every appearance of being a genuine peace policy.

In January 1940, the chairperson of the Central Committee, Misha Black, had to apply all his well-attested, diplomatic skills and powers of persuasion when he warns against the serious danger of the whole body foundering on these rocks of political division. Black felt the need to state his personal regret at some of the statements published in the emergency bulletins, and pointed out that, since there was no consensus of opinion on war policy and on attitudes to the Soviet Union amongst the membership, the Central Committee must refrain from issuing any such official statements. He enumerated five positions which could be argued for by different sections of the membership: 1) to call for immediate armistice without condition, 2) for armistice with a guarantee of sovereignty for Czechoslovakia and Poland, 3) opposition to any involvement by artists in a war of Imperialism, 4) opposition to war on the

basis of pacifist principles and 5) the determination to pursue the war to its natural conclusion.

Black foreshadows the eventual direction of the AIA's war-time policies in his suggestion that the real job of the Association now was the two-fold necessity of 'stopping artists starving' and of 'preserving our culture intact'.

Notes

1. Richard Carline, interview with the author April 6th, 1979.

2. A handbill advertising the exhibition cites the following press reports of Hitler's reaction:

 Herr Hitler complained of the impertinence of a London exhibition of pre-Nazi, German artists, which he likened to the staging of the opposition Reichstag Fire Trial.

 News Chronicle, July 11th, 1938.

 Modern Art had no place in National Socialist Germany. He intimated that modern artists who had not yet left Germany should do so now.

 Scotsman, July 11th, 1938.

3. Fred Uhlman recalls in 'A Personal Memoir', *Hampstead in the Thirties*, Exhibition catalogue, Camden Arts Centre 1974, p. 29:

 One of the critics said to me 'I paid 2/6 for seeing the exhibition, I would willingly pay 5/- for not seeing it'. Another told me 'I hate Nazis but one can't deny that Hitler was right calling them degenerate'.

4. Diana Uhlman, *Hampstead in the Thirties*, catalogue of exhibition at the Camden Arts Centre, 1974, pp. 30-1.

5. Editorial, *The Artist*, November 1938.

6. A vivid description of the activities of the Free German League of Culture is given by Gertrud Heartfield, 'Im englischen Exil' in E. Siepmann, *Montage John Heartfield*, Berlin 1977, pp. 222-7. See also *Kunst im Exil in Grossbritannien*, Berlin 1986.

7. *Townsend Journals* (published) entry for May 1st, 1938.

8. Julian Trevelyan, op. cit. p. 79.

9. R. Penrose, *Scrapbook*, London 1981, p. 87.

10. Victor Pasmore, letter to the author, February 1980.

11. L. Gowing, Introduction to the exhibition catalogue,
 Rodrigo Moynihan, Royal Academy, London 1978, p. 11.

12. The Central Committee of the AIA did respond to the
 Finland question however by calling a public meeting
 at the Conway Hall which heard the matter debated by
 MPs D. N. Pritt and Sydney Silverman and chaired by
 Will Robert.

13. Letter from Stella Snead, quoted in Emergency Bulletin
 no 3, 1939.

THE WARTIME YEARS 1940-45

It became clear that the whole direction of AIA activity would have to undergo considerable transformation in order to survive under the new conditions of wartime Britain. The principal problem lay in the need to react positively to the changes in the political motivation which had maintained the association's sense of purpose and ensured its level of support throughout the seven years of its existance. For although the state of war was no more than that conclusion to the expansion of Fascism in Europe which had long been predicted, up until now, the AIA's position had always been that of mounting political opposition to both the Conservative dominated National Government as well as the weakened Labour party, which was blamed for its renunciation of the opportunity to help create the Popular Front in Britain. But now, with the exception of the ambiguous opening months of the 'phoney war', the general strength of national unity behind the war effort meant that very little support would be forthcoming for any organisation which found itself in systemic, political opposition to the official policies of the state.

However, the AIA's alignment on the political spectrum remained sufficiently clear to permit its Central Committee to add support to such particular issues as the protest campaign against the suppression of the publication of *The Daily Worker*, or to join in the complaint against the release from internment of Oswald Mosley. But on the whole, its prevailing stance was now one of a watchful co-

operation with the Establishment.

Certainly the AIA's personality changes were fairly gradual but perhaps irretrievable as the organisation cast off some of the enthusiasms of its youth and adolescence to take on the new roles of responsibility more befitting its years of maturity. For some of its members, those for example who had been lucky enough to land an important and satisfying job with such establishments as the Ministry of Information or one of the camouflage units where their occupational skills could be employed, the AIA practically ceased to retain any useful function. For others, for whom conscription meant separation from friends and colleagues and the frustrations and discontents borne by the artist suddenly converted to the state of the private soldier, its continuation provided an invaluable lifeline of moral support. Indeed a very significant feature of this period of the AIA's history is the very insistance by its membership, that it should survive and maintain its momentum despite the inordinate difficulties brought on by the geographical dispersal and the changing occupations of its regular organisers.

So if the directly political role of the artist engaged in opposition to reactionary forces within society had to be foregone for 'the duration', wide scope remained for new and necessary directions of activity to replace this role and these could largely be assimilated under the second part of Misha Black's definition in January, 1940 of the AIA's wartime roles of working to stop artists from going hungry and of 'preserving our culture'.

The invocation of 'culture' occurs with an unqualified and unembarrassed frequency in public pronouncements during the first days of the emergency, often following the idealistic strains of Geoffrey Holme, the editor of *The Studio* :

> More than ever now should works of beauty remind us of the better aspect of things. . . . To help us keep the lamp of culture burning is 'The Studio's' aim. In the ideals that great artists have set before them is a spring of faith and belief — in works of beauty, a great healing. This is rebirth, the present phase will pass, mankind is being reborn and beauty, honour, faith will all play their part in bringing forth a better world.[1]

Fortunately the AIA did not simply let the matter drift aloft in heady rhetoric but pursued a programme over the next five years which put into practice a number of projects directed at achieving the democratisation of art. These

117

initiatives can be summarised under three headings: 1) investigation into the problems of art media, trying out ways of promoting the sale of inexpensive artists' prints and the encouragement of schemes of mural decoration, 2) responding to the acknowledged isolation from contemporary art suffered in the rest of the country outside London by setting up regional AIA groups as nuclei of local energies and by expanding the travelling exhibitions programme and 3) the development of an exhibition policy which sought to respond with a greater consideration for the general public's wishes and needs rather than to continue the traditional patterns which were tailored more for the benefits of the artist and the dealer. Considerable invention was to be demonstrated in several schemes to attract new and more socially diversified audiences by means of a considered choice of site and theme.

As to Black's first concern, as conscription expanded, with age limits widened, there was little chance of artists starving since they were being increasingly incorporated within the war effort; but their professional survival qua artists was of course another matter,[2] and it is significant that the most concerted efforts to organise the AIA along Trade Union lines took place during the war. Certainly the AIA was to be instrumental in proffering advice and applying pressure on ministerial policies to safeguard the interests of artists, on many occasions. This pressure was generally exerted through the channels of the Central Institute for Art & Design (CIAD), which was the co-ordinating body set up in 1939 to look after the interests of the members of some 40 different organisations concerned with art and design.[3] The AIA was active in the organisation of this quango and was always ready to direct new schemes to its attention for the employment of artists, for example a memorandum was offered early in 1940 suggesting a scheme for wide-scale Government patronage which derived from the experience of the American WPA/FAP operations.

That stream of British wartime initiative which has often been noted was also running high in London's art world. Suggestions for relieving the drab effects of the blackout regulations on shop windows came from an exhibition of painted shop window blinds and emergency hoardings,[4] enthusiastically opened by Sir Kenneth Clark, who was reminded by the occasion of the taste for household decoration in Renaissance Italy. A suggestion was put to the CIAD by a correspondent, who complained that sculptors were experiencing particular difficulty in finding appropriate war work, that three-dimensional publicity displays, following the example of Russia, should be set up

in public places like Piccadilly Circus to advance such causes as National Savings. The *AIA Bulletin* had already had to scotch the rumour that a number of sculptors could be taken up by the medical services to work on plastic surgery. A portrait scheme was initiated by the AIA whereby a register was kept of artists who were willing to undertake portrait commissions, for a modest fee, of young men who were shortly due to enter the forces. This idea, which might seem a little insensitive, was apparently instituted in response to a suggestion from a correspondent to *The Times*.[5]

The first months of adjustment to the new conditions were certainly not without difficulty for artists. Everyone had their own story about how they were mistaken for a spy when out on an innocent sketching expedition, and an example was given in March 1940's *Bulletin*, of an artist who was painting a street scene when he was 'threatened by a menacing crowd and only rescued by a policeman who read the artist's War Office permit to the angry assembly'.

The AIA conducted a survey of its members shortly after the declaration of war which generated the alarming statistic that some 73% of artists had either lost their jobs or had their commissions revoked as a direct result. This extreme level of unemployment was soon to be ameliorated to some extent, not just as a result of the increased haul of conscription, but also through the realisation by the artists' main employers, the art schools and the advertising agencies, that they had rather over-reacted, and that much of their work could after all carry on as before — or almost as before. In December 1940, Heatherley Art School for example, in announcing the re-institution of its courses, added the reassuring information that there was an air raid shelter on the premises.

The most significant initiative undertaken by the AIA in 1940, and one which aimed to satisfy demands both for the popularisation of art and for an assured income for artists, was the 'Everyman Print' scheme.

It had been hoped that the *Britain Today* touring exhibition, which had been put on the road in 1939 and aimed specifically at working-class locations, would at least lead to some good sales. In the event, these hopes were ill-founded and it was realised that even at the relatively low prices asked — a half to three guineas — the prints remained beyond the reach of working people. This was after all at a time when £5 was considered a good weekly wage. At around this time, George Bernard Shaw initiated an exchange of correspondence in *The Times*,[6] with a provocative statement that artists were generally asking too much for their work and that they should take a hint from

Woolworths and offer pictures at £2 plain or £5 coloured.

In an effort to circumvent the seemingly intractable problem of the high unit cost of the artist's production, the AIA brought out the 'Everyman Print' series, reproduced by offset lithography from plates worked on directly by the artist, which could be sold at mass production prices.[7] Comparisons were drawn with earlier occasions on which popular print editions had satisfied the demands for low cost without any consequent sacrifice of artistic quality, the work of the English C18th caricaturists, the lithographs of Daumier and the woodblock prints of Hokusai being mentioned as honourable precedents. As if to demonstrate the added bonus of today's bargain, it was pointed out that Hogarth's *Cruelty in Perfection* was issued in 1750 at what was then an unusually low price of one shilling.[8] The 'Everyman Print' series ran to 52 titles, of which ten were in two colours and the rest in monochrome. They were priced at 1/6d (7½p) for the coloured and 1/- (5p) for the plain, and special care was given to the question of promotion and distribution, with simultaneous opening exhibitions in London, Bristol and Durham and a touring exhibition for smaller locations such as Luton, Winchester and the Mid-Rhondda. In order to overcome the uninviting associations of the conventional art gallery, it was felt that any new public would have to be courted in its own familiar territory and arrangements were made with Marks & Spencers to retail the prints over the counter of a number of selected stores. The ubiquitous Sir Kenneth Clark revealed his full support for this venture when he opened the introductory exhibition for the scheme at the Picture Hire Gallery, in London:[9]

> [The prints] appear to be the first concrete solution to a problem which has always seemed insoluble; how patronage of art by the people could be possible in a way which fitted with the conditions that had developed during the last hundred years. The problem of how many people could have works of art as private possessions at a cost which everyone could afford was partly solved by reproductions. But reproductions always have the same effect, they go dead on one. This shows the importance of people being able to buy direct works of art.

He then went on to comment on how the format affected the style and content of the prints:

> As regards the subject, the price of the print has enabled the artist to become a little less high hat in

the choice of subjects. By using a popular medium, artists hope to get in the way of drawing subjects from familiar things, which, if painted in oil or as decorations, would tend to get frozen up. Now we are bringing art back to the representation of the passing scene.[10]

The initial sales amply justified this enthusiasm with some 3,000 prints sold within the first three weeks and the work shown at 22 exhibitions and on sale in six shops. Twenty-three of the titles were acquired by the British Museum and international tours were planned.

In a style, recalling a little the preoccupations of Mass Observation, Percy Horton sets out to characterise the class characteristics of the 'Everyman' purchaser.[11] Firstly the new working-class clientele were identified as possessing an independent judgement but having a particular preference for works of social comment, though (it was reported from Bristol) it was often felt that the social comment had been made from a too superior angle. The intelligentsia were seen to be simply buying names whilst the 'uninformed' middle classes were attracted to the safest, least experimental works.

It is evident from an examination of the subject matter of the prints, that an effort to attract popular interest had been made, not just in respect of price and distribution but also in the adoption of a style and content which would be appropriate to the experience of everyday living. Another obvious advantage of this medium over painting was its capacity for topicality and the majority of the subjects referred to various aspects of the new conditions[12] of war-time life. These subjects ranged in mood from the stubborn humour of De Saumarez's *A Garden — God Wot* to the celebratory *Barage Baloons Ascending over Hampstead* by Russell Reeve or the cynical *Candidates for Glory* of James Boswell.

The theme of evacuation proved suggestive, attracting interpretations from Pearl Binder, Diana John, Vanessa Bell and Raymond Coxon. The political issues of the thirties were not entirely forgotten though, in such work as Clifford Rowe's *Unemployment Assessment Board*, Durac-Barnett's *Bread and Circuses* and Boswell's *Hunger Marchers in Hyde Park*.

This popular art style would have appealed to a number of AIA members who were frequently employed in book illustration and advertising and who might be eager to pursue this approach positively as a kind of antidote to that self-consciousness in relation to 'gallery' art to which Boswell refers in *The Artist's Dilemma*. One of the dangers of the

illustrator's style, however, was acknowledged by Horton when he complained of an occasional lapse into the sentimental and the jocose in the Everyman series.

In the event, the claims that the 'Everyman Print' scheme could establish a viable basis for the employment of artists in wartime, when income from picture sales and commercial art and teaching would be drastically curtailed, were not to be fulfilled. In 1942, it was reported to members that the scheme had run into production and retailing difficulties and with, ultimately, only about 5,000 prints sold, the royalties could not have been very remunerative.

The AIA was eager to restore some degree of normal functioning within the art world and instituted a series of public lectures on 'The Purpose of Art Today' at the National Gallery, organised by Ewan Phillips. The AIA was also the first exhibiting society to mount an annual members' exhibition under wartime conditions which was certainly by no means free of hazard, as was proven by the arrival of an incendiary bomb through the roof of the RBA Gallery just before the show opened.

The AIA's programme of travelling exhibitions also got under way again, with a show in April 1940, specially prepared to be shown at the canteen of the Ministries of Shipping and Economic Affairs. The paintings selected cover a good range of mainstream styles but show very little tendency to any social comment or even war-time scenes. Jan Gordon — who was a regular contributor to the reviews in *The Studio* and an AIA member — strikes a conversationalist tone in the catalogue foreword, he starts off:

> Two ways of looking at a picture exhibition: the ordinary and the unordinary. The ordinary, pick out the one you like and say 'Pooh!' to the rest. This has advantages. You don't have to worry about what Wodehouse calls 'the old beezer' and there are two manifest pleasures, enjoying the ones you really like and pooh-poohing the others in a superior way.

He has presumably gauged the level of knowledge and sensibility of his public whom he gently coaxes into a more sympathetic contemplation of those works which they might not at first understand. The obvious benefit of being able to set up some relationship with a painting over time and in the relaxing atmosphere of a mealtime was well exploited in this canteen exhibition which was soon to lead to the organisation of a factory canteen tour, whose first venue was the Morris works at Cowley. A further tour, in association with CEMA (Council for the Encouragement of Music and the Arts), a forerunner of the Arts Council, was

brought together to serve the needs of British Restaurants.

Another touring show, 'AIA Travelling Exhibition No. 2', started off in February 1941 and toured a wide circuit of municipal art galleries. A very different tone is established however in Anthony Blunt's catalogue foreword in which he claims that the restrictions of war-time access to art were leading to a greater appreciation of its value by the public and had imposed on the artist a corresponding responsibility for a serious approach to his work. Whilst evading any direct statement to the effect, Blunt is setting out the case again for Realism, in affirming the importance in wartime of the artist having something worthwhile to say and in inviting the public, from the evidence of the work shown:

> To decide whether we really think it worthwhile to study paintings in which intellectual ingenuity or an over-refined sensibility is the only talent displayed by the artist.

He then goes on to call for an increasing role to be played by the state in evolving an organised policy to utilise the country's artists in the future by greatly expanding the programme of commissioning War art.

Whether works such as Duncan Grant's *Ballet at Sadlers Wells* or Carel Weight's mischievous *Lovers interrupted by a Sprite* upheld this appeal for gravity is doubtful and if Blunt's advice was directed towards the artists and the ministries, the public were well compensated with an afterword, 'About the Pictures', in which Carel Weight does a highly creditable job in bridging the gap between the day to day experience of a presumably unsophisticated public and the examples from various art tendencies on show, pointing out, for example, the proximity of modern advertising art to surrealism. Weight strikes, in his tone and content, something of the fine balance between populism and seriousness of intent which one might expect from such a painter. The show, though largely of members' contemporary paintings, was supplemented by loans from the private collections of Blunt and Clark, as well as a Matisse, a Bonnard and a Roualt, amongst a number of works from the Courtauld collection.

Taken altogether, about 500 prints and paintings by AIA members were circulated via various travelling schemes during the wartime period, and not only did the artist have the chance of sales, but an agreement was negotiated with the Government for a royalty of £5 per exhibited picture per year to be paid to the artist, which was seen as providing a potential basis for a realistic form of state

patronage.

The need for artists to align the content of their work with the common experience of everyday life was a frequently quoted axiom of the AIA, and, since the realities of War-time living dominated the experience of most people in Britain in 1941, the next exhibition was restricted specifically to 'War Pictures'.

It was also to be their most popular exhibition, attracting an attendance put at around 150,000 in just three weeks. The explanation for this astounding figure was to be found in the choice of site — the ticket hall of Charing Cross underground station — rather than any special quality of its content. The AIA was unwittingly fulfilling the ambitions of such diverse luminaries as Victor Considerant, Gustave Courbet and Roger Fry, who had all in their time called for exhibitions to be held in railway stations. Charing Cross underground station was a regular site for displays and promotions — the public had recently flocked to admire a Spitfire on display there — and was obviously highly effective in furthering the principle of providing a welcoming access to a public who would not otherwise have been drawn through the turnstiles of the conventional gallery. Furthermore the standard of presentation was of the usual high quality associated with AIA exhibitions and reflected the professional engagement in exhibition design of such members as Misha Black who was later to be responsible for much of the design programme of the Festival of Britain.

Francis Klingender in a brief but scholarly catalogue, introduction calls to mind the impressive precedents for the genre of war art from Republican France, from Goya's Spain and 'from the mighty avalanche of propaganda art' coming from the Paris of 1870. He points out from this evidence the apparent confluence of broad, popular support for an action in defence of liberty with the quality of response from the artist, and he concludes:

> In Britain too the war has brought about a heartening revival in artistic activity and of a public interest in art. The common struggle against Fascist aggression has bridged the gap which has for so long divided the interests of the artists from those of the people at large . . . British war art . . . will take its place in the grand tradition of democracy.

Percy Horton's afterword makes a rather lower keyed appraisal of the potential of British war art, based on the recent National Gallery and the Auxiliary Fire Services exhibitions as well as the work on show at Charing Cross, yet he noted that many artists have beneficially altered their

style to a more realistic and sympathetic means, as a result of the special stimulus of the war subject. He distinguishes the character of the AIA work as being essentially 'undress' in comparison to the official commissions on show at the National Gallery, in that here was to be found work produced in their spare time by artists principally engaged in various aspects of war service.

This might certainly explain the recurrent tendency in the Charing Cross show, to the sardonic anti-heroic statement, as in Boswell's *Three volunteers — You, You and You* or Ruskin Spear's *Yes, the National still Urgently Needs Your Railings*. Carel Weight's *It Happened to Us*, depicting passengers scurrying to safety during an air attack on a London trolley bus, has that quality of transcending the prosaic which characterises the best of his work, and which must have compellingly reflected the stresses and sudden terrors of civilian life commonly experienced through the Blitz.[13] On another tack, Stella Bowen's picture of bomb damage, *Flight from Reason* presents a more philosophical reflection, with the collapsed and devastated structure of contemporary society, revealing the classical monuments of the Age of Enlightenment, preserved below the debris.

Figure 14

14. Carel Weight,
*It happened to us, Daylight
raid on London, 1941.*

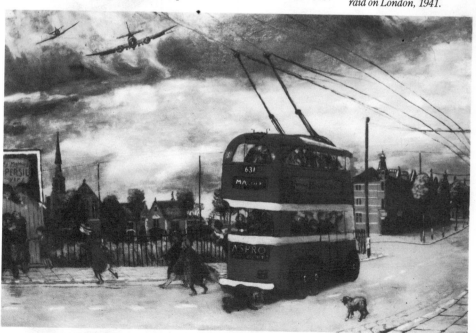

Such paintings were vastly removed from the general run of archly heroic War pictures which constituted the official style for recording the war and they were apparently well received by the visitors to the exhibition who did how-

ever complain of the overall tendency to avoid the depiction of people 'You'd think it was a Wellsian War, fought by robots and not by human beings'[14] was one of the recorded comments but the compliment, 'It's ever so real', was taken as confirming the artists' intention to express the widely held experiences of the audience's own lives, rather than referring to any photographic verisimilitude in the work.

If, as Percy Horton says, some of the work by AIA artists was relatively 'undress', they were also capable of producing work which was intentionally offensive in its lack of 'good taste'. While Boswell was serving with the Royal Army Medical Corps he continued to record his reactions to the disconcerting reality of the life of a medical orderly in a number of sketchbooks and loose drawings, since acquired by the Imperial War Museum. The earliest sketchbooks contain the bitterest imagery, in which his instinctive recognition of the continuous waging of the class war is grafted on to his reaction to all the petty indecencies and inhumanities of army life. He invents a bestiary of bull-headed members of the officer class, who collude in perpe-trating the gross acts of war — blindly, stupidly and unquestioningly.

Figure 15

15. James Boswell,
*Page from a war-time
sketchbook.*

Although Boswell's later drawings show a more moderated tone of expression, they are still determinedly anti-heroic and the fact that two sketchbooks were brought up by the War Artists Advisory Committee says more for the breadth of mind of the selectors than for the work's compliance with the idea of war art as a means of maintaining morale. We are shown such scenes as *Nursing Orderlies at Play* which, with characteristic irony, illustrates a punch-up at a Dance Hall, and a rectum examination is conducted, *In Pursuit of Science*, the other side to Ardizonne's cosy bar scenes is revealed in inglorious scenes of drunkenness and a Daunier-like power of characterisation is approached in the *Candidates on Sick Parade*.

A collection of service drawings by Pat Carpenter recently came to light which chillingly parallel the subjects and tone of Boswell's work; again we meet the bedraggled, disenchanted faces of the conscripts and the madness of the form-filling and rubber stamping bureaucrats.

Figure 16

16. Patrick Carpenter,
*War-time drawing,
ink and wash.*

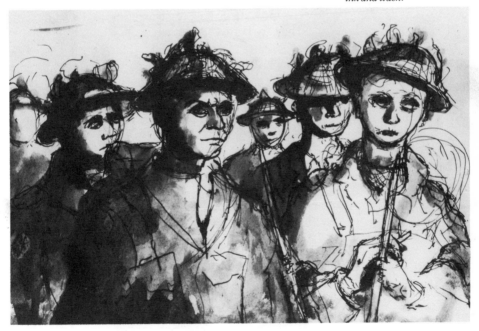

Much of the special force of Boswell's and Carpenter's imagery derives from the immediacy of the medium, typically pen and wash drawings, for of course oil painting or even water colour work was out of the question given the practical restraints of barrack life. Both artists were conscious of the contrast between their circumstances and those of the official War Artists, especially those who had been granted service commissions, and it is obvious that

127

their mordant commentary on the depressing and doleful life of the private soldier in war-time reflects a more realistic record than could ever be expected from the cossetted and protected encounters of the official artists.

Boswell, after entering a discussion in the AIA Bulletin about whether extended leave should be available to artists working in the forces, characteristically points out that any such leave could only be obtained at the cost of one's comrades.[15]

It is evident that, for most purposes, the average AIA member was not the best candidate for gaining a commission as an official war artist — the member's world view would rarely coincide very closely to that of the service chiefs, and the record of past association with the AIA would be of concern to the security vetters. Alan Ross in *Colours of War* records a War Artists Advisory Committee minute from an Air Ministry Official:

> The War Artists Advisory Committee have suggested to us Paul Nash and Edward Bawden. They are both a bit Leftish . . . p. 31.

and even more laconically:

> The Ministry of Supply reported that Mr David Bomberg had approached them with a request to do publicity design for Russia. The artist had not been encouraged. p. 32.

Considerable embarrassment was afforded to the WAAC when its selection of Robert Medley to depict the British Expeditionary Force disembarkment posts in France was countermanded by MI5 on the grounds that he had been 'closely associated with subversive Communist doctrines for the last 8 or 10 years'.[16] However, the illustrative skills of many AIA artists were made good use of in the apparently less problematic tasks of depicting civilian contributions to the war effort. The work of Evelyn Gibbs, Figure 17 Evelyn Dunbar and Ethel Gabain is particularly successful here. But such subjects were still not exempt from official anxiety; Gabain was engaged to draw scenes of evacuees but was not allowed to include a scene showing the evacuation of children to the USA as it was thought this would arouse class hostility.[17]

The next AIA Members Exhibition was held in the West End, RBA Galleries during February, 1942. It was hoped that such a location would afford members an improved opportunity to make good sales. This show also included contributions from a number of refugee artists

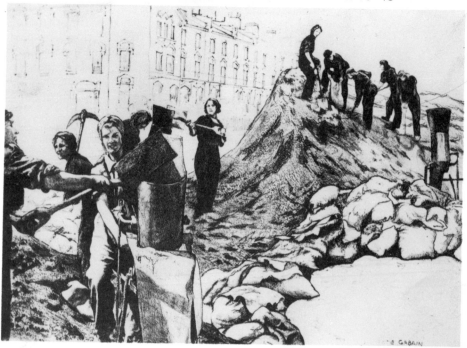

17. Ethel Gabain,
*Sand-bag filling, Lithograph,
c 1941.*

including a piece by Kurt Schwitters, *Memory of a Lady We Never Knew.* But even this otherwise conventional show did not go forward without one experimental measure being implemented. Exhibitors were asked to complement their works with a brief written statement to which request most complied, but with a varying degree of helpfulness. Ithell Colquhoun proffered:

> A record, without further elaboration, of the interdependence of the animal, vegetable and mineral kingdoms of the earth and their vitalisation from the sun

in respect of her painting, *Earth Processes,* though Wilfred Adam's *Portrait of a Miner* draws out the more appropriately down to earth information:

> This portrait was painted in four sittings just as he left the pit in a small room, 6′ × 4′. The background was painted in first in blueish-purple. This gave me the means of first softening the values owing to the coal dust on the human face.[18]

By January 1942, the Central Committee were able to

129

put to members their 'New Programme', which sought to establish for its members some of the benefits associated with a Trade Union or a Professional body. In return for the increased subscription of £1. 7s. 6d (£1.37p), professional members were entitled to such facilities as legal advice, debt collection, credit advice, War Work advice and unemployment and sickness benefit. There were reduced rates for Associate and Student membership. The proponents looked forward to a period of expansion which would lead to such developments as the establishment of their own clubroom and gallery, to the publication of books and pamphlets, and to the co-operative retailing of artists' materials. Such proposals were evidently practical and this programme was to be substantially achieved during the post-war phase of the organisation.

So far as the war in Europe was concerned, any embarrassment that might have been felt amongst members arising from the difficulty of reconciling their admiration for the Workers' State of the USSR with the Russian/German non-aggression pact and the subsequent inroads into Poland and Finland, was immediately assuaged in June 1941 when German troops swept over the Soviet Union's borders towards Leningrad and Moscow. Almost overnight the Great Bear appeared to have transformed its personality, and the political contortions of Press and Parliament in its changed attitude to our newest ally must have delighted all those with an eye for the absurd.[19] The *AIA Bulletin* for July, 1941 commented cryptically;

> The German attack on the USSR has made every member of the Central Committee still more certain that his own political theory has been proved valid.

Following AIA suggestions to the CIAD, an officially patronised 'Artists Aid Russia' exhibition was held at Hertford House in London, raising over £2,000 for 'Mrs Churchill's Aid Russia Fund', with the artists donating half the selling price of their works. This success was followed up with a companion 'Artists Aid China' exhibition under the patronage of Sir Stafford and Lady Cripps, and AIA members including David Caplan and F. H. K. Henrion lent their specialist display skills for a documentary show in November 1942 answering to the theme of 'The Soviet Union in Peace and War'.

One of the more curious products of this intense period of Russophilia was an anthology of poems and etchings, published in an edition of a hundred, entitled *Salvo for Russia*. The plates, by Ithell Colquhoun, Penrose, Banting, Buckland-Wright and Piper were situated generally in the

Surrealist territory between Klee and Masson, except for Piper's *Ruined Cottage*, which was typical of his wartime style. Poems were contributed by Nancy Cunard, James Forsyth, J. F. Hendry and Cecily Mackworth and there should have been something from Dylan Thomas[20] but this did not materialise in the final publication. A few lines from Nancy Cunard's *Russia — The USSR* indicate the extent of adulation that was possible at this time:

> I see a man standing sharp against the skyline, a woman on the horizon,
> Born in a vast October guarding the East and West of Life.
> It is here, they say 'no citadel we cannot take in the end'.
> Was it Lenin? It is all — This is the USSR.
> The giant slept so long in the world, awakened in Russia,
> You had forgotten his name, his old simple name which is: truth.

The proceeds from *Salvo for Russia* were to go to the 'Comforts Fund for the Women and Children of Soviet Russia'.

It was well recognised in AIA circles that one of the great hindrances to any expansion of both the practice and appreciation of art in Britain was the dominant position of the art establishment in London. This hegemony was based on the concentration of the necessary system of support for the artist, the premier Art colleges, providing firstly training and then employment, as well as the West End art dealers and exhibiting societies, providing both the only channel for the sale of fine art and the principal means of exposing and exchanging new ideas. Equally importantly, London provided the camaraderie of like minds, to be encountered in the Charlotte Street pub or the studio party, which at times would be the only defence against the doubting public or the wavering confidence. As a result of these institutional realities, there grew up a set of beliefs which could hardly conceive of any serious work emerging north of the Finchley Road and the provincial art society was dismissed with a snobbish shrug.

Initiatives were therefore taken by the AIA in 1938 to rectify this by making contact with likely individuals and societies in the rest of the country to form Regional sub-groups and a schedule of advice and standard procedures was prepared to help anyone wishing to establish such a group. It was suggested, for example, that they attach themselves to local pockets of energy which might be found

in existing Left Book Clubs and Peace Groups. However, it needed the particular circumstances of war conditions before these regional groups were firmly established.

Firstly, this was due to the dispersal of members on various aspects of war service with units scattered throughout the country. This broke their ties to the London art world and exposed them to something of the isolation which their colleagues in provincial art schools, for example, must have experienced all along. The second stimulus was the fact that war-time gave rise to a particular kind of work which seemed especially appropriate to the social programme of the AIA and which essentially called on the benefits of collaboration. This was the provision of schemes of mural decoration for the large number of temporary and converted buildings which were coming into commission to satisfy the many new functions that were demanded by the war-time administration both in military and civilian areas. These included hostels for factory workers, as well as barracks and NAAFI canteens, but the most commonly recognised need was in respect of the 'British Restaurants' which were the large, centralised, government-operated canteens which compensated for the closure in most towns of many of the small cafes and restaurants which did not fit in well with the programme of food rationing and control. Since most of these were housed in Drill Halls, converted shops and offices and the like, it was felt that the artist could render a tangible service to the nation's morale by brightening up the appearance of these establishments.

Of the dozen or so regional groups so established, usually with at least one former London-based AIA member at its nucleus, some, such as those at Sheffield, Oxford and Nottingham, were to survive the duration of the war and to establish lively centres for art activity which are still going strong today. Other, rather more exotic locations — The Barbados or Mauritius — had rather less substance, reflecting the temporary location of individual members. It was also felt advisable to set up local groups within London itself, at Croydon, Purley, Henley and Hampstead. The Charlotte Street Centre was also established at 84 Charlotte Street, which provided a couple of rooms for meetings, lectures, discussions and monthly bottle parties. It was largely the initiative of F. D. Klingender, who established it after 1943 as a technically independent but closely affiliated organisation.

One of the most interesting groups, both in terms of its scale of activities and the value of its example, was to be found at Leamington Spa. The explanation for the establishment of an 'Artists' and Designers' Collective' engaging

the talents of over fifty professional workers in such an unlikely Midlands town, lies in the fact that it was also the location of the Camouflage Directorate during the war to which many artists managed to get deployed. Leamington was then the place of the greatest concentration of artists anywhere in Britain during the war with between 150 and 200 working there during its heyday. Richard Carline, who summoned the inaugural meeting to establish the AIA group at Leamington recalls such figures as Stephen Bone, Robin Darwin, Cosmo Clark, and Thomas Monnington being there. The proposal to keep up some artistic activity in their spare time was understood as a means of psychological survival and was generally well received by the artists present, though some demurred and objected that all the artist's effort should first of all be directed towards winning the war. The sculptor, Trevor Tennant and the painter Edwin La Dell were prominent in the group's subsequent organisation. The British Restaurant at Leamington was furnished with six panels, ranging from 8' × 10' to 10' × 20' and painted on asbestos sheets. They were the work of separate artists, though in some cases more than one artist assisted with each panel. After the initial preparations of designs, the group met together to decide the basis on which the designs should be integrated. The subjects included *Scene on a British Trainer Aerodrome, Carrying on with domestic duties after an air raid, A Scene of Contemporary life at Leamington Spa* and *Home Guard Manoeuvres and the use of Camouflage.*[21] These subjects were a celebration of the day to day, non-heroic experience of the civilian working-class enduring wartime conditions. Dorothy Annan's *Scene of Leamington Life* discloses a fruitful blending of Chagall and the popular cartoon in this, not untypical example of the search for a popular figurative style.

Figure 18
18. Dorothy Annan,
Leamington Life, mural for the British Restaurant, Leamington Spa.

Another venture, for decorations at a workers' hostel at Finham Park, near Leamington, was carried through with a greater regard for all the democratic implications of the medium of· mural painting for public consumption. Here, the workers were first approached for their suggestions about what topics should be pictured and *War-time holidays by the Sea* and *Holidays at Home* were agreed to. Next, the artists, now working together as a 'collective', submitted a number of designs for approval and selection by the residents, who in return contributed up to £20 of the cost, a further £80 being obtained from CEMA (Council for the Encouragement of Music and the Arts). It was consistent with the Collective's approach that they did not offer their services gratis, both in order to avoid the patronising impression this might make on the hostel residents and to support their contention that public art work should be sponsored as governmental policy, so they established a rate of payment for the job of 4/- (20p) per square foot up to the first 100 square feet, and 2/- (10p) per square foot thereafter.

Gradually, as the work was planned and carried out the virtues of the co-operative experience of working together on a mural as part of a team impressed many an artist, who would formerly have rejected the idea out of hand in his or her defence of the sovereignty of the individual's inspiration. We can see, in Trevor Tennant's manifesto *Art for the people and the people for Art* [22] how the work of the 'Artists and Designers Collective' might have suggested a paradigm for the organisation of art in Britain after the War especially, as Tennant wrote:

> The winning of the peace will inevitably mean a
> tremendous change in our social and economic
> system. The success of the planned, state-
> sponsored policy for the Arts in Russia and formerly
> in the USA provides us with a profitable example for
> replacing the present decadent state of
> contemporary British art with its sloppy
> pretentiousness and the smothering cant of neurotic
> plants nurtured in the hothouses of Bond Street.

A modest revival of interest in mural painting had been growing in Britain for a number of years; The Society of Mural Decorators and Painters in Tempera had been formed specifically to promote the work of mural painters and the mode of gentle classical and rococo parody which had been established by Duncan Grant and Vanessa Bell and Rex Whistler in the twenties still held much sway. The signal achievement of Stanley Spencer's Burghclere Chapel

was always there to remind the would be muralist of the profounder reaches to which the medium might extend, and in another direction, there was a growing taste for mural decoration in pub and hotel interiors. Hans Feibusch[23] and Olga Lehman brought to the mural the expertise derived from advanced techniques and high standards of execution and this promising state of mural painting was celebrated by an exhibition (in the form of photographic reproduction) at the Tate Gallery[24] in June 1939 of current mural work in Britain.

Similar schemes to those produced by the Leamington Collective were to flower in Nissen huts and Drill Halls up and down the country. They were conceived and carried out on the basis of having a short life only, since it was realised that very few were likely to survive beyond the war when the buildings would be dismantled or given over to other uses. Certainly none of the Leamington murals which have been mentioned are still in existance.[25]

But the new element that was introduced by the AIA mural artists was the emphasis on the mural as an essentially popular art form; its democratic attributes deriving both from its content and its location. It was a perspective which clearly took a lead from the example of the WPA/FAP schemes in America and of the pioneering, Revolutionary art of Mexico. Even before the War and the particular stimulus of the British Restaurant and hostel projects, a members' meeting had come to the conclusion that the death bell had been sounded for easel painting and that the only viable future lay in developing on the one hand lithography and on the other the mural, and that accordingly the LCC should be approached to support mural schemes in the city as public works.[26] It is not surprising to find that Richard Carline, who had been on extended visits to America in the 1930s to see at first hand how the WPA system operated and who had been frustrated by the outbreak of the War from mounting a full-scale exhibition of realist American art at the Tate, was determined to build up on these AIA initiatives. His ambition was to establish a National Mural Council to provide finance and guidance at a ministerial level, and to this end he worked to bring together a high-powered conference of representatives from the Trade Unions, Industry and Government Departments in 1943. Despite the somewhat deterring advice from Factory Inspectors about the need for washable surfaces and from nursery supervisors warning against such offences to the cause of rational education as pink elephants and hens that wore hats, the conclusions of the conference remained encouraging, but in the end the necessary ministerial or Arts Council backing was not forthcoming and the

idea fizzled out.

The AIA's 'New Policy' of 1942, in addition to setting out to provide professional and welfare benefits, also called on members 'to organise themselves as propagandists' as a reaction to the Government's apparent inadequacy in this direction. It was felt that ministerial exhortations to 'Dig for Victory' or to mind what you said on the back seat of the bus fell rather short of the more positive aspects of ideological encouragement which were fostered in other countries, notably Russia. The most substantial response to this call to work as propagandists took shape in the AIA's exhibition, 'For Liberty' which took place in March 1943. Suitable exhibition sites were not easy to come by at this time but eventually a venue was found which effectively symbolised the spirit of resistance and phoenix-like reconstruction. This was the new basement canteen that John Lewis had constructed near the site of their Oxford Street store which had been destroyed by enemy bombing. Sponsorship from the popular newspaper *The News Chronicle*, which was generally regarded as Liberal in political tendency, ensured wide publicity for the event; it also indicates the broad acceptibility of the AIA position at this stage. The exhibition was opened in tones of ringing praise from the Minister of Information, Brendon Bracken, and the popular Russian ambassador Ivan Maisky was also there.

The foreword to the exhibition catalogue, by Misha Black, sets out to clarify the growing conception by the AIA of a new role for the visual artist, the evolvement of a new genre, described as 'propaganda of the imagination' which was to be distinguished from the respective contributions to the business of communicating ideas made by the poster and the written tract. As part of the job of neutering the word 'propaganda' and absolving it of its pejorative connotations, it was pointed out that the country's magnificent heritage of church architecture, wood carving and stained glass was also inescapably propagandist in intent. Further, the socially cohesive qualities of propaganda were applauded as signifying the new, purposeful contract between the artist and the new patron — the general public. This was seen as the logical means of refilling the vacuum left by the cessation of religious patronage.

Misha Black's catalogue introduction also claimed that this new conception, 'the propaganda of the imagination', would have the effect of countering the styles and attitudes of esoteric escapism in which the modern artist had so often taken refuge, as a reaction to his alienation from the former, more democratic patterns of patronage:

Here is a demonstration that artists feel they can

contribute more than is at present being asked of them: that the function of art in wartime is not only to record what is happening and to give enjoyment and recreation, but to stimulate and encourage, by vividly representing what we are fighting for. [27]

Towards this end, artists were asked to submit paintings which adhered to a programme of certain, specified themes and to limit their works to standardised sizes, 24" × 30" and 24" × 20". The centre piece was a group of pictures to the format of 4' × 5' devoted to the celebration of the four liberties of the Atlantic Charter — the liberty of Speech, and of Worship and the liberty from Fear and from Want. Other sections were concerned with the themes of 'This is what we are fighting for', 'This is how we are Fighting', and 'This will happen unless'. In this way they attempted to bring into life a new and more effective propaganda medium by blending the written caption and quotation with thematically coherent visual imagery: 'To show that the artist can formulate ideas and express ideas as well as illustrate and interpret facts'. [28] It was felt, however, that this demand for coherence and standardisation would not extend to matters of style, and the artist's right to his personal means of expression was duly recognised; indeed it would be hard to imagine how it could have been done otherwise, although the inconsistency of style in the exhibition did not escape criticism.

This central group on the 'Four Freedoms' theme included one larger, invited work; [29] Augustus John's picture *The Fisherman's Return*, measuring 11' × 8' (and described in the catalogue as a cartoon for decoration), was generally reviewed as distractingly irrelevant — 'like a ballet dancer in a boxing ring' (*The Studio*) — 'Art for art's sake, old fashioned' (*Apollo*) though, to be fair, the subject seems to amply symbolise, through its many hints of religious iconography, the promise of the return of hope and peace when the war is finally over. [30]

Some indication of the familiar diversity of style associated with AIA shows, can be gained from the following further examples from the fifteen works which made up the Four Freedoms section. Socialist Realism is represented by Clifford Rowe's *Freedom of Speech*, showing a street corner meeting being addressed by a woman speaker with the slogan 'Lift the ban on the Daily Worker' prominently displayed on the factory wall behind; and by Pat Carpenter's *Death of Gabriel Peri*, an impressive image of the editor of *Humanité* who had been executed by the Nazis in 1941, which owes as much to De Chirico as it does to Gérôme's *Execution of Marshal Ney*. [31]

Figure 19

137

19. Patrick Carpenter,
Death of Gabriel Peri, 1943.

Edward Le Bas takes a well-judged quotation from Seurat's *Bathers at Asnières* in his own *Bathers on the Serpentine,* and for a closely parallel purpose, in establishing an image of peace and social harmony to augment the theme of 'What we are fighting for'.

Kenneth Rowntree's lighthearted, near naive, decorative style is put to good purpose on the theme of freedom of worship, though there is surely a wry comment about religious sectarianism in Rowntree's small clerical figures each in their distinctive vestment, marking out their individual building plots.

Figure 20

Maurice Kestelman's *Lama Sabachtani — Why has thou forsaken me* and Hans Feibusch's *Resurrection* return us quickly to the European experience of Fascist terror. The mode of expressionism, which in Feibusch's case is somewhat informed by El Greco, carries well enough the generic description 'Emotionalism' which was briefly current at the time.

Surrealist directions were no hindrance to responding to the Four Liberties theme as was demonstrated by Carel Weight's *The Land of Ears,* nor within even the movement's more abstract tendencies with Tunnards' *Focal Point* and Matvyn Wright's *Fear Motive.*

Sculpture was also admitted in the form of Betty Rea's *New World*, a group of eager children's heads and arms, in terracotta.

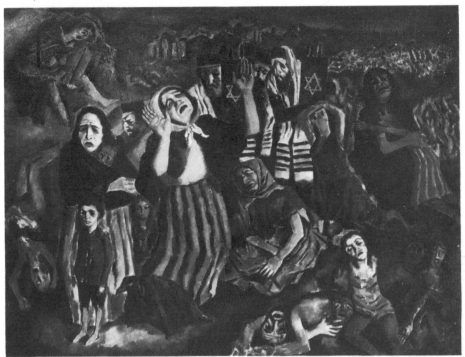

20. Morris Kestleman,
Lama Sabacthari, 1943.

C. Day Lewis composed the following verse in response to specific works in the 'Four Freedoms' section, and in the final exhibition display the appropriate line was placed as a caption under the image to which it relates.

> They cry for help, each cry is an open wound on the
> body of Freedom:
> In their defenceless bodies, Freedom is starved,
> betrayed, crucified:
> Prisoners, they dream of water reviving the flesh,
> the spirit releasing.
> But Freedom lives wherever men meet to speak
> their minds in the open.
> But listen! Freedom works underground, volcanic
> beneath the oppressor.
> But one man's blood, for Freedom shed, can shake
> the towers of tyrants.
> Men of all lands, all faiths, start NOW to lay your
> hope's foundations,
> To design a world that shall tremble no more to the

139

tread of gathering armies,
A world where the rat-toothed nightmare of want
shall gnaw man's breast no longer.
So shall our time reveal long vistas of calm, of
natural growth,
A pattern mysterious yet lucid, for Love is the focal
point of the pattern;
And our heirs shall unfold, like a cluster of apple-
blossom, in a fine tomorrow.

In a post-mortem survey of Press reviews of the exhi-
bition, the *AIA Bulletin* recorded that of the 23 notices that
they had compiled, 18 were counted as favourable to the
show, two were equivocal (including *The Times* reviewer
who obstinately refused to acknowledge the programmatic
purpose of the show), and only three were hostile. Neither
was the AIA too put out by these last three reviews, from
The Tribune, *The Spectator* and the *New Statesman*, which,
although they were all to some extent to the Left in ten-
dency, could be relied on to take an anti-populist approach
to the visual arts. Typical was the all-out attack by
Raymond Mortimer for the *New Statesman*, who takes par-
ticular objection to 'the pretensions' of the catalogue pre-
face, denying that art can be enjoyed 'like ice-cream', or
that the mass of people were artificially estranged from
viewing pictures, claiming that they choose rather to spend
their money at the cinema. Mortimer equally denied the
special role of the artist in war-time: 'Obviously art has no
place in total war, along with the pursuit of truth and culti-
vation of friendships'.[33] Furthermore he judged that most
of the artists, 'despite the jabber of the catalogue', were
pursuing their normal inclinations and practice, irrespec-
tive of the overall themes.

One of the four works from 'For Liberty' which has
survived to any extent in public awareness is Kokoschka's
What We are Fighting For, now in the Kunsthaus, Zurich.
On analysis, the painting soon emerges as a crushing
denunciation of warfare in general, rather than a response
to the more positive vision anticipated by the designated
theme. The central figure is an emaciated woman, prone
and close to death; her child fondles a rat as its pet. Behind
her is placed a figure in the posture of crucifixion who is
branded with the initials P. J. — Perish Judea. A fantastic
war machine on the left feeds upon a constant diet of bones
while spewing out bullets in return, at the same time as
delivering mechanised, Nazi salutes and embracing a globe
of the world picked out with flags of Nationalist aggression.
The collaborative guilt of Church and Capital in furthering
war is pointed to by such figures as the over-weight bishop

dropping his penny in the Red Cross box, and by identifiable representations of the German industrialist Schacht, and Montagu Norman, a governor of the Bank of England, who had been forcibly criticised for his pro-German sympathies. In contrast to these menaces, the farmer continues to productively plough his fields. A rickshaw can be discerned to the right of the picture drawn by Gandhi, whose mode of passive resistance in the struggle for Indian Independence, much impressed Koloschka. The apparent collusion between Gandhi and Voltaire in the right foreground, suggests the approaching ascendancy of the East in the wake of the West's evident drive towards self-destruction.

This combination of complex, political allegory, Baroque composition and rich colour and painterily handling obviously stood out against the blander British fare and probably proved very hard to digest. *What we are fighting for* stands at the peak of a series of works painted by Kokoschka in England which, because of their direct connection with specific, contemporary political events, are worth looking at further.

Figure 21

21. Oskar Kokoschka,
What we are fighting for, 1943.

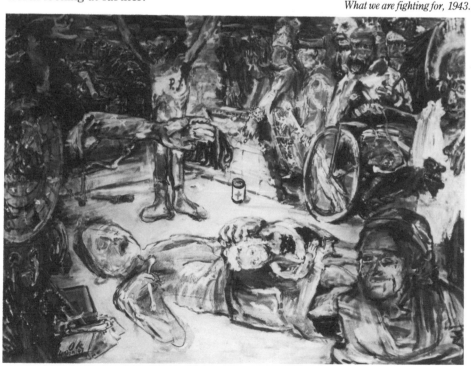

Kokoschka had come to London in 1938 only with reluctance, taking the last possible flight out of Prague, to find little recognition, or understanding of his work even amongst other artists, let alone the public at large. He also

sensed that a deterioration had overcome the British character, from its former openness and amiability to its present coldness and distrust of foreigners. On the reverse of one of the first paintings he did here, a portrait of Michael Croft, he wrote:

> In dirty exile, ill and poor . . . at this dirty time, when they all everywhere are hunting the artist and become slaves themselves.[34]

The first signs of the development of allegory in his painting occur in *Private Property,* in the form of the woman knitting on the sea front whose head has been transposed into that of a cat. Allegory is also present in the painting called *The Crab,* in which a menacing, anthropomorphic crab is identified by Kokoschka: 'This is Chamberlain after Munich! Yah! What have I done'.[35] Sometimes these political paintings remain somewhat cryptic as in *Lorelei* of 1942 in which a leering Queen Victoria haughtily averts her gaze from the sailors floundering in the sea who have been wrecked as a result of the activities of a U-boat which scuttles away.[36] Astride a vastly gaping fish she indignantly surveys a bright green frog (Ireland?) which the great Imperialist gullet seems unable to swallow. On other occasions Kokoschka is much more precise in directing our

22. Oskar Kokoschka,
*Arischloss, or,
Alice in Wonderland, 1942.*

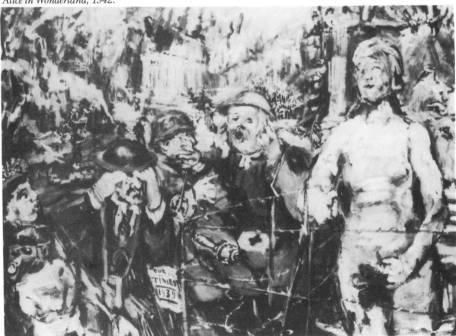

reading as in *Anschluss — Alice in Wonderland*, 1942, a reminder of the annexation of Austria by the Third Reich in 1939. Our attention is also drawn to the wider aspects of the hypocrisy shown by the foreign policy of the Allies. Before a bomb-damaged Baroque altar stands the conventional figure of Naked Truth, but she is both unable to move and unapproachable because of the barbed wire surrounding her. This detail might also allude to the internment camps where many of his compatriots were restrained as enemy aliens and on whose behalf he vigorously campaigned. The presence of such innocent and undisguised truth is repulsive to the senses of a trio of air-raid wardens, distinguished by their garb as the capitalist, the soldier and the priest, and who are enacting the gestures of the Buddhic monkeys, who neither see, hear nor speak any evil. To the left the victims — a mother and child look to the altar, war damaged as it is, for guidance. The child wears a gas mask and the Temple of Culture is in flame behind.

It is significant that it is here as elsewhere in his oeuvre, that it is the men who warrant Kokoschka's scorn and derision, while the suffering woman looks to the female figure of truth and innocence to show the only way beyond the chaos. It is clear that he attributes a superior wisdom to the female principle:

> I believe in the Goddess, the return of the Matriarchate. Do you remember in Geothe's *Faust*, when Faust turns to the mothers in his search for the secret of life? The maternal side of life is a reality, not an idea.[37]

Having said this, it is by no means immediately obvious whether the central figure in *Marianne* (the colloquial name for the French Republic) is an innocent or willing accomplice to the lounging soldiery who are passing the time with her instead of pressing ahead with the Second Front which is announced on the bar wall behind. The lethargy of Marianne as she kicks her shoe off in the direction of a departing rat and the accidental release of a shot through the ceiling by one of the soldiers is a cutting comment on what many people saw as a lack of determination in repelling the German armies from the occupied territories.

Even more specific is *The Red Egg*, exhibited in 1942.[38] Kokoschka was deeply attached to Czechoslovakia, his father's birthplace and the land of his mentors Comenius and Masaryk; so it can be imagined with what bitterness he regarded the willingness of the European powers to sacrifice its sovereignty at the Munich Agreement. Much of this bitterness surfaces in the imagery of

Figure 23

143

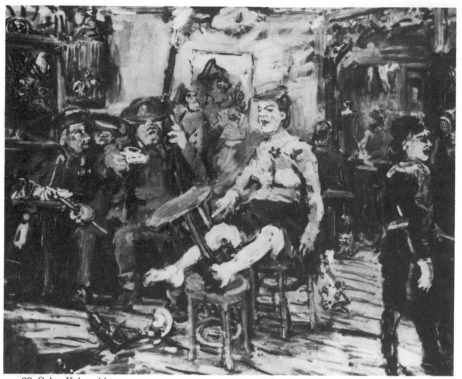

23. Oskar Kokoschka,
Marianne, or, Maquis, 1942.

Figure 24

The Red Egg. The representatives of the Axis powers sit round a table — their forks signalling the direction of the axes. The yelling head of Hitler, clad in fool's cap, marked with a double cross, is partnered by the gross form of Mussolini. The Britannic Lion reaps his share of the blame; at first sight, dignified in pose, we then notice his tail rearing up into a Sterling sign, and that he stands on a pile of books marked 'in pace Munich'. France appears as a wily cat, with a tiny Napoleonic tricorne hat, its displaced fur and sudden leap under the table suggesting, at very least, vacillation. The gross figure of Mussolini squats polyp-like, dominating the right-hand side of the picture. Czechoslovakia is the plucked chicken for which they have assembled to carve up, but it has escaped from the table, a knife in its back, but not before depositing the large Red Egg which is the centrepiece of the composition. What is this red egg which has caused the company such undisguised perturbation? Is Kokoschka predicting the embryonic Communist state in Czechoslovakia which would eventually emerge as a result of their conspiracy? Certainly the immediate result of their conduct is announced in the back-

drop of Prague in flames.

It is interesting to see how Kokoschka turned to his eminent predecessor in the art of satire, Gilray, to enrich his imagery, for surely two of the most effective motifs of this composition, the disputed egg at the focal point and the indecently fugitive chicken, are derived from two of Gilray's designs, *The Plum Pudding in Danger* and *The Fall of Icarus*.

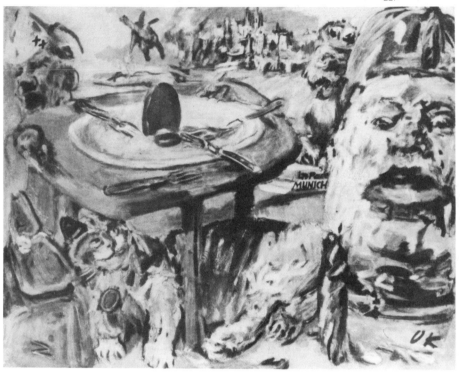

24. Oskar Kokoschka,
The Red Egg, 1940-41.

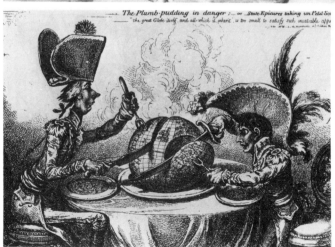

25. James Gillray,
The Plum Pudding in Danger.

Figure 25 *The Plum Pudding in Danger* provides that well-known image of Pitt and Napoleon arrogantly apportioning their agreed spheres of influence in the world which is neatly re-applied to this latter day example of the tyranny of power. It may well be that Kokoschka was deliberately drawing on the native tradition of political satire to persuade his public to decode his imagery rather than merely appreciating the painting's formal qualities. English caricature was a source of inspiration shared with his fellow exile Ludwig Meidner and with Klingender who opened the Charlotte Street Centre with an exhibition of Hogarth's prints.

These paintings highlight the question of how effective this complex, allegorical mode was in communicating definite ideas to a contemporary public unpracticed in such 'reading skills'. The *Apollo* reviewer, ironically pseudonymed 'Perspex', plainly admitted about the *Red Egg* that he 'Couldn't read it'. Jan Gordon in *The Studio*, rather more helpfully analyses the problem:

> It appears to strain the medium: if one is to enjoy the masterly paint, the subject drags it down; if one is to weigh the subject, the paint seems superfluous.[39]

If this were in fact to be the case for everyone, it would be a fundamental blow to the AIA's professed ideal of achieving a 'propaganda of the imagination'.

Kokoschka was also ready to offer his services as an artist in a manner similar to the 'Portraits for Spain' scheme when he painted a portrait of the Russian ambassador, Maisky. He donated his fee of £1,000 from a private buyer, Dr Henry Dreyfus, to the Stalingrad Hospital Fund, but characteristically made the stipulation that the money was to be expended for the relief of the wounded amongst both the German attackers and the Russian defenders. The portrait, which was subsequently donated to the Tate, includes the figure of Lenin rising wraithlike above the sitter's shoulder and pointing to a globe of the world dominated by the USSR.[40]

For most of the War, when he was in London, Kokoschka continued to be very active as a publicist and organiser within Refugee circles. He was a President of the Free German League of Culture, for example, and was a member of the advisory Council of the AIA, attending its meetings and discussions from time to time.

Towards the close of the War his attitude towards his host nation has considerably ameliorated, he prepared a long essay on the tyranny of nationalism and the need for world-wide educational reform, entitled *A Petition from a*

Foreign Artist to the Righteous People of Great Britain[41] and by 1947 he applied for and received British naturalisation.

One of the less obvious ways in which the AIA can now be seen to have broken new ground was in its organisation of historical exhibitions concentrating on areas of art history which had been previously overlooked. The large-scale historical exhibition was very much rarer in the days prior to the efforts of the Arts Council, and the few that were brought together normally followed a very conventional pattern of connoisseurs' and dealers' taste. The AIA's programme on the other hand concentrated on areas of popular art and was notable for a high standard of research and presentation. The first show of this kind was *Hogarth and English Caricature* held at the Charlotte Street Centre in August 1943. The selection of works and, (what were for the day), the unusually thorough catalogue notes, were the work of Klingender and the show's sub-title, *Popular Art in Britain 1730-1838*, demonstrates his intention of reminding the public of their inheritance of a strong tradition residing in the broadsheet and the cheap print. In addition to re-dressing the balance against the limited apprehension of British C18th art which then predominated, (the exhibits seem to have come as a refreshing surprise for most of the reviewers), a connection was also suggested between the current times and the period of the Napoleonic wars. It was pointed out that this earlier occasion on which a nationwide unity of purpose had been established, also gave rise to a corresponding movement for social equality. Jan Gordon, in *The Studio*, takes up this theme, and warns against any recurrence of that slackening of radical sentiment which followed the victory over Napoleon. He hoped to see the appearance of a new public for whom a robust, popular art would have a meaning and he cites the success of the Everyman prints. The visual aspects of the exhibition were augmented by a talk from Osbert Lancaster and a performance of C18th popular song, introduced by the folk music scholar A. L. Lloyd.

The comparisons which pointed to resemblances between the two periods were taken up again in January 1944, when Gilbert Spencer contributed to that long-standing British habit of making fun of our Civil Defence operations, in a show entitled 'John Bull's Home Guard'. A set of 15 gently amusing water colour lampoons of the Home Guard by Spencer was shown alongside examples of the same genre from the Napoleonic wars. However innocuous these images might at first appear today, we should not underestimate the power of such satire to offend. When Spencer sent them to a publisher they were returned to him ripped in half.

147

The Silver Jubilee of the Amalgamated Engineering Union was celebrated in 1945, and this presented to the AIA an opportunity to mount an exhibition which demonstrated the common ground which potentially existed between the artist and the worker, at the same time as exploring further areas of popular, as opposed to bourgeois or collectors', art.

Furthermore, the socialist implications redolent in the celebration of a Trade Union could be widely promoted without incurring charges of blatant political propagandising. Establishment support was forthcoming; it was one of the first ventures of this kind to receive aid from the newly instituted Arts Council and the opening was performed by the veteran labour MP, Ernest Bevin. However, the polemmical level was low-keyed, though a Marxist complexion was sometimes visible in the catalogue introduction in such claims as 'Engineers and artists have much in common, they are both technologists'. Again, Klingender was responsible for the catalogue and for collecting together the prints, paintings and photographs of industrial landscapes and architecture, the early engineering drawings, blueprints, trade union banners, pamphlets, etc., which made up the historical section. It was from this material that Klingender published his pioneering works *Art and the Industrial Revolution* in 1947. There was also a section devoted to contemporary paintings of industrial subjects, largely drawn from the considerable collection of the War Artists' Advisory Committee.

As for the remainder of the AIA's wartime programme of exhibitions, a small show of watercolours, mostly from Welsh subjects was held as, 'After Duty', in December 1943 at the Charlotte Street Centre, the work of Carel Weight and three other fellow sappers, Patrick Gierth, Albert Patterson and William Reed. The latter deserves mention if only for his use of the classic Social Realist title for one of his works, *Sunset on the Gasworks*.

The AIA's annual show for 1944 returned to the traditional West End setting of the RBA Galleries in the hope of attracting better sales for the members, and although an attempt was made at imposing a theme — 'People in 1944' — it is clear that there was no overall didactic flavour to the final section of work shown.

More effort was put into regaining a sense of social responsibility in the AIA's major show for 1945, which was called 'This Extraordinary Year' to indicate the events leading up to the final victory by the allies. It returned to its more ideologically credible location at the Whitechapel Art Gallery and a degree of standardisation of format and themes was requested from exhibitors. Carel Weight, in his

catalogue preface, invites us to imagine the magnificent prospect of a Rubens, inspired to represent a 'Fall of Nazism', or a Goya, with the subject of 'The End of Mussolini', and exhorts the artist of the day to show how the artistic needs of a new patronage could be met. Twelve artists were specifically invited to illustrate the title theme, but even so, the show failed to spark off much excitement and most of the reviewers felt that there was little 'extraordinary' painting to do justice to the events.

Notes

1. Editorial, *The Studio*, October 1939.

2. And for those who were not immediately taken up by the War effort, there was, according to *The Artist*, no sign of slackening sales at the Royal Academy Summer Show.

3. The CIAD operated between 1939 and 1948 with Charles Tennyson as Chairperson and T. A. Feenemore as Director. It published the journal *Art and Design* and maintained the National Register of Industrial Art Designers as well as organising exhibitions of Historic and British Wallpapers and Inn Crafts. It also acted as a publisher of art historical studies and was generally engaged in finding employment for and protecting the interests of professional designers and artists. The release of 10,000 yards of canvas for the use of artists from Government restrictions in 1942 is an example of their intervention.

4. *AIA Bulletin 59*, January 1940. The exhibition was an initiative of the Society of Mural Painters.

5. *CIAD Bulletin*, December 31st, 1940, annual report from the AIA.

6. He was answered by two academicians who pointed out the high cost of the artist's overheads and the fact that no-one could do more than twenty pictures a year and still maintain a level of quality.

7. A comparable scheme, christened 'Tomorrow's Masterpieces' was being tried out in America at the same time, where department stores were offering original paintings for sale at prices ranging from $25 — $350.

8. Percy Horton 'Art for Everyman'. *The Studio*, May 1940.

9. The Picture Hire Gallery opened in 1935 with the aim of facilitating a regular change of pictures in the home and also of bringing works of contemporary art within the range of patrons with lower incomes. Hire charges were at the rate of 2% of cost per month and the work of such artists as John Armstrong, Augustus John and Matthew Smith was available through the scheme.

10. Sir Kenneth (later Lord) Clark, as reported in *The Studio*, May 1940.

11. Horton op. cit. May 1940.

12. According to a Mass Observation survey of 1,220 pictures on exhibition in London between October and December 1939 which revealed that only 2% bore any reference to the War and most of these were portraits of sitters in uniform. *Us*, February 3rd, 1940.

13. The painting was in fact based on an incident personally experienced by Weight. The gap between the AIA's approach to War Art and that of the Government is indicated by this item from the minutes of the War Artists' Advisory Committee, concerning *It Happened to Us*: 'Mr Carel Weight's picture of a German aeroplane swooping down on a trolley bus was found unacceptable as not fulfilling the conditions of his commission. Agreed, that he was asked to try again' — quoted in Ross, A. *Colours of War*, London 1983, p. 31.

14. *AIA Bulletin*, 68, December 1941.

15. James Boswell, letter to *AIA Bulletin*, 71, May 1942.

16. M & S Harries, *The War Artists*, London, 1983, p. 167.

17. M & S Harries, op. cit. p. 165ff.

18. As quoted in the exhibition review for *The Studio*, April 1942.

19. See Angus Calder's *The People's War* for an account of such events as 'Tanks for Russia' weeks, civic receptions which included the toast to Lenin, and the BBC's resistance to broadcasting the 'Internationale'.

20. According to an advertisement for 'Salvo for Russia' in *AIA Bulletin* for January 1942.

21. The work of the Leamington muralists is reproduced in *Our Time*, May 1943 and *The Studio*, November 1943.

22. April 1943, AIA Archive, Tate Gallery.

23.　Hans Feibusch, *Mural Painting*, London 1946.

24.　This was accompanied by two major articles for *The Studio* by Percy Horton, September and October 1939.

25.　One scheme which does still survive from this wartime movement is at the Vauxhall Motors Canteen at Luton. It consists of a series of farming and fishing scenes, but the artist is not identified.

26.　As reported in *AIA News-Sheet*, June 1939.

27.　*For Liberty* exhibition catalogue, introduced by Misha Black.

28.　*For Liberty* exhibition catalogue introduction by Misha Black. This aim of inspiring AIA artists and designers to devise real propaganda techniques is reiterated in the preamble of the sending-in form: 'The artist should by reason of his education foresee more clearly than others the measure of disaster which defeat would bring and the future which victory may promise. It is therefore his duty to do all in his power to use his technical skill and ability a) to bring home to less imaginative people the significance of defeat; b) to inspire and encourage them by recording their heroism and their suffering; c) to show them the possibilities which could spring from an imaginative peace.

The exhibition will be an effort to mobilise painters and sculptors, the aim is not that painters should design posters, but rather that, in collaboration with poets and designers, a new propaganda technique should be evolved.'

29.　An invitation had originally been extended to Pat Carpenter to complete a work for this main position but he had felt himself unready to take on a painting on this scale and opted for contributing a work on the smaller format.

30.　A more anecdotal account of the subject frequently recited was that the 'old fisherman' was a self portrait and the host of accompanying figures represented John's numerous offspring, acknowledged or otherwise. The painting does not seem to have survived, and was described as being 'more turps than paint', which corresponds with the catalogue entry 'cartoon for decoration'.

31.　The work of Rowe, Rea, Kestleman, Carpenter and Weight, together with an installation view of the show, is reproduced in *Our Time*, May 1943.

32.　*AIA Bulletin*, May 1943.

151

33. Raymond Mortimer, *New Statesman & Nation*, April 17th, 1943.

34. Hans M. Wingler, *Kokoschka, The Work of the Painter*, London 1958, Appendix I.

35. Edith Hoffmann, *Kokoschka Life and Work*, London 1947 and J. P. Hodin, 'Oskar Kokoschka's Politische Gemalde', *Das Werk*, Winterthur, no. 7, 1945.

36. The incident of the sinking of the 'Arandora Star', in which many of the 600 internees on their way to a camp in Canada were drowned, may have been Kokoschka's concern here.

37. Quoted in J. P. Hodin, *The Dilemma of being Modern*, London, 1956, p. 315.

38. Although Hoffmann op. cit. states that the *Red Egg* was exhibited with the AIA in 1942, it does not appear in the catalogue of the annual exhibition; but it was shown with the London Group that year, and is mentioned in Jan Gordon's review for *The Studio*.

39. Jan Gordon, *The Studio*, May 1942.

40. In the notes to the plate of the *Portrait of Ivan Maisky*, in L. Goldscheider, *Kokoschka* 1963, p. 77, the artist is quoted: 'As a test of people's vigilance, I painted Lenin in the background, pointing to a globe in which nothing can be seen but the Russian Empire. But nobody noticed it.'

 It is doubtful that Kokoschka would have given the same interpretation when the picture was painted, at the time of the Anglo-USSR alliance.

41. Reprinted in Hoffmann, 1947, op. cit.

SCHISM AND FADING PURPOSE 1945-53

The AIA entered the post-war years with apparently favourable prospects. The simple fact of survival through the last years was itself an ample token of the strength of purpose and loyalty of its members; furthermore it had gained the recognition and respect of such official and semi-official bodies as CEMA and CIAD, so much of its philosophy with regard to the popularisation of art and its encouragement outside of London was to be incorporated in the programme of the Arts Council.[1] It was shortly to take on the kind of gallery and clubroom facilities that it had always felt it needed and membership was higher than ever before. The ambitions of the AIA immediately after the War are set out in a leaflet, *Full Employment for the Artist?*, published in 1945:

> What of the future? Detailed plans have been worked out with our help by the CIAD and other bodies to ensure the continuance of the cultural revival which began with the Battle of Britain and to safeguard the rightful place of the artist, whether he be painter, sculptor, poster artist, designer or teacher, in the work of reconstruction. Through public sponsorship, both national and local, together with a sustained interest in art among the general public, post-war Britain can achieve full employment for the artist. But only — only — if the

artist himself plays his part in urging and publicising his claims. But to be successful all such efforts require the driving force of a powerful organisation embracing the great majority of British artists. It is our aim to make the AIA that organisation. We have the standing and the experience to fulfil its tasks.

And yet any survey of the following eight years must inevitably be read as a time of dissension and fracture which could only have caused profound regret to the original supporters of the movement. For paradoxically, the roots of its decline grew directly out of the loam of its success. The institutional credit that had been built up during the war years was in danger of cementing the body firmly on to the plinths of the establishment and that temporary cessation of hostilities with the Government and established social order, which the war years had required, was increasingly developing into a permanent détente. The tension which was to develop within the AIA, and which culminated in the final rejection of its political objectives from its constitution, developed out of the contest between those who wanted to maintain this newly-won institutional respectability, to cultivate its role as a social and professional association with particular interests in promoting popular interest in the arts, and those who sought to return to its original course of radical opposition in both artistic and political arenas.

To some extent, this dispute was coloured by questions of generation conflict. The young artists and designers in their twenties, with little to count by way of established career, who had typically constituted the original membership, were now twelve years older. Many had gained prominence in their professional work, so that not only had the spur of sparse or exploited employment been removed for them, but also much of the eagerness and mutual tolerance of youth — the idealism of working together for a greater goal — must inevitably have diminished. This would have held true to some degree for any generation, but for those who had undergone the very particular strains and experiences of the war, the effect must have been even more profound.

The AIA had always encouraged the support of students, mostly from the London art schools and a distinctive student section had been fostered within the membership, so naturally there was a constant revocalising, from students and young artists, of discontent about conditions, and a reminder of the radical, political attitudes which had motivated the original conception of the AIA. Not that the call for a restatement of the earlier directions should be

155

identified exclusively, or even predominently, with this newer generation however. There were certainly many older members who were not yet ready to forget their former opposition to fascism, war and imperialism, but they were to find that the overall political climate was now far less propitious for the reiteration of these views. Quite clearly, the days of Popular Front unity and tolerance of individual political identity were over, and the work of recalling the AIA to its original firmness of radical opposition fell increasingly to those who were either Communist Party members or still very sympathetic to it.

For various reasons, these more radical members were feeling themselves drifting further away from the consensual attitudes held within the association (though of course it would perhaps be more accurate to speak of the continental drift to the Right of most of the membership). For although the Communist Party had enjoyed unprecedented support at the time of the USSR's wartime alliance with Britain, this ground was gradually eroded as the period of Cold War began. Indeed British antipathy to the USSR was increasingly reflected by the party itself, in its rejection of Popular Front concessions, and in its requirement from its members of stricter adherence to centrally determined policies. Also, for many Communist Party members and sympathisers, the ending of hostilities had afforded an opportunity for a more dispassionate examination of their personal beliefs and their reactions to the Stalinist policies of the intervening years. Many had survived the crises of the reports of the political trials in Moscow in the thirties, the non-aggression pact with Germany, the movement of Soviet troops into Poland and Finland at the opening of the War, and who had accepted them at the time out of expediency or complaisance, but who were now more easily persuaded that these actions conformed to a pattern of totalitarian power which they should no longer be prepared to accommodate. This tendency was steadily refuelled during the subsequent years, with the disputes over the nature of Russia's policies of coercion in Eastern Europe.

The political mixture of the AIA after the war was further complicated by the attraction to its lists of a number of artists who, whilst not being especially active politically, were, by most standards, pretty High Tory in background and social attitudes. Presumably, they were attracted by the association's professional achievements and potential as a successful exhibiting society whose former political associations were considered so distant as to be no longer embarrassing.

Moreover it is easy to understand the position of the

mainstream members who had willingly weighed in with their support for anti-war and anti-Fascist causes in the thirties, but who were now genuinely unclear as to where the future directions of the association could usefully lead. The epidemic of Fascism spreading through Europe and Britain had at least been curtailed, if not entirely eradicated, so, in the immediate aftermath of the war, the relevance of these formative concerns was thrown into doubt. Equally, the political atmosphere in England was now very different from the thirties, when the AIA found itself in systemic confrontation with the views and policies of the Conservative dominated National government. For many, the policies of the new Labour government based on principles of equality of education and opportunity, the promise of the Welfare State, and the general optimism which went with the possibilities of reconstructing a new social order in the country, amply matched the limits of their social concern, and their automatic presumption of opposition to government policy no longer applied.

The symptoms of this mood of uncertainty and anticlimax can be read both in and between the lines of James Boswell's book *The Artists' Dilemma* written in 1947 (the year when he gave up his employment as Art Director with Shell), in which he examines many of the ambiguities affecting the working artist's life as seen through a post-war perspective. The dilemma to which Boswell refers is nothing less than the directions which the artist must now follow in persuit of patronage, and his conclusions are, on the whole, despondent, even though he claims interestingly enough, that the war years had been boom times for the artist both in terms of sales, and the renewed interest with which the public had responded to the travelling exhibitions and promotion schemes of CEMA and the AIA. There had also been the public's curious reaction in suddenly revaluing the contents of the national collections as soon as they were rendered scarce by their removal to a safe place. People had kept up the habit of going to the galleries much more since the War and the success of the Picasso exhibition at the Victoria and Albert Museum (in 1946) is seen as significant of the public's acceptance of contemporary art. Further, for the time being, sales were high for contemporary work as those with surplus revenue were restricted by rationing and availability, from spending on conventional consumer goods. Quite apart from these trends, Boswell feels that some approachment between the artist and public had been forged through the general sense of social unity engendered in the war period and by the integration of artists into the work of the civilian and armed forces.

Yet despite all these good omens, Boswell doubts if

157

the basic inconsistencies between the artist's self-image and the reality of the frustrating working conditions which the artist had had to tolerate in the '20s and '30s were likely to be substantially eased, especially with the predicted demise of the private purchaser.

In order to maintain oneself as a progressive artist (i.e. not tied to pot-boiling flower pictures, hunting scenes, boardroom portraits and the like), Boswell points out that supplementary income must be looked for either in art school teaching or in commercial art. In connection with this first option, Boswell paints a depressing picture of the state of the provincial art school, castigating it for its low standards of achievement, its primary intake of less than committed daughters of the local burghers, and its teaching methods, geared to irrelevant examinations. Confined by such circumstances, it is inevitable that the bright young art masters will soon succumb to this doleful atmosphere and 'continue to mangle and maim the talents that are entrusted to their care'.

The alternative solution (pursued by so many of Boswell's colleagues in the AIA during the thirties), of earning one's living from work for advertising agencies, he now saw as totally cancerous to the creative will of the artist:

> If you start by offering the business man the sort of muck that he wants, you will most likely end up by being unable to offer him anything else.

The advertising agent is attacked as the great seducer, who, with over two million pounds to distribute to artists — far more than the contemporary market for fine art — buys up the best talents of the time and stands in the way of good painting being produced.

The crisis of conscience that Boswell depicts is simply a restatement of the search for an honourable and serious role for the artist in a changing society — a role which had been temporarily deferred by the special circumstances of the War. But he is unable to offer any very resounding alternative to the dismal patterns of employment he has been describing, beyond a vague and indetermined demand for the right to:

> paint for the community . . . those dreams and visions which enrich the present and predict the Future.

This mood of uncertainty is mirrored in the unsettled currents at the AIA. The quick turnover of chairpersons

after the resignation of Misha Black who had held the post from the inception is an index of this. He was succeeded briefly by Boswell in 1944, then, in succession, by Morris Kestelman in 1945, Maurice de Sausmarez in 1946, Beryl Sinclair in 1947, and Richard Carline in 1950, and this change of rhythm was primarily due to the difficulties of holding together a consensus within the membership.

But some of the original objectives still maintained their justification, and one of the particular strands of policy which was actually further developed during this period, was the effort to draw attention to the popular arts and to the encouragement of the untrained artist, and a number of exhibitions reflect this approach.

1945 saw an exhibition which anticipated the fascination for popular imagery that was later cultivated by the Independent Group connected with the first days of the ICA. Richard Carline presented a selection from his collection of picture post cards as 'A survey of the taste of the million, during the last few decades'. This exhibition, at the Charlotte Street Centre, highlighted a view which Carline shared with a number of other AIA contemporaries that popular art, far from being represented as a degenerate derivation from high art, on the contrary should be seen as signalling a more promising direction for the energies of contemporary artists than the decadent aestheticism of the high art styles they had inherited. Later on he was able to explore the material further in his book *Pictures in the Post*, which was published in 1959.

Earlier in 1945, the gallery space at the Charlotte Street Centre had been given to a pavement artist well known in the Hampstead and Finchley area, David Burton. For the purposes of the exhibition he employed the medium of water colour, and his qualities were applauded by Julian Trevelyan as representing the genuine popular forms of art which were everywhere losing ground to the imposed mass-culture of Walt Disney. 'It is significant, says Trevelyan, that Burton complains that Disney doesn't know how to draw ducks.'[2]

Another example of the AIA's concern to promote popular art styles, was the invitation given to L. S. Lowry, whose work was still little known or appreciated in London, to contribute to 'This Extraordinary Year', the AIA's exhibition at the Whitechapel Gallery in 1945. Francis Klingender also wrote an appreciation of his work in *Our Time*[3].

One well-received show, restricted to 'Under Thirties' (1948), included worker artists George Poole, a Battersea carpenter who had been painting for only 18 months and whose painting skills had been learnt at a workmans club, and Eric Thornton, a foundryman by trade,

159

described by Gerald Marks as 'a genuine primitive'. Something of the outgoing spirit of the 1930s was caught by the sandwich board parade which some of the exhibitors took part in to publicise this show.

One of the most convincing talents to come out of the search for the artist whose values and world view had been shaped by the conditions of working-class experience was that of Hubert Cook. As a foundry worker in the railway works at Swindon, his artistic skills had been recognised when he consistently hauled off the prizes in the annual Great Western Railway's art competition. Cook was awarded a scholarship at the Central School, which enabled him to perfect his command of lithography to produce works of both high aesthetic quality and a sense of commanding authenticity in his industrial scenes.

The exhibition called 'The Coalminers' in 1950 marked the last occasion when the socially conscious aspect of the AIA's work was demonstrated in its exhibition programme. The show included work from several worker artists drawn from the major coalmining areas — Norman Cornish, J. J. Roach and Oliver Kilbourn from the North East, George Bissill from Chesterfield, Harold Lightfoot from Lancashire, C. Ifold from South Wales and S. Farrer from Nottinghamshire. The subject matter concentrated on the life and work of the miner and was supplemented by contributions from a number of professional artists, notably Henry Moore, Josef Herman and Paul Hogarth. 'The Coalminers' became the subject of a television film, produced by the DATA film unit.

Much of the post-war activity of the AIA was patterned by the creation of its own gallery and basement club-room in premises at 15 Lisle Street close to Leicester Square. This need was particularly urgent following the closure of the Charlotte Street Centre, at the end of 1945. It appears that Claude Rogers was the first to light upon the Lisle Street premises and the AIA quickly agreed to take up the lease in April 1947, seeing how well it fitted their needs, even though they nearly bankrupted themselves in the first year of its operation because of debt charges which had to be paid off.

But matters were soon put in hand and a long succession of one person and group shows of the work of AIA members was to be maintained until the expiry of its lease in 1971. As a major point of principle, it was felt that the AIA's control of the gallery and the selection of work by artists themselves could do something to oppose the power of the dealers to restrictively influence art production. An arrangement was made whereby the gallery would be supervised by a permanent curator, in return for a percen-

tage of sales proceeds in lieu of salary.

A programme of lectures for members was well supported for a time. In 1948, for example, William Townsend and Millicent Rose were responsible for selecting speakers on such varied topics as Indian dancing, Chinese Architecture, American Folk Song, the Planning of New Towns, Racism and Anti-Communism in the United States of America, and Stanley Spencer speaking on his own method of working. Naturally talks by fellow artists were of particular interest to members and on another occasion, the surrealist painter Ithell Colquhoun 'intellectually as precious as can be' according to Townsend, who, after dismissing all contemporary painting in Britain as valueless, predicted that the only future could possibly lie with 'automatic marks and stains'.[4]

It should not be supposed, however, that the left wing of the AIA (for now such a concept was becoming apparent) acceded to this shift away from the original objectives of the movement by complacency and inactivity; in the first *Bulletin* after the Victory, a member wrote in to urge the Central Committee to reaffirm its political position in the light of the forthcoming General Election and to hold an exhibition to illustrate members' views.[5] A characteristically diplomatic resolution came from Misha Black in response, which urged that the Central Committee issue a circular advising members to vote for candidates, 'who in their individual opinion were more likely to further the aims of the AIA', and further that members offer their services as 'technicians' to their preferred candidate.

Neither was the membership's sense of concern for international cultural issues entirely dulled; as a result of the growing harassment of Hollywood filmworkers by the Committee for Un-American Activities, a telegram was sent to Katherine Hepburn offering 'Warmest support to your stand against political witch-hunt' and affirming 'You defend freedom vital to all artists'.[6] Obviously behind this statement of solidarity with American film workers was the concern that similar reactionary forces were at work in Britain and in June 1948, the AIA endorsed the objections raised by NCCL to political discrimination in the employment of Civil Servants — a policy which operated to discriminate against Communist Party members.

The AIA's links with artists from Germany, which had been formed before the war out of feelings of political solidarity and basic humanity, but which had often flourished into close, personal friendships entered another phase immediately after the war, when decisions by refugee artists, about returning to a destitute and politically divided Germany, had to be made. The situation of those who had

161

not been able to take refuge and had been forced to live through the Nazi regime was also recognised. Some had been overtaken by events, like the sculptor Tisa Hess. Hess had come to England in due time and had gone to live in Ashington to find out more about the worker artists living there but had been recalled to Germany in 1939 by her father's death. Despite her adamant anti-Nazi and anglophile views, she had been refused re-entry to Britain and had had to live out the war in Germany.[7] John Heartfield was not fit enough to take up his teaching post in the GDR until 1950; Schwitters was never to regain his health sufficiently to return to Hannover to resurrect his Merzbau, and for many other refugee artists there seemed too little to entice them to return.

Richard Carline, always the ready traveller, visited Hamburg in 1947 and made contact with Martin and Ruth Irwahn of the Hamburg Artists' Union, who proudly maintained in their organisation's name the stigmatic epithet 'degenerate artists'. The Irwahns came over to England as delegates of the Union and were able to point out the poverty and lack of working materials from which its members were suffering. The AIA agreed to give some assistance with materials but established a priority for giving support to concentration camp victims.

There was great interest among individual members in the various ways the new European Communist countries were developing, and in 1947, Percy Horton, Lawrence Scarfe, Ronald Searle and Paul Hogarth had all been on a visit to Yugoslavia and the results of their records were shown at the Leicester Galleries. The four artists were particularly concerned with documenting the construction of the Bosnia railway which was being undertaken by a youth volunteer force which symbolised the idealism of the country's period of social reconstruction. Henry Gottlieb reported to members on the situation of artists in the newly socialist Poland, from where he reported that he had found little official interference or direction on questions of style, but that the artist enjoyed much greater acceptance and understanding from the people than in England and that his works were likely to be better distributed, through Trade Union clubs and the like.

But the serious ideological rift which was to divide the loyalties of AIA members was soon to surface in mid-1948 over attitudes towards the Soviet Union. The British press had reported a dispute within the Moscow Union of Artists which had obvious implications for all Communist Party artists internationally since it reaffirmed Moscow's insistence on strict adherence to Socialist Realist principles. Primarily the criticism had been levelled against

certain named composers like Prokofiev and Shostakovich who were accused of retaining inappropriate elements of formalism in their composition and of substituting an ill-considered love of novelty, to the neglect of the best traditions of Russian music. Although this complaint had been stimulated by a particular operatic production, Muradeli's *The Great Friendship*, the Moscow periodical *The Bolshevic* gave no room for complacency on the part of visual artists whom it claimed were plagued with the same disease. Naturally this matter came up for energetic discussion at the AIA, and Jack Chen and Francis Klingender were there to clarify the position of the British Communist artists. After pointing out the distorted and prejudiced tendency of the accounts of the proceedings which had come through the British press, they demonstrated the errors which automatically arose from any discussion which was limited to the established points of view about the role of art in Britain. Members were asked not to close their eyes to the cultural dictatorship of the BBC and art dealers' shows, which dogmatically rejected any socially real content. It was pointed out that the main difference between the work of the Russian artist and his counterpart in Britain was that in Russia the artist is understood to be a moral leader, whereas here the artist prefers to stand aloof from the concerns of the people.

Correspondents were able to point to many examples of ideological dogmatism from the West; the destruction of Rivera's Rockefeller Centre mural was recalled and Peri pointed out that the War Artists' Advisory Committee had in practice imposed an 'Ideological adherence', on its participant artists.

This issue was merely the first spark, and was soon overtaken in importance by dispute over the Russian presence in Czechoslovakia. The most active spokesman for the Right Wing of the AIA emerged in the person of Stephen Bone, a landscape painter and Art Correspondent to the *Manchester Guardian*, who determined on confrontation by calling for an AIA statement criticising Russia's interference in the affairs of an independent state. There was an intense and varied reaction to this call. Pat Carpenter complained of the war hysteria prevalent in the Press and BBC in their reporting of the events, Ray Watkinson countered Bone's move by requesting a resolution censuring the USA's ban on the 120,000 members of the German League of Culture. It was clear, however, that there was a surge of unease and uncertainty expressed by many members situated between these positions, and a Central Committee statement was issued which said that, although the press accounts were conflicting and confusing, it appeared

that changes in the Government of Czechoslovakia had proceeded in a democratically acceptable manner, the statement concluded:

> If unjust actions and victimisations have occurred
> we would certainly condemn them. At the same
> time, mindful of the present state of International
> tension, we do not intend to join in any general
> mood of panic, opposing East and West.[9]

If this was intended as an attempt to allay the concerns of the Right, it fell signally short of the mark, and Bone next proposed that the political clause in the AIA's Objectives be suspended in order to avoid an irrevocable split within the organisation. He justified his anxiety about what he saw as the Left bias of the Central Committee by pointing out that the Labour Party had openly condemned the course of developments in Czechoslovakia.

An Extraordinary Meeting was called, and following acrimonious discussion Bone's resolution was rejected by 58 : 43, but confidence was not improved when Beryl Sinclair had to declare the vote null and void through a technical irregularity in checking the vote.

This was one of the occasions on which reference was made to the individual members of the advisory council consisting of James Bateman, Vanessa Bell, Misha Black, Anthony Blunt, Sir Muirhead Bone, Frank Dobson, Duncan Grant, Percy Horton, Augustus John, E. McKnight-Kauffer, Oskar Kokoschka, David Low, Henry Moore, Paul Nash, Lucien Pissarro and Ethel Walker. This was so unusual an occurrence that at least two advisors, Vanessa Bell and Duncan Grant were surprised that they were still members of the Council and promptly resigned — Grant adding that he felt that the AIA had become purely a political society.

Gradually the pressure from the forces within the AIA which were opposed to its retention of a political voice gained ground, especially under the guidance of Beryl Sinclair, and October 1949 saw a policy statement from the Central Committee, to the effect:

> That no action on any issue which could have a
> political interpretation will be taken without
> consultation with the membership.

The last attempt to revive the spirit and purpose of the thirties was in the summer of 1950 when Carpenter, Leslie Hurry, Minton, Herman and Pasmore were among those who called an extraordinary meeting to react to the

threat to world peace, which was posed by the Korean conflict. Members were reminded of their record of the past when they acted with political responsibility, and the Central Committee was asked to sign a petition against the use of the atomic bomb — a petition which already included Picasso, Shostakovich, Thomas Mann and Sybil Thorndyke as signatories — and to send delegates to the British Peace Committee. But even these moves were deeply distrusted by many within the AIA as embodying Communist Party tactics and were strenuously opposed.

One more postscript, which serves to signify the dispersal of aims and the crumbling of a unified ideology, was the situation which concluded in the exhibition 'The Mirror and the Square' held in December 1952.

In addition to the continuous programme of one-person shows held at the AIA's Lisle Street gallery, the tradition of the special annual show drawn around a given major theme was kept up, in order to catch the public attention and to guard against the impression of the AIA being some venerable exhibiting society with another tired Annual Exhibition. But the strains of finding a theme which would attract a broad consent of the membership reveals again the dissolution of purpose and the drawing up of opposing ranks. To an extent this tension can be taken as a microcosmic reflection of the uncertainties within British art generally in the 1950s. Essentially the question was, where did one's loyalties lie? — to the traditions and patterns of a national culture, or to the international avant-garde, whether located in Paris or, later in New York.

One discarded suggestion for the major theme for the 1952 exhibition was 'Art for a Purpose', but whilst most members held on to a firm notion of the usefulness of art to society, there was evidently growing uncertainty now as to what that purpose might be. The group who were constantly pressing for the AIA to support the Peace movement and to protest against the atom bomb proposed that the Association should take steps to organise an exhibition 'To show artists support Peace as against War', and indeed this proposal was at first agreed to, with the provision that it avoided collaboration with the British Peace Committee (because this organisation was considered unacceptably identifiable with the Communist Party). In the event no such exhibition did take place under the AIA's auspices although three exhibitions entitled 'Artists for Peace' were held in 1951, 52 and 53. These were organised by, and included work from, a large group of artists who had in the past always been in the forefront of AIA activity, Pasmore, Rowntree, Minton, Spear, Weight, Hurry, Rogers, Chittock and many others, but who by this time had found it

165

necessary to act independently in order to put on a politically contentious exhibition.[10]

The theme which emerged instead for the 1952 show, *The Mirror and the Square*, was an attempt to accommodate what Stephen Bone identified as: 'the prevailing controversy between those whose work is abstract and those with a humanistic approach' under the AIAs former traditions of tolerance on matters of style. According to the catalogue introduction the 'Mirror' symbolized 'a literal image of the visible world', and the 'Square serves the draftsman as a precision instrument, but it is also an abstract, geometrical concept'. Consequently the show evolved as a survey of the range of current British art from the Socialist Realism of Chittock, to Constructivist reliefs from Mary Martin and Victor Pasmore, and including the younger modernists like Frost, Heron and Hilton; but whereas in the 1930s such a span of work would have been assembled to demonstrate professional solidarity and support for certain, stated social and political ideals, now the intention seemed to be exclusively to serve art's own internal purposes. The medium had become the message and even Realism, given this presentation, was reduced to being simply one of the stylistic choices available to the artist of the 1950s.

By 1953 the AIA had been finally gelded of its political purpose, with the adoption of a new constitution, and with much of its most active support moving on elsewhere; membership had declined from nearly 1,000 immediately after the war to some 375, as it moved into a different phase, with different personnel and different objectives and values.

Notes

1. The Dartington Report *The Arts Enquiry* (published by PEP 1946) which had been set up to advise the Government on future policy in supporting the arts, acknowledged the importance of the AIA in demonstrating the social and political effectiveness of the artists' contributions, as well as commending its innovations in setting up regional groups, touring exhibitions and the mass-produced artists' print scheme.

 For a history of the Arts Council, see E. W. White, *The Arts Council of Great Britain*, London 1975.

2. Julian Trevelyan, *AIA Bulletin*, 85, 1945.

3. F. D. Klingender, *Our Time*, April 1945.

4. Townsend Journals, (unpublished) entry for April 30th, 1949.

5. *AIA Bulletin*, 87, 1945.

6. *AIA Newsletter*, December 1947.

7. T. von der Schulenburg, (Tisa Hess) *Ich Hab's Gewagt*, Basel, 1981.

8. Henryk Gottlieb *AIA Newsletter*, July 1948

9. *AIA Newsletter*, June 1948.

10. The Artists for Peace organisation and exhibitions are discussed more fully in L. Morris and R. Radford op. cit. pp. 86-7.

THE COMMUNIST ARTIST

The concept of the Communist Artist working in Britain during the time under review cannot be delineated with much precision, and in any event it would be a mistake to differentiate too forcibly between the activities and the world view of artists who were members of the Communist Party and the activities and world view of the typical member of the AIA. We are dealing in either case with individuals from a number of different backgrounds and life experiences about whose motivations and commitment it would be misleading to generalise. For some, it is certain that the struggle for the Workers' Revolution had become the overwhelming driving force in their life, which they served to the best of their ability by their skills as artists. For others, success in their career as a fine artist or a commercial designer was more important and could be separated without hindrance from their political engagement. There were yet others who, even though they might be deeply involved in their desire for social and political change, remained unable to make the necessary compromise between their received ideas about art and being an artist, and the Party's demand for adherence to the principles of Socialist Realism. Yet for all these cases, it is certain that membership of the Communist Party indelibly affected their attitudes, for membership was not to be undertaken lightly, nor was it lightly granted. A deal of personal commitment was required from members in terms of time and effort, attending and addressing meetings, re-

cruiting, leafleting and canvassing, in addition to employing their trade skills as visual communicators. This level of commitment was supported by an effective level of organisation, and further maintained by a cultivated sense of conscience and self-criticism; past members have often commented on the parallels with the codes of behaviour of evangelical religion.

Some Communist artists had joint membership of the AIA and others had no connection with it. Over the two decades, a kind of *pas de deux* was played out between the two groups, on occasions they were inextricably linked and mutually supporting, then as the pace of the music changes, they drift somewhat apart but continue to move in harmony, till at the final act, the AIA undergoes a tortuous crisis of doubt and gradually fades from the stage.

The character of the first phase of the AIA, the period of the Artists' International, is evidently closely identifiable with the ideology of Communism. One of the proposed names put forward at the inception of the body was 'The International Association of Artists for Revolutionary Proletarian Art', which bears something of the ponderous stamp of Moscow — and it has been noted to what extent, the first manifestos are particularly supportive of the Soviet Union. The work of AI members and accounts of its activities appear regularly in the Moscow-published periodical *International Literature*. Yet curiously enough, even at this initial stage, Communist Party members were in the minority, though it is equally significant that the majority was happy to comply with the AI's expressions of Marxist ideas, because for many in 1933, the Communist Party was the party of youth and promise. Above all, it was seen as the only substantial political movement which was pursuing a policy for world peace and opposition to Fascism; aims with which the majority of politically informed young people were ready to associate. It should also be stressed that the analytical methods of Marxism asserted an attraction for many through its claims to be able to clarify historical and art historical problems. Indeed this attraction was felt by many for whom social revolution was less than paramount, and who were certainly not necessarily members of the Communist Party.

Some of the founder AI members like Rowe, Boswell, Lucas and Angus had already been engaged on some kind of work for the Communist Party prior to 1933, designing pamphlets and publicity material, and opportunities for exploiting their graphic skills were increased by the establishment in 1930 of *The Daily Worker*. An example of such work is the spirited strip cartoon by Peggy Angus for a women's page,[1] which points to the issue of the exploitation

Figure 26

of women workers by regulating their numbers in employment and their wage levels in the interests of capitalist production — this at a time when inequality of opportunity for women was rarely discussed as a major issue by the Left. The Communist Party was still relatively small (membership in 1930 was around 2,500, largely drawn from trade unionists in the heavy industries) and the formation of the AI was one of the first signs of the expansion of support amongst the middle-class and the intelligentsia; an expansion which was to lead to a membership of around 56,000 by 1942. When in 1935 the AI sloughed off its too obvious Marxist appearance and metamorphosed into the AIA, its Communist members were put to no difficulty in staying with the organisation in its new form as such a move was fully in key with the Party's Popular Front policy.

The pages of *The Daily Worker*, through the middle years of the decade, give some impression of the kind of propaganda work undertaken. Besides the work of the regular house cartoonists, Gabriel (James Friell) and Maro (M. A. Rowley — subsequently killed in the Spanish Civil War), work which had originally appeared in the American Journal *New Masses* was also occasionally published. *The Daily Worker* carried photographs of various forms of agit-prop activity — slogans painted on the front of locomotives, lorries decorated for festivals, banners depicting appropriate scenes from British history for a recruitment rally, a giant banner for the 1937 LCC elections declaring solidarity between Battersea and Madrid, a major historical pageant for Tonypandy, and preparations for May Day celebrations including the appearance of the newly restored banner which had been originally painted by Robert Tressall. The production of all this propaganda material was greatly assisted by the establishment of a special studio at *The Daily Worker* offices.

By 1939, artists and designers within the Communist Party had organised themselves into a body known as the Hogarth Group (or Club). Although they were still influential within the AIA and particularly on its Central Committee, they were probably becoming increasingly conscious of the inertia imposed by the liberal rump of the Association, and of the need to maintain a more concerted radical approach. There was not, however, any sense of schism between the two bodies at this stage, and in the long hot summer before the outbreak of war we find them playing out whatever differences they might have had in a cricket match.

It has been noted that, prior to the German attack on Russia in 1941, the Communists in Britain largely regarded the War as a conflict between rival forces of capitalism and

its cartoonists were busily occupied in promoting this position. When in January 1941, the Government used its emergency powers to suppress the publication of *The Daily Worker* because of its continued support for the People's Convention and its 'demoralising' reporting of the war, *The Daily Worker* artists had to find alternative means to carry on the protests against the Government's war policies, and in particular against the ban on their paper. One such venture was an exhibition of drawings and cartoons by Gabriel, Jack Chen, Pat Carpenter and 'Hob-nob', brought together under the title 'The Front Line'.[2] The catalogue foreword, after complaining of the injustice of the ban, the absence of any right of appeal and the consequent deprivation of livelihood for its artists, was able to point to Nazi Germany as the country which up until then had been most usually associated with suppressing newspapers and banning artists.

When a year later the ban was eventually lifted and *The Daily Worker* was on the presses again, the dominant themes of the cartoonists were the inefficiency of the war measures and the tardiness in preparing the Second Front to relieve Russia from the burden of defence against the concentrated forces of Germany. In October 1942, the Hogarth Group was out on the streets of London using the 20' hoardings of advertising sites, to paint images and slogans aimed at encouraging production and pressing for the advancement of the Second Front.

Undoubtedly, one of the main functions of the Hogarth Group was to provide facilities for debate about the nature of Socialist Realism, and it is instructive to examine the views of two artists who were constantly engaging this issue in their painting, and were also ready to clarify their attitudes in print — George Downs and Cliff Rowe, who were both AIA and Hogarth Group members.

The situation of George Downs is of some interest, since his origins were undeniably working-class and deprived and his career as a painter was attained without the benefit of formal art training. The son of a bar-worker and orphaned at nine, he spent the rest of his childhood in a convent children's home. He took briefly to numerous jobs — messenger boy, waiter and market trader — whilst educating himself about art via the agency of the museums and dealers' galleries. Neither did he neglect the broader aspects of his education, reading philosophy, psychology and sociology until 'I arrived at Marxism which supplied me with an evolutionary and dynamic explanation of Society'.[3] He claims to have worked for six years at his painting, following his own initiative and without contact with other artists until in 1939 he met Julian Trevelyan, who together with Tom Harrisson advised him in authentic Mass Obser-

vation tones, 'to paint your own life, your own experiences, use that for your subject matter'.[4] Any fascination that the London Art World might have found in the prospect of discovering a 'naive' painter must have been quickly frustrated by Downs' evident wide reading and articulacy. If Naivety exists to any extent in his painting, then it is a version of that cultivated naive style recognisable in Trevelyan's painting at this time. The decorative manner of Braque and the techniques of Surrealist simultaneity are equally present in his visual language as can be recognised in his rendering of *Young Cockney,* but a more realist expression is

27. George Downs,
Young Cockney, 1945/6.

reserved for his East End scenes. Downs' exemption from art school conditioning enables him to accept the force and validity of popular art without compromise and he cites the historical tradition of popular painters as commonly defined by Marxist art historians like Blunt, of Breughel, Daumier, Goya and Van Gogh, but adds a personal extension to include Modigliani, Braque and the Picasso of *Guernica*. He sets out to correct what he sees as the common misapprehension of identifying popular art with uninspired realism, insisting that poetry and lyricism are also needed in order to appeal to the heart as well as to the mind of the people. In an article written on the occasion of the 1942 exhibition of 'Russian Painting in Reproduction', he takes the opportunity to drive home the point:

> What is realism in Art with Repin, today if uncritically copied, degenerates into a superficial mode of expression, into an academic formula of illustration.[5]

Not unnaturally, he puts forward a case for considering the value of Surrealism, suggesting that the multi-layered symbol, the painting's engagement of the viewer's dynamic and creative faculties, are more applicable to the intelligence of modern man that the simpler idiom of nineteenth century Realism which makes no demand on the viewers creative co-operation with the artist.

The more orthodox voice of Socialist Realism can be recognised in the work of Cliff Rowe who in his consistent production of paintings through the 1930s and 40s, pursued just that quality of narrative realism which Downs rejected. In his numerous scenes of life in the factory, the pub, the fish-and-chip shop or the intimate groups of idlers on the pavements and front steps of Kentish Town, the Realist mode is well presented; but in addition to these celebrations of working-class life, another mode is adopted when any more definite political statement has to be made, and in the interests of clarity of reading the written word is often incorporated into the imagery in the guise of slogans on poster and banner. The most fully realised example of Rowe's work in this idiom can be found in the large mural scheme he painted between 1953 and 56 for the Electrical Trades Union (since incorporated into the EEPTU) at their training college at Esher depicting the history of British Trade Unionism. Rowe points out that the conventional Socialist Realist style in which the paintings are executed conformed more to the preferences of his patron than his own, since by that time he was wanting to introduce more advanced formal techniques. This can be seen, for

Figure 28

28. Cliff Rowe, *Panels for the mural depicting the history of the Trade Union Movement, for the ETU Training Centre, Esher, 1952-6.*

Figure 29 example, in *Pipe Cutter*, from around 1952.

For those who required it, guidance was becoming increasingly available by the 1940s regarding Socialist Realist theory and Marxist Art History. Regular articles and synopses of conferences appeared in the various publications coming out of Moscow, and for those who might be deterred by the starkness and distance of these deliberations, Klingender's *Marxism and Modern Art*, which was published in 1942, mediated these theories with a greater sensitivity to the nature of the British cultural tradition. In a recent interview[6] Rowe gave an illuminating account of the stages through which he and a number of his colleagues had progressed in reaction to the theory of Socialist Realism.

Firstly, he stressed the persuasiveness of the ideas as simply stated. They possessed for him an immediately apparent logic and were backed up by a chain of historical evidence, as soon as the history of art was examined from a social and economic viewpoint; but, after having pursued the paths of orthodox Socialist Realism for five or so years, doubts began to set in over the effectiveness and applic-

ability of naturalism. However, it was awkward to admit these doubts too openly, because one exposed oneself to censure, particularly from non-artist colleagues, who, in all sincerity, suspected that hidden, anti-Soviet propaganda lay behind this 'revisionism'. To make matters more difficult, there existed no tangible body of work resulting from these doubts which could adequately answer the charges.

29. Cliff Rowe,
Pipe Cutters (detail),
oil on board, c 1950.

175

The central difficulty for Rowe and his colleagues was the Stalinist line that 'all art is propaganda', which could too easily be reduced to 'all art is nothing but propaganda', whereas most artists would of course want to claim that art had an independent aesthetic value over and above simply its use value. Even when one restricted one's survey to the great realists, Breughel or Rembrandt for example, it was obvious that there was much more here than just 'propaganda'. But the next stage of analysis of the problem posed the greatest difficulties. Since it was clear that form and content were mutually inseparable within Socialist Realist painting, the unsatisfactory condition of such painting would require a re-examination of matters of content as well as form which 'at the time seemed like blasphemy and I hardly dare look at the implications'. Again referring back to the history of art, Rowe considered that the narrative style of Soviet Socialist Realism was also common to both bourgeois Victorian painting and to contemporary, popular fiction illustration, and furthermore it was apparent that the Soviet artists were using this naturalistic style for much the same purpose, though probably just as innocently as their Victorian predecessors, to create a romantic illusion of well-being and to substitute complacency for criticism. Again the fear of being misunderstood and earning the label 'subversive' hampered open discussion of these conclusions.

This was the stage that had been reached in the thinking of Communist artists like Rowe and Carpenter after the war, and it coincides with their parting from the AIA after it had shed its political objectives, or 'after it had lost its mainspring', as Rowe put it.

How to proceed from this point? John Berger's opinion was that a socialist art could only be expected to emerge once a socialist state had been established, and even then only from a generation of artists who had grown up in that state, untainted by capitalist traditions of art; but Rowe preferred to believe that in just the same way as there could be individual Communists existing as 'prototypes' within an existing Capitalist body politic, by the same token, there was always the possibility of a prototype Socialist art, germinating within Capitalist society.

The work of the Hogarth Group was carried over into the activities of the Communist Artists' Group, which was set up in 1947 as a sub-group of the Party's Cultural Committee, and which took its place alongside other special interest groups dealing with writing, music and the theatre. The Group's brief was to deal with the operation of its members as Marxist artists and to discuss the practical and theoretical problems peculiar to the visual arts, in the hope

of improving the quality of their own creative work and of influencing other artists towards an appreciation of Marxism.

Membership was not limited to professional artists, since it was realised that such a restriction would lead to very few likely candidates. The proportion of Artists' Group members working in various aspects of commercial practice as distinct from the fine art element of the profession was greater than that within the AIA membership. It was also ruefully admitted that there were too few Communist artists or writers of high standing and reputation in the cultural world and so this became one of the major issues to warrant the group's attention. The Party's equivocal embrace of Picasso in this post-war period reflects the division of attitude between the political and cultural interests within it. While the political wing was well aware of the propaganda benefits to be derived from celebrated cultural figures who were seen to be sympathetic to Communism and therefore encouraged their cultural wings to pursue this approach as a matter of policy, it was still resistant to pressures coming from artists to moderate the restrictive interpretation of Socialist Realist style.

This element of conflict was to dominate the debate within the various cultural groups over a number of years even though it was frequently shrouded in a Byzantine complexity. The tendency of ideas of the Communist Party of Great Britain was dominated by the political, economic and scientific disciplines and it was acknowledged that the cultural workers would have to continuously press, through argument and practice, for any rebalancing of emphasis and tendency within socialist art. Clearly this pressure was often fired by frustration, as the Writers' Group commented in 1946:

> some would-be Marxist critics have been able to palm off judgements made on purely economic and social grounds as genuinely Marxist analyses of art, but one cannot solve aesthetic problems by doing away with aesthetics and confusing the context of art with its content.[7]

The work of the Artists' Group seems to have been largely taken up with theoretical concerns and less by way of practical production can be directly associated with it, with the notable exception of the graphic work and illustrations to the magazines *Arena* and *Daylight. Arena* (1949-51), with its editorial board of Arnold Kettle, Montagu Slater, Randall Swingler and Alick West, attempted to retrieve

some of the ground and the reputation that had been enjoyed by *Left Review*. Alongside poetry and prose from European socialist writers, it aimed to encourage writers to find ways to celebrate British cultural values, and this concern to reinforce national cultural strengths in order to resist what were seen as the insidious effects of American cultural domination became a major policy directive. It was to be the central theme of the annual conference of the National Cultural Committee for the two years 1951 and 52 and a special issue of *Arena*, in June/July 1951 was published to consider 'The Threat to British Culture'. The United States was accused of supplementing its policies of economic and military imperialism with a concerted effort to undermine Britain's ethical values and working-class traditions through dishonest but seductive representation of 'The American Way of Life', particularly through the film industry. Pornographic pulp literature and horror comics for children were also seen as ways of demoralising and brutalising the youth of the nation to make them more amenable to the conduct of warfare.

Daylight first dawned in the Autumn of 1952 with the stated object of mirroring the experiences of life of working people through stories and poetry from

> nationally known writers and many whose work has never been published before, from engineers and housewives, miners and teachers, from Labour and Communist and people of no party.

It provided an opportunity for cover drawings and illustrations to the stories from amongst others, Paul Hogarth, Derek Chittock, Reg Turner, Sheila Dorrell and Cliff Rowe.

It is noticeable that it is also from the period of the early 1950s that some of the most substantial examples of Socialist Realist painting were generated in Britain, presumably in response to the official party call for adherence to discipline and orthodoxy. Such works were produced with the aim of presenting events from working-class and labour history in the monumental tradition of history painting.

Figure 30

Lucian Amaral's *The Raising of Lazarus* (69″ × 78″), takes its subject from the return to the surface by miners at Fernhill Colliery, in South Wales after a stay-in strike which was seen as achieving the first major, successful resistance to the employers since the General Strike. The imagery can be related to an (uncredited) photograph in the original edition of Orwell's *Road to Wigan Pier*. According to Amaral, *The Raising of Lazarus* was painted specifically to

coincide with a Communist Party Cultural Conference, with the intention of asserting the values of Socialist Realism, taking on an optimistic and heroic theme, as an answer to the current revisionist pressures. He further expands, on his aims for the work:

> One element that was close to my heart was the dialectic inherent in the situation; the men who were blinded by the light they had not seen for two weeks were the men who most clearly discerned the way ahead; those who were overjoyed were weeping; so the hero of the day appeared as a clown.[8]

30. Lucian Amaral, *The Raising of Lazarus.*

Derek Chittock was art critic for the *Daily Worker* during 1952 and 3 (writing under a pseudonym to protect his employment as art master at a public school), and, on a visit to Paris, had been greatly impressed by the work of Gérard Singer about whom he wrote an article. Singer was working on a representation, on a heroic scale, of dock-workers at Marseilles throwing American arms imports into the sea. Inspired by this example, Chittock made contact with London dockers and discovered that the potential subject for a picture that they frequently mentioned was the arrest in February 1951 of members of a Dockworkers' Committee by Special Branch detectives under an emergency Wartime regulation intended to deal with acts of subversion by Fascists. The resulting painting, again on a considerable scale (48″ × 72″), contained individual portraits of the men arrested to which was added a representation of

Figure 31

179

the artist as a gesture of solidarity. The painting was presented to a meeting of dockers and later bought by the London district of the Communist Party; it is now in the possession of *The Morning Star*. An interesting side-light on the work reveals the facility with which folk-myths can germinate. The story has grown in its present location that one of the figures originally portrayed around the table had had to be erased when he was later discovered to have been a police spy — a story that was received with total surprise when related to the artist.

31. Derek Chittock,
The Arrest of the Dockers, 1952.

Cliff Rowe's commission in 1953, from the ETU for the mural scheme at Esher Place and the stipulation of its Executive Committee, with Walter Stevens as General Secretary, of the Rivera derived, orthodoxies of programme and style, can also be read as a response to the call to order in cultural and political directions of the Communist Party in the early '50s.

The issues connected with the degree of independence of action which should be allowed the individual Communist artist were more hotly debated in France, where the Party held a much more impressive position in the spectrum of national politics and where cultural policy had been traditionally regarded as a major responsibility of the state. The debate was fuelled by the eager desire of Picasso to broadcast the fact of his membership of the Communist Party and to direct his services as an artist to the Party's cause, wherever applicable. Certainly, while there was general agreement that support from such an inter-

national celebrity was undoubtedly a bonus, his practical contributions, particularly his poster designs, his Peace Dove symbol and his large-scale paintings and murals such as *Massacre in Korea,* or *War and Peace* were not always easily digested by the traditionalists.

Klingender, writing in *Communist Review* in 1947, reports to British readers some current manifestations of that debate, which would certainly have been well understood here. Roger Garaudy in *Arts de France* and Pierre Hervé in *Action,* both Central Committee members of the Communist Party and Deputies to the National Assembly, openly denied that there was such a thing as a Marxist Aesthetic. According to Garaudy, the battle between realism and formalism was no longer relevant, a Communist artist had the right to paint according to his artistic conscience; if this fails to coincide with what is morally desirable, then this is no more than a reflection of the discordant state of current society:

> If in this regime you can find nothing else to paint than three fried eggs on a plate, I do not blame you. I blame the regime. Your skill as a craftsman is unaffected by that. On the other hand, I blame an artist who attempts to express a good cause with inadequate means; for he compromises what is great in itself by his own feebleness.[9]

This gross heresy was responded to by Aragon, who saw that it necessarily encouraged a route of irresponsibility and escapism for the Communist artist. There *was* a Marxist aesthetic, he asserted, and that was Realism, not its simplistic interpretation in terms of bourgeois naturalism, but in its profounder, philosophical sense.

The wheels of aesthetic debate within the British Communist Party ground slowly, for it is by no means clear that any advance towards reconciliation had been achieved ten years later, when a new impetus within the artists' group led to the publication of *Realism,* a magazine of the visual arts which ran to six issued during 1956. Rowe is now able to write on behalf of 'those of us who wish tacitly to drop the term',[10] referring to Socialist Realism, yet Rowe still regretted the failure of accomplishment of British Communist artists. In a similar vein, Pat Carpenter admitted the mistakes that had been made in the past by those who remained too attached to Soviet ideas. They failed to see that practising artists must on the whole reject the slogan 'Grasp the weapon of Culture' which opposed their view of the humanising role of art.[11]

Realism founded its hopes for advance in Socialist art

practice on such models as Guttuso's *The Beach* which was acclaimed with enthusiasm by John Berger and on the rising school of British Realists — Brathy, Jack Smith, Middleditch and Greaves — to whom the dubious label 'kitchen sink' was being applied. However, their work was received with some caution and reservation by other Communist artists, suspecting that it was a realism of style more than a realism of content.

26. Peggy Angus, *Strip cartoon for Women's Page, Daily Worker, February 18th, 1932.*

Notes

1. *Daily Worker* February 18th, 1932.

2. The exhibition, 'The Front Line' was held at the RBA Galleries, March 1941.

3. George Downs, 'Why I Paint', *Horizon*, September 1942.

4. Downs, 1942, op. cit.

5. George Downs 'The Tradition of Russian Painting', *Our Time*, 1942.

6. Cliff Rowe, interview with author, October 1979.

7. Report of the Writers' Group, August 1946 (unpublished).

8. Letter to the author, 1984.

9. Roger Garaudy, as reported in F. D. Klingender, 'Communism and Art — A Controversy' *Communist Review* January 1947 pp. 18-21.

10. Cliff Rowe, letter to *Realism* No. 3, April 1956.

11. Pat Carpenter, letter to *Realism* No. 3, April 1956.

AFTERWORD

When reviewing the aims and achievements of the AIA, one point that always comes quickly to mind is the doleful reminder that the experiences of one decade can return again to affect the lives of another generation separated by half a century, and there is naturally an invitation to see the 1980s as some frightening replay of the 1930s. The points of comparison that can be made are only too evident — economic decline, widespread and long-term unemployment especially chronic in communities built up round the older, basic industries, the election of a reactionary government dedicated to a policy of accelerating the arms race and in opposition, a grass-roots Peace movement and a vocal, idealistic but often disarrayed movement of the Left.

But it would be an error to claim that the patterns matched absolutely, for clearly there are significant differences, largely of emphasis and sense of urgency. In the 1930s there was a widespread opposition in the country to a government which was accused by many of being recklessly militaristic in the first years of the decade, and later of being conciliatory and appeasing towards Fascism. Of course, we are not simply considering the Fascism that lurks typically today as outbursts of misdirected discontent in depressed urban areas, but the vast and tangible political forces which were seen spreading relentlessly over Europe. The AIA was founded in 1933, the year in which Hitler came to power, and in Italy and then in Spain the ring was drawing tighter around Britain; at home, the Union of Fascists was

parading the streets, recruiting successfully and obviously had friends in high places in the Press and the Royal Family. The reality of the Nazi suppression of political or cultural expression was soon brought home to AIA members with the arrival of the first of many Jewish and Left-wing refugee artists in London.

On the other hand, alternatives to the spread of Fascism seemed clear-cut. Russia still provided a glowing inspiration for those seeking revolutionary change, its image unblemished by any real knowledge of the extent of Stalinist tyranny. Young idealists like some of the founders of the AIA could visit Russia in the early 30s and echo the famous headline, 'I have seen the future and it works'. The dynamic expansion of the Communist Party in Britain and the influence of Communism in intellectual and literary circles has been well chronicled, as have such initiatives towards popular political education as the *Left Book Club* scheme. There is no doubt that for a considerable section of the younger generation growing to political maturity in the thirties, the promised revolution was only a matter of time.

Added to this, there was in Britain in the early 1930s a potent sense of national crisis, with the collapse and division of the Labour Party and the consequent creation of a National coalition. It was much easier to interpret events as signalling an imminent collapse of the Capitalist system. It was a mood which inspired the kind of heroic conviction of those who joined the International Brigade. There appeared to be a general acceleration of political consciousness which stepped over barriers of class division and which was fuelled by a deeply-felt disgust with the hypocrisy and self-interest of the Establishment.

In short, in comparison with today, there was a good deal more belief in the inevitability of social revolution and a great deal less doubt and cynicism about its attainment.

Of course this sketch of an overall climate of ideas is not sufficient in itself to explain the circumstances, unique in the history of art practice in Britain, whereby artists and designers from all wings of the profession joined together in an organisation dedicated to the expression of their opposition to war and cultural oppression. It is perhaps this unanimity and commitment to social responsibility amongst artists which is hardest to conceive in today's terms. Explanations of the differences between the 1930s and the present position are perhaps to be found in differences in the occupational experience and self-image of the artist and designer, as well as in differences in the perceived measurement of political urgency.

It was easier in the 1930s for artists to be considered, and to consider themselves as authentic cultural workers with demonstrable occupational roles to fulfil in society and

with particular roles and skills to be employed in changing that society. There were in the 1930s fewer opportunities for practising artists to do part-time teaching in the art schools, which were still very much the territory of the specialist 'art masters' so the circular definition, with its implications of insularity, 'I am an artist because I teach art to art students', was less available. Also, against the background of punitive means-tested state allowances, there was no question of the support of the artist through social security agencies which are today such crucial suppliers of economic backing to the young artist.

The means of survival as an artist in the 1930s were much more dependent on direct production than today; there was still room for a certain number of painters to succeed by supplying the traditional middle-class buyer with traditional picture types, though certainly this aspect was rapidly declining through a combination of economic decline and change of taste, but the artists who more typically swelled the ranks of the AIA were men and women who were quite prepared, by both training and disposition, to produce 'commercial art', — book illustration, advertising, exhibition design, etc. — as a means to supporting their personal artistic development. It was typical that the main illustrators of *Left Review,* 'The Three James'', Holland, Boswell and Fitton, all followed this path. The idea of working as a designer for textiles or posters, far from being derided as some kind of loss of integrity, was seen by many progressive artists like Paul Nash — another consistent supporter in the early years of the AIA — as a highly practical tactic to bring contemporary art before the mass public. This is not to deny that there was still a large proportion of the profession who relied for the most part on unearned, inherited income to allow them to pursue the course of their personal artistic development, at the very least by smoothing them through their apprentice years. But whatever the economic position and art ideology of the individual artist or designer, it is certain that they were all severely affected by the slump in trade following the Wall Street collapse, and this economic pressure was one of the factors of common experience which contributed to the strength of the AIA in its early years and which encouraged an assertion of solidarity with working-class movements.

One factor which aided the movement's formation and which has definitely declined since the 1930s is the sense of community amongst artists. Even more than now were artists concentrated in London, but also in 'villages' within London, whether Bloomsbury, Fitzrovia or Hampstead. There was a much greater likelihood of artists being regularly acquainted with each other, of exchanging ideas in the artists' pubs and cafes of Soho, and of being able

to turn up to meetings or joint working sessions of an organisation like the AIA.

What is debatable is whether or not AIA members were initially any more politically informed and socially committed than their counterparts today. For the most part, few would have made any claims to political sophistication prior to their membership of the AIA; they would claim to have been motivated only by a grass roots awareness of the threats posed by Fascism and the arms race and a realisation of the urgency of resistance. However, the AIA saw self-education for its members as a high priority, and classes and lectures and debates were organised, particularly with a view to presenting Marxist approaches to the history of art, and to discuss strategies for contemporary action.

The primary task which the Artists' International set itself was to use the specialist skills of its members on propaganda work (a recurrent theme for discussion was the need to re-establish a reputable meaning for the term 'propaganda') posters, pamphlets, agit-prop for demonstrations, designing banners and floats, etc. Later, with the expansion of membership following the increasing political awareness triggered by the Spanish Civil War, the series of large-scale exhibitions organised by the AIA called on the involvement and collaboration of artists and designers from the whole spectrum of the profession. This process was instrumental in establishing a sense of occupational identity and collectivity of interest, which is difficult to envisage today, where vocational specialisation and the diversification of ethical and artistic values is engendered right from the beginning of training.

If the first decade of the AIA's operation is to be compared to the period of revival of interest in Art and Politics issues of the mid-1970s, a number of further dissimilarities would soon emerge, foremost among which would be a different balance of relations between art theory and practice. The mid-seventies was largely dominated by a corps of critics and art writers, each with their own emphasis but united in a call to order, who argued for a reintegration of the artist into the mainstream of social life and for throwing off the cosseting coverlet of aestheticism to confront the political and social realities of the larger world. Such voices were often painfully embarrassed by the absence of an acceptable contemporary art practice which to any extent answered this call, and what endeavours by individual artists or occasional collective undertakings did emerge lacked the feel of a concerted programme with any unity of purpose. Furthermore the greater part of the established art profession found itself out of sympathy with this call to order, and sought to resist it by upholding with some pas-

sion the primacy of the aesthetic claims of art. As a result the conflict soon degenerated into a caricature confrontation between the chiding, insensitive art critic and the smarting artist, defending his right to an individualistic and unrestricted search for higher truths.

Whereas in the thirties, the initiative came from the ranks of the artists themselves; at first from only a small pioneering section, but one which gradually spread its influence throughout the profession. Their approach was pragmatic and empirical; there was a willingness to take risks, to learn from them and to correct their tactics. The theoretical explorations into the nature of political art which were often born of the same endeavours, were likewise initiated by artists, and directed towards practical ends and advanced in harmony with the practice of artists, rather than in advance of or in conflict with them. The contribution of theory was respected only as long as it retained its credibility, and there was always a mixture of scepticism (perhaps characteristically anti-intellectual in origin) and populism to combat any excesses of speculative discourse; in 1938, AIA members were regaled by a set of talks which included 'Too much theory?' and 'Why ordinary people gave 1938's painting the raspberry'.

There was good justification for this scepticism. The status of the visual arts in British culture has traditionally had to take second place to that of literature; a dominance nurtured by the academic hierarchies established in its universities. Too often artists in Britain have been badly served by 'men of letters', pot-boiling poets or historians of remote periods, as their critics. They have grown suspicious of and defensive towards those they consider outsiders who were probably unsympathetic to the current thinking of artists. Artists have suffered the results of the crude application of modes of analysis derived from literary criticism without sufficient understanding of the specific problem of the relations between form and content in visual art, let alone the all-important issue of context — failing to distinguish, for example, between the function (and the consequent critical criteria) of a poster fly-posted on the factory wall and the same image in an exhibition gallery.

The case of how Soviet-style Socialist Realism was presented, provides a classic example of this literary fallacy — the mute assumption that a painting is a text. The directives that were presented to radical artists in Britain in the 1930s were taken over from the programmes of the Soviet Writers' Congress without the necessary and fundamental restatement that the visual medium required. The same obtuseness is still apparent today in many examples of equally crude misapplication of tools of analysis derived

from linguistic structuralism which again forget that a picture is not a sentence nor yet a film narrative. Even if it were conceded that a political painting, being primarily didactic by definition, is a special case, there is often too little understanding of the rhetorical modes peculiar to the visual image.

The AIA provides a valuable example of how artists themselves could confront these elementary and compelling questions about the place of art in society — about how to extend its audience, about how to make the artists' work more accessible and more significant, about the effectiveness of art as a means of social and political change, about the subjects of the artist and the social ramifications of style — questions which had barely surfaced to trouble the mind of the practitioner in Britain up until that point, and they were encountered head on with a directness and honesty which the urgency of the times demanded.

Many would claim that the resolution of these same questions has advanced very little during the subsequent decades, however, with the last wisps of '60s hedonism and escapism far out of mind, it is clear that today there are many individuals and groups who are committed to pursuing these basic questions about the social relations of art with equal determination. But their paths are widely divergent and their initiatives sporadic and unconnected. The example of the AIA suggests that any wide-scale programme which seeks substantial change in the purpose and functions of art must, first, exert a claim for unity amongst artists and for the establishment of an enabling body to co-ordinate these initiatives, which has something like the flexibility and tolerance that the AIA achieved in its days of strength.

We may have to conclude that a sense of social and political crisis comparable to that of the '30s must again become the common experience of artists before any such co-ordinated expression of social responsibility asserts itself.

APPENDIX

Exhibitions Organised by the AIA and Related Bodies between
1933 and 1953

Date Title

1934
Sep 27 — Oct 10 *The Social Scene*
 The Social Conditions and Struggles of Today.

1935
Nov 13-27 *Artists Against Fascism and War.*

1936
Apr 16 *The Condition of Working Class Housing.*

Oct 15-29 *Drawings by Felicia Browne*
 In aid of Spanish Medical Funds.

Dec *Artists Aid Spain*
 In aid of Spanish Medical Funds.

1937
Apr 14 — May 5 *Unity of Artists for Peace, Democracy and Cultural*
 Development.

Nov *5,000 Years Young*
 Chinese Graphic Art

1938

1939
From Jan 16 *Britain Today*
 Drawings, lithographs and woodcuts.

Feb 9 — Mar 7 *Unity of Artists for Peace, Democracy and Cultural*
 Development.

From March *Travelling Exhibition of Contemporary Painting*

1940
Jan 31 — Feb 24 *Everyman Prints*

Location	Organiser
64 Charlotte Street	AIA
28 Soho Square	AIA & Others
The Housing Centre, Suffolk Street	Architects & Technicians Association
46 Frith Street	AIA
46 Frith Street	AIA
41 Grosvenor Square	AIA
'Constable's House', 76 Charlotte Street	AIA
Sundry settlements, co-operative and School halls	AIA
Whitechapel Art Gallery	AIA
Sundry Municipal Art Galleries, York, Hanley, Brighton, Bradford etc.	AIA
Picture Hire Gallery and simultaneously at Bristol and Durham and then touring sundry provincial towns.	AIA

Date	Title
Sep 19 — Oct 10	*Members Exhibition*
From Oct	*Travelling Exhibition No. 2* Including loans from Courtauld, Blunt and Clark collections.

1941
April	*Exhibition of Modern Painting*
Jul 19 — Aug 9	*Exhibition of Sculpture, Pottery and Sculptors' Drawings*
Sep 16 — Oct 9	*Exhibition of War Pictures*
Sep	*Children's Art from all Countries For Refugee Children Evacuation Fund*

1942
Feb 7-27	*Members' Exhibition*
Sep	*Factory Canteen Travelling Exhibition*
Sep	*British Restaurant Travelling Exhibition*

1943
Mar 8	*Poster Design in Wartime Britain*
Mar 13 — Apr 11	*For Liberty*
Aug 5 — Sep 4	*Hogarth and English Caricature*
Nov 16 — Dec 18	*After Duty* Water Colours by Sappers Carel Weight, Patrick Gierth, William Reed and Albert Patterson

1944
Feb	*John Bull's Home Guard* Water Colours by Gilbert Spencer and caricatures from the French Wars.
Apr 15 — May 6	*Members' Exhibition*
May	*On Duty in the Desert* Drawings by James Boswell
May	*Work by Cliff Rowe*

Location	Organiser
RBA Galleries, Suffolk Street	AIA
Sundry Municipal Art Galleries	AIA
Canteen of Ministries of Shipping and Economic Warfare and other Services locations.	AIA
36 Upper Park Road, NW3	AIA & Free German League of Culture
Charing Cross Underground Station Ticket Hall	AIA
36 Upper Park Road, NW3	Free German League of Culture
RBA Galleries, Suffolk Street	AIA
Opening at Morris works, Cowley then to other factory sites.	AIA & CEMA
Sundry small town British Restaurants	AIA & CEMA
Harrods, then touring USSR and USA	AIA
John Lewis' basement, Oxford Street	AIA
84 Charlotte Street	Hogarth Group
84 Charlotte Street	AIA
84 Charlotte Street	AIA
RBA Galleries, Suffolk Street	AIA
84 Charlotte Street	Hogarth Group
84 Charlotte Street	Hogarth Group

Date	Title
1945	*Exhibition of Contemporary Paintings*
Undated	*Paintings by Contemporary Artists* An 'Art for the People' exhibition on behalf of Arts Council of Great Britain
	Modern Art Exhibition
June	*David Burton,* Pavement Artist
Jun 16-30	*The Engineer in British Life AEU Silver Jubilee Exhibition*
Sep 8-29	Members Exhibition, *This Extraordinary Year*
Oct 4-27	*Sculpture in the Home*
Oct 16 — Nov 3	*AIA Students' Exhibition*
October	*Picture Postcards,* a survey of the taste of the million
1946 Jun 6-26	*Painters Today*
1947 Oct 2-16 Nov 24-7 *Nov 15-29*	*Members Exhibition Part I* *Part II* *Part II*
1948 Jan 24	*The Under Thirties*
Apr	*Flower Painting*
May 29 — Jun 12	*Exhibition of Unpublished Illustrations*
Jun 23 — Jul 14	*Sculpture and Sculptors' Drawings*
Oct — Nov	*People by Peri* Sculpture by Peter Peri
1949 Jan	*Lithographs by La Dell, Mozely, Lynton Lamb*
Feb	*Small Pictures at Small Prices*
Apr	*50 Suggestions for Collections, Painters Known and not yet Known.*
May 1 — Jun 1	*Six Artists Abroad* Ainsworth, Boswell, Hogarth, Searle, Scarfe, Topolski

194

Location	Organiser
Sundry Army locations in the London District	AIA
	AIA and Brit. Inst. of Adult Education
ENSA Leisure Centres in Britain, then to Paris, Brussels and Rome	AIA
84 Charlotte Street	AIA
Whitechapel Art Gallery	AIA/Arts Council
Whitechapel Art Gallery	AIA
Heals, Tottenham Court Road	AIA
Foyles Gallery	AIA
84 Charlotte Street	Hogarth Group
54 Pall Mall	AIA & ACGB
AIA Gallery, Lisle Street	AIA
AIA Gallery, Lisle Street	AIA
AIA Gallery, Lisle Street	AIA
AIA Gallery, Lisle Street	AIA
AIA Gallery, Lisle Street	AIA
AIA Gallery, Lisle Street	AIA
AIA Gallery, Lisle Street	AIA
AIA Gallery, Lisle Street	AIA
AIA Gallery, Lisle Street	AIA
AIA Gallery, Lisle Street	AIA

Date	Title

N.B. From this point onwards, as the programme of one-person and small group exhibitions develops, only selected events will be listed.

Oct — Nov

Lowry, Minton, M. Rothenstein, Trevelyan, Uhlman, Weight

1950
Apr 20 — May 17

The Coalminers
Paintings and Drawings by Coalminers and
Professional Artists

1951
May 22 — Jun 11

Abstract Art
(Adams, D. H. Frazer, Frost, Heath, Hepworth,
Hill, Hilton, K. Martin, M. Martin, Nicholson,
Paolozzi, Pasmore, Richards, Turnbull et al)

Jul — Aug

AIA 1951 Lithographs

1952
Dec 2-20

The Mirror & The Square

1958
Mar 23 — Apr 28

AIA 25
Commemorative Exhibition

Location	Organiser
AIA Gallery, Lisle Street	AIA
AIA Gallery, Lisle Street	AIA
AIA Gallery, Lisle Street	AIA
AIA Gallery, Lisle Street	AIA
New Burlington Galleries	AIA
RBA Galleries, Suffolk Street	AIA

SELECT BIBLIOGRAPHY

1. Studies of the AIA

Books
Egbert, D. D. *Social Radicalism and the Arts: The West*, New York, 1970
Morris, L. & Radford, R. *The Story of the AIA 1933-53*, Oxford 1983

Articles
Rickaby, T. 'The Artists' International', *Block*, no 1, 1979, pp. 5-14
Sinclair, B. 'The Artists' International Association', *The Studio*, May 1949, pp. 129-132

2. General Studies in Cultural History and Art History of the Period

Books
Ashcroft, T. *English Art and English Society*, London, 1936
Blythe, R. *The Age of Illusion*, London, 1963
Branson, N. & Heinemann, M. *Britain in the Nineteen Thirties*, London, 1971
Chamot, M. *Modern Painters in Britain*, London, 1937
Clark, J. et al (eds) *Culture and Crisis in Britain in the 1930s*, London, 1979
Coe, P. & Reading, M. *Lubetkin and Tecton, Architecture and Social Commitment*, London, 1981
Dennett, T. *England: The (Workers') Film and Photo League*, in *Politics/Photography I*, pp. 100-17, London, 1979
Gloversmith, E. (ed) *Class, Culture and Social Change: A New View of the 1930s*, Sussex, 1980
Harries, M. & S. *The War Artists*, London, 1983
Harrisson, T. & Madge, C. *Mass Observation*, London, 1937
James, C. V. *Soviet Socialist Realism*, London, 1973
Lambert, R. S. (ed) *Art in England*, Harmondsworth, 1938
Lewis, C. D. (ed) *The Mind in Chains*, London, 1937
Martin, L. et al (eds), *Circle*, London, 1937
Mowat, C. L. *Britain Between the Wars*, London, 1956
Orwell, G. *The Road to Wigan Pier*, 1937
PEP *Dartington Report, The Arts Enquiry*, London, 1946
Priestley, J. B. *English Journey*, London, 1934
Read, H. (ed) *Unit 1*, London, 1934
Read, H. *Contemporary British Art*, Harmondsworth, 1951
Ross, A. *Colours of War*, London, 1983
Rotha, P. *Documentary Film*, London, 1936

Spender, S. *The Thirties and After,* London, 1980

Symons, J. *The Thirties: A Dream Revolved,* London, 1956

Symons, J. *The Angry 30s,* London, 1976

Wood, N. *Communism and British Intellectuals,* London, 1959

Articles

Bergonzi, B. 'Myths of the thirties', *Times Higher Education Supplement,*
 March 19th, 1982, p. 13

Jones, L. 'The Workers' Theatre in the Thirties', *Marxism Today,* Sep 1974,
 pp. 271-280

Monroe, G. 'The '30s: Art, Ideology and the WPA', *Art in America,* v 63, pt 6, Nov/
 Dec 1975, pp. 64-7

Morris, L. 'Realism: the Thirties Argument, Blunt and the Spectator', 1936-8,
 Art Monthly, vs 35, 36, 1980, pp. 3-10, 6-10

Picton, T., Mellor, D. et al. Mass Observation, *Camerawork,* no 11, 1978

Wadman, H. 'Left Wing Layout', *Typography,* 3. Summer 1937, pp. 24-8

Wilson, S. 'La Beauté Révolutionnaire?' Réalisme Socialiste and French Painting
 1935-1954, *The Oxford Art Journal,* v 3, no 2, Oct 1980, pp. 61-9

Catalogues

Circle, constructive art in Britain, 1934-40, Kettle's Yard Gallery, Cambridge, 1982

Fitzrovia and the road to York Minster, Parkin Gallery, London, 1973

Hampstead in the Thirties — a Committed Decade, Camden Arts Centre, 1975

Kunst im Exil (in Grossbritannien, 1933-1945), Neue Gesellschaft fur Bildende Kunst,
 Berlin, 1986

Thirties, Hayward Gallery, London, 1979

3. Studies by and relating to individual members of the AIA

Books

Bell, G. *The Artist and his Public,* London, 1939

Binder, P. *Odd Jobs,* London, 1933

Binyon, H. *Eric Ravilious — Memoir of an artist,* London, 1983

Boswell, J. *The Artist's Dilemma,* London, 1947

Feibusch, H. *Mural Painting,* London, 1946

Forge, A. (ed) *Townsend Journals: An artist's record of his times 1928-1951,*
 London, 1976

Gill, E. *Collected Letters,* London, 1960

Herman, J. *Related Twylights,* London, 1975

Hogarth, P. *The Artist as Reporter,* London, 1967

Hynes, S. *The Auden Generation,* London, 1976

Medley, R. *Drawn from Life: A Memoir,* London, 1983

Rea, B. (ed) *5 on Revolutionary Art,* London, 1936

Schulenburg, von der T. (Tisa Hess), *Ich hab's gewacht,* Breiggult, 1981

Trevelyan, J. *Indigo Days,* London, 1957

Uhlman, F. *The Making of an Englishman*, London, 1960

Articles
Bell, G. 'Escape from Escapism', *Left Review*, Jan 1938, pp. 662-6
Carline, R. C. 'For Liberty', *Our Time*, May 1943, pp. 25-30
Curtis, B. James Boswell, *Block*, no. 1, 1979, pp. 53-6
Klingender, F. D. 'Abstraction and Realism', *Left Review*, June 1936, pp. 472-3
Klingender, F. D. 'Problems of Realism', *Our Time*, Aug 1943
Klingender, F. D. 'Communism and Art — a Controversy', *Communist Review*,
 Jan 1947, pp. 18-21
Henderson, W. 'George Downs: Social Realism in Contemporary Art', *Our Time*,
 Oct 1945, pp. 46-7
Horton, P. (Toros) 'The Naive and the Sophisticated', *Left Review*, Apr 1938,
 pp. 927-930
Rowe, C. H. 'Auto-Lithography', *Our Time*, Dec 1943, pp. 19-20
Rowe, C. H. 'A Painter on his Method', *Our Time*, July 1944

Catalogues
Peggy Angus, 'A Plea for Creative Patronage', Swiss Cottage Library, London, 1978
James Boswell, 'James Boswell, 1906-71, Drawings, Illustrations and Paintings',
 Nottingham University Art Gallery, 1976
Felicia Browne, 'Drawings by Felicia Browne', London, 1936
James Fitton, 'James Fitton, RA', Oldham Art Gallery, 1983
Sam Haile, 'The Surrealist Paintings and Drawings of Sam Haile', Manchester
 Institute of Contemporary Art, 1967
Percy Horton, 'Percy Horton 1897-1970, Artist and Absolutist', Sheffield City Art
 Galleries, 1982
Laszlo/Peter Peri, 'Peri's People', Minories Gallery, Colchester, 1970
'Laszlo Peri 1899 — 1967', Neue Gesellschaft fur Bildende Kunst, Berlin, 1982
William Scott, Tate Gallery, London, 1970
Humphrey Spender, 'Worktown, Photographs of Bolton and Blackpool, taken for
 Mass Observation 1937/38', Brighton, 1977

4. Periodicals

Arena 1949-52
Artists International Bulletin 1934-5
Artists International Association Bulletin 1935-6
Artists' News-sheet 1936-8
Artists International Association Bulletin 1939-47
Artists International Association Newsletter 1947-72
Daylight 1952-4
Freie Deutsche Kultur 1942-4
Horizon 1940-

International Literature 1934-6
Left Review 1934-8
Our Time 1941-
Realism 1955
Viewpoint 1934
World News and Views 1938-53
World News 1954-

INDEX OF NAMES